ᵣe tʰᵉ last date st

MICHAEL FREEMAN'S
PHOTO SCHOOL
PORTRAIT

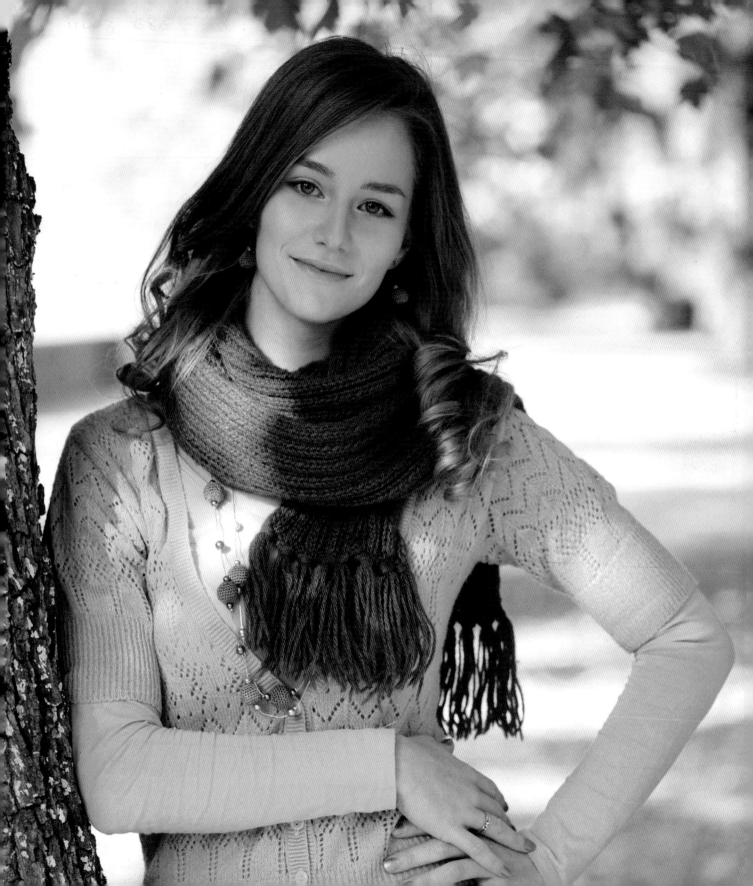

MICHAEL FREEMAN'S
PHOTO SCHOOL
PORTRAIT

EDITOR-IN-CHIEF **MICHAEL FREEMAN**
WITH **GARY EASTWOOD**

First published in the UK in 2012 by

I L E X
210 High Street
Lewes
East Sussex BN7 2NS
www.ilex-press.com

Publisher: Alastair Campbell
Associate Publisher: Adam Juniper
Creative Director: James Hollywell
Managing Editor: Natalia Price-Cabrera
Specialist Editor: Frank Gallaugher
Editor: Tara Gallagher
Senior Designer: Ginny Zeal
Designer: Lisa McCormick
Colour Origination: Ivy Press Reprographics

British Library Cataloguing-in-Publication Data
A catalogue record for this book is available
from the British Library

ISBN: 978-1-908150-95-0

Printed and bound in China

10 9 8 7 6 5 4 3 2 1

Photo on p2 © Lithian; p4 © Subbotina Anna;
p14 © JorgoPhotography; p54 © Gabriela;
p84 © George Mayer; p108 © XtravaganT; p134 ©
FotoDuki. All other photography © as indicated.

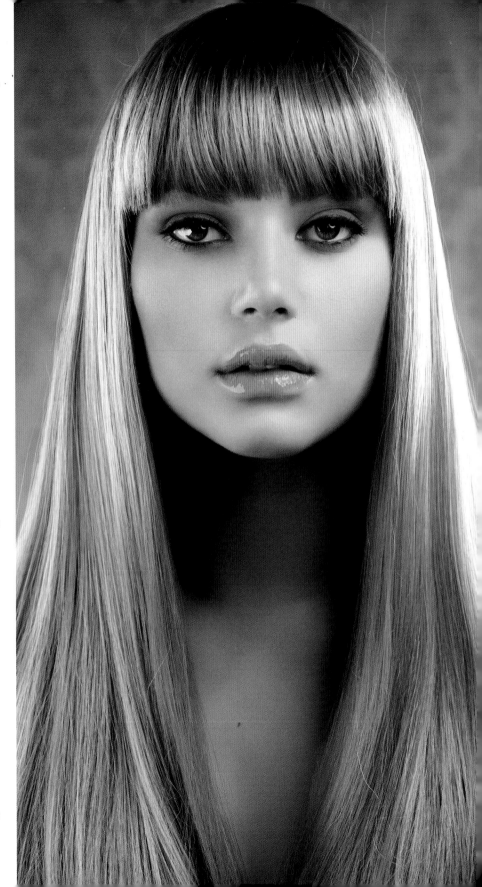

Contents

About This Series

Photography is what I do and have done for most of my life, and like any professional, I work at it, trying to improve my skills and my ideas. I actually enjoy sharing all of this, because I love photography and want as many people as possible to do it—but do it well. This includes learning why good photographs work and where they fit in the history of the craft.

This series of books is inspired by the structure of a college course, and of the benefits of a collective learning environment. Here, we're setting out to teach the fundamentals of photography in a foundational course, before moving on to teach specialist areas—much as a student would study a set first-year course before moving on to studying elective subjects of their own choosing.

The goal of these books is not only to instruct and educate, but also to motivate and inspire. Toward that end, many of the topics will be punctuated by a challenge to get out and shoot under a specific scenario, demonstrating and practicing the skills that were covered in the preceding sections. Further, we feature the work of several real-life photography students as they respond to these challenges themselves. As they discuss and I review their work, we hope to make the material all the more approachable and achievable.

For you, the reader, this series provides, I hope, a thorough education in photography, not just allowing you to shoot better pictures, but also to gain the same in-depth knowledge that degree students and professionals have, and all achieved through exercises that are at the same time fun and educational. That is why we've also built a website for this series, to which I encourage you to post your responses to the shooting challenges for feedback from your peers. You'll find the website at: **www.mfphotoschool.com**

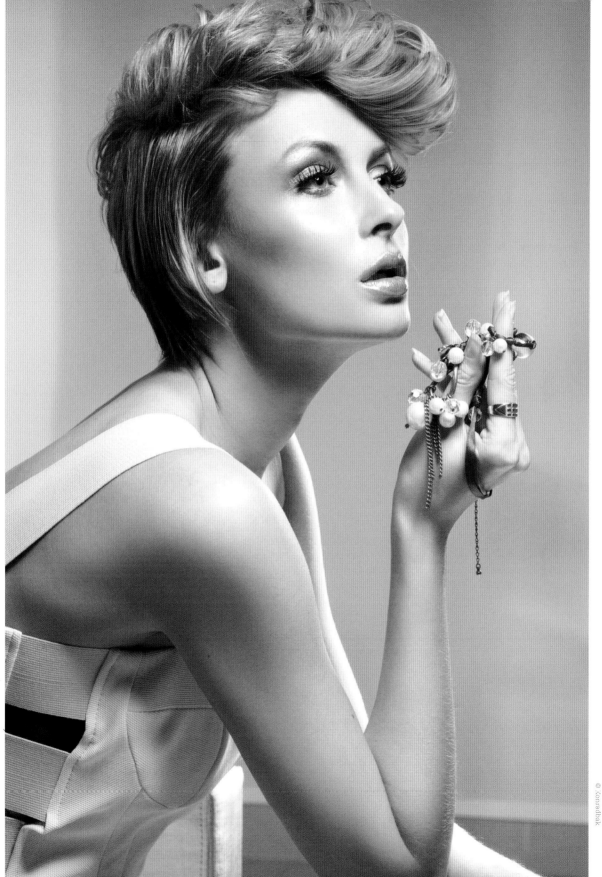

Student Profiles

Brittany Chretien

Brittany is a Louisiana native who was born on 14 March, 1992. Despite her young age, Brittany's interest in photography was first piqued at the age of eleven after receiving her first digital camera. She concentrates primarily on portraiture, oftentimes with dark and whimsical additions.

Since upgrading to a DSLR in 2007, Brittany works with a Nikon D40x and D90, and the 50mm AF-S G Nikkor lens. With the encouragement of family, friends, and mentors, Brittany has thoroughly advanced her photography skills and is currently pursuing a multidisciplinary BFA in photography, drawing, and sculpture at McNeese State University in Lake Charles, Louisiana. It is there that she fell in love with film photography and various alternative processes such as cyanotypes, pinholes, and platinum palladium, using a combination of traditional and digital techniques. Brittany's desire to learn and create something new grows stronger everyday. When not working on personal projects or classwork, Brittany enjoys reading and researching different artistic mediums and techniques.

You can find more of Brittany's work at: www.brittanychretien.com

Faith Kashefska-Lefever

On top of being a mother and a wife, Faith is a freelance photographer and photo restorer, and very passionate about both. Her restoration work includes repairing and coloring old photographs. "It is my way of helping old memories stay alive, and preserving pieces of family history," she says. "I love to use my photography as a way to show a different point of view, as well as to show the beauty in everything and everyone. I am always asking, 'If a photo is worth a thousand words, what would you like yours to say?'"

Faith's education comes from two places: NYIP (New York Institute of Photography) and herself. If she is not snapping pictures or working on a restoration, she usually has her face in a book learning something new. All of her post-processing and digital manipulation is self taught.

To see more of Faith's work, check out www.fklgz.com

Robert Bieber

A software engineer by trade, Robert practices photography as a long-time hobby and occasional weekend job. He began his photographic journey in high school as a yearbook staffer, struggling at first with the basics of exposure and composition, but slowly becoming comfortable juggling camera settings and framing. He later learned to work video cameras as well, picking up occasional concert and event videography jobs.

As his comfort with the camera grew, Robert stumbled upon the Strobist Lighting 101 guides and began to learn photographic lighting. He augmented his meager camera and lens collection with some old Nikon speedlights and radio triggers, and discovered an entirely new photographic realm. As his lighting competency grew, he began to evolve his own style, focusing primarily on simple, striking portraits and still-life scenes.

Now Robert works a full-time day job, but still shoots when he can find the time, working with a handful of lenses, some radio triggers, hand-modified flashes, a pair of light stands, a shoot-through umbrella, and a few hand-made light mods. From time to time he blogs about technique and occasionally hardware modifications on his photo blog at bieberphoto.com. You can view his assorted collection of images, ranging from portfolio-grade portraits to personal snapshots, at: www.flickr.com/photos/tehbieber

Mikko Palosaari

Mikko has been snapping photos ever since the first digital point-and-shoots came around. After his daughter was born three years ago, he got his first DSLR and photography soon become his main hobby. A self-taught amateur photographer from Finland, Mikko's main areas of interest are landscape and portrait photography. He shoot mainly with manual primes and recently moved to the full-frame format. In the future, he would like to get better with his portrait work and especially with how he interacts with the model. He certainly doesn't mind the occasional paid photography gig, but never wants to be a professional photographer—he just doesn't want to ruin all the fun.

You can go and check out his work at: www.flickr.com/photos/palosaari

Introduction

Portraiture is one of the oldest and most enduring themes in human art. For millennia, the need to capture an individual's physical likeness, character, mood or personality—or to portray their social status, wealth, and moral influence—has compelled artists to create human portraits through a huge variety of media.

Photography, of course, has brought portraiture to the masses and, more recently, digital photography has not only put the ability to create amazing digital portraits into the hands of the majority, it has also ushered in a new and exciting time for the portrait photographer. Classical, staid poses are being usurped by dramatic camera angles, tight framing, unusual lighting, and dynamic posing.

Until relatively recently, a portrait sitting was a privilege granted only to those few individuals deemed to have high moral, religious, financial, or social standing. This need to portray authority, power, and austerity has dictated the style of portraits since the ancient Greeks, whose classical posing and lighting rules have directly influenced sculptors and painters throughout the ages, as well as the early photographers. Of course, these poses were to some extent dictated by the technology in use. Early photographs, in particular, needed an exposure time of 30 seconds or more, again dictating the need for very stiff and static poses.

The photographic boom of the last century and the growing ubiquity of digital cameras means that we have become a sophisticated and demanding audience when it comes to viewing portraiture in all its forms. Portrait photography is now deeply rooted in our cultural and social iconography, from glamorous editorial and fashion imagery to marketing, advertising, and even photojournalism.

At the same time, the constant, artistic urge to remain innovative and unique means that the boundaries are being pushed by photographers eager to stand out from the crowd. As a result, the classical rules that have influenced portrait styles through the ages are being deconstructed, reconstructed, and even thrown out altogether. Framing, cropping, eye contact (or lack thereof), stance, pose, composition, lighting, and every other aspect that comes together to create the final look and feel of each portrait, are now up for interpretation, ushering in an exciting new era for portrait photography and photographers. Today's photographer is more likely to break as many formal posing rules as adhere to them, in order to create drama, tension, energy, mood, or uniqueness in a portrait.

But here is the important point: How does a photographer know how to break the rules, without knowing what the rules are in the first place? The

← Modern style
Modern portraiture frequently adopts a high-fashion, glamor approach, with unconventional posing and dynamic colors.

classical rules have evolved over centuries, adopted and refined by some of the finest artists that have ever lived—so who are we to ignore them? Understanding and mastering the classical rules, like so many subjects, provides the foundation on which we can build and refine our own style and techniques. Traditional techniques can still very much be applied today to create elegant and sophisticated portraits.

One thing is for sure, today's professional photographer has to be an accomplished portraitist, regardless of specialization. Photojournalism, commercial, fashion, war, or wedding photography, to name a few—all have portraiture as a significant component. Indeed, there can be few photographers in the world who will not at some point be asked, or compelled, to create a portrait of friends, family, colleagues, clients, celebrities, or even strangers.

It is more important than ever to create something unique and individual. In order to create eye-catching portraits, we have to master technique. We have to learn how to control a portrait sitting and exude confidence, and understand how a certain pose or lighting arrangement will influence the final look and feel.

Having a solid grasp of both classical and contemporary portrait techniques is therefore more vital than ever. This book will not only provide an exciting insight into the classical styles of portrait photography, but also highlight the contemporary trends that are being used to create some of the most enigmatic, charismatic and original portraits yet produced.

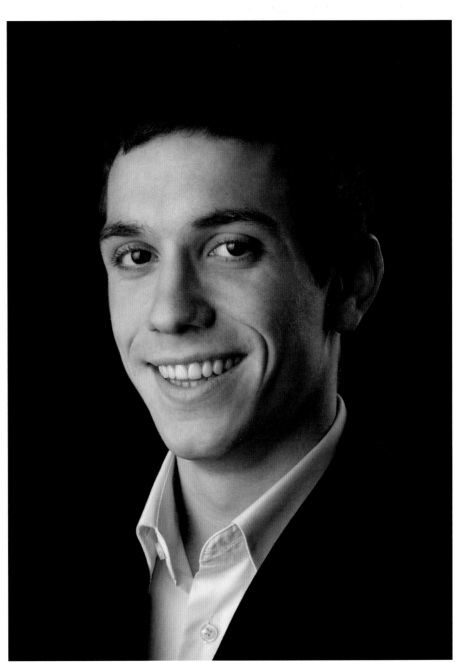

© ra2 studio

↑ Classic & timeless
Compared to the portrait on the page opposite, this traditional head-and-shoulders shot is different, but not better in any objective sense. Both types of portraiture have their place, and understanding how to go about achieving both looks is essential.

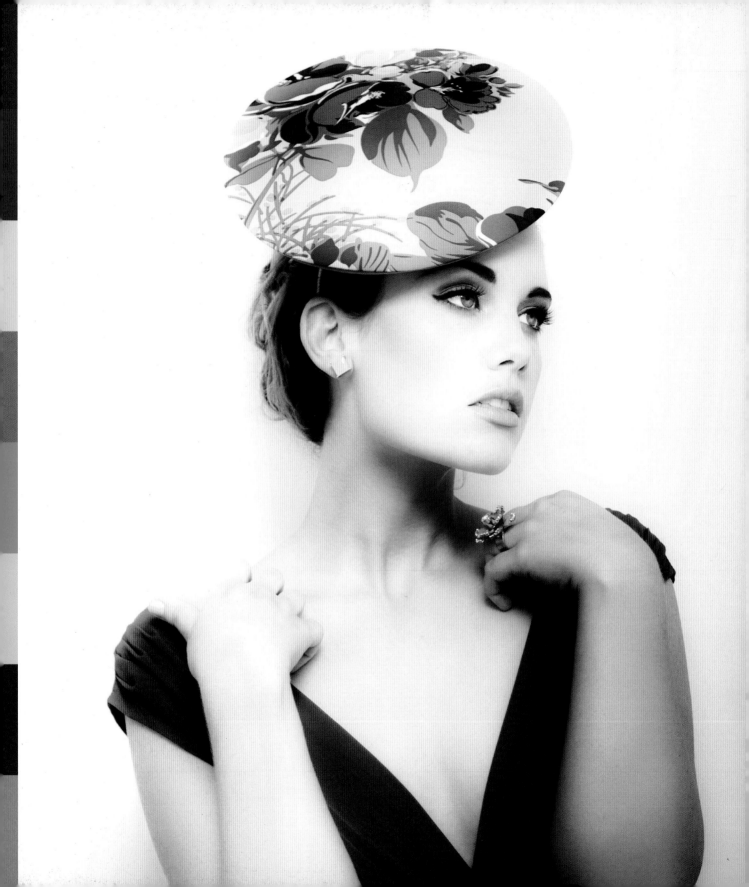

Posing & Framing

Mastering the art of posing and framing is a fundamental requirement for any photographer looking to create natural and elegant portraits. Mood, expression, background and, of course, lighting, are all essential ingredients for cooking up a unique portrait, as they create the nuance and detail that can elevate an adequate portrait into a great portrait. But a subject's pose and the overall image composition can make or break a portrait in an instant—simplicity and orderliness are key.

There are two main requisites for posing: that the pose remains natural; and the subject's features remain distortion-free. The pose of a subject must appear natural and comfortable (unless the creative intention is otherwise). Awkward or clumsy posing will ruin a portrait, while overly posed interpretations will look exactly that.

Poor composition and framing, meanwhile, can create dull, uninteresting portraits. One of the most common mistakes is to make the subject too small within the frame—don't be afraid to fill the frame and crop-in tightly. Guidelines such as the rule of thirds and the golden ratio provide a foundation upon which to build the portrait, but more importantly, they open the possibility for experimentation with composition.

The use of diagonals, triangles, and other asymmetric shapes are also considered to create visually pleasing shapes and lines within portraits. These can be created using body parts, such as arms, hands, legs and shoulders for longer body length portraits, or using facial features, such as the jaw line, chin or eyes in head-and-shoulder crops. A well placed hand or angled jaw line can be used to draw the viewer's eye up to the main subject: the face. The following section will address all of these challenges, and more.

Rapport & Confidence

Photography can be seen as a rather solitary pursuit. However, the ability to instantaneously establish rapport and trust with people from all walks of life can mean the difference between capturing a run-of-the-mill shot and an extraordinary one.

The portrait photographer in particular has to be a people person in order to gain the trust of their subjects. It is human nature to operate behind a mask of sorts, perhaps only revealing our true selves to families and close friends. It is the portrait photographer's job to try to get behind this façade and capture the essence of the real person behind the mask, often in a matter of minutes.

When a viewer says: "You've really captured John, or Mary …," what they are often referring to is not a physical likeness (which of course is a given), but rather that you have caught some element of the subject's personality or a unique expression that characterizes that person in the eyes of those who are closest. You have to establish trust quickly in order to gain access to the inner personality of the model.

Rapport

If one thinks about it, the idea of portrait photography is a daunting one! As portrait photographers, we have to quickly assess not only the physical traits of our subject, but also their personality, likes, dislikes, unique expressions and mannerisms, and of course their insecurities, usually

in a matter of minutes from the first meeting—all the while thinking about which lighting and posing arrangement might best suit their physical traits, and what particular techniques will work best.

Perhaps the best studio tool we have at our disposal in terms of establishing trust and building rapport is our mouths. Talk about anything. The weather. The journey here. Their fantastic outfit. Ask the subject what they expect from the session, or if they are not a talker themselves, explain to them what to expect. Just chatting to your subject for a few minutes can do wonders for building trust and rapport.

If it suits your personality, be brave. Flattery (subtle) can work wonders with some subjects. "I hadn't noticed, but I was thinking about how best we can capture those strong cheekbones." Obviously, there is a thin line between being corny and allaying your subject's anxieties, but it is not rocket science. Having said that, some photographers insist that outrageous flattery works for them, perhaps adding an element of humor.

Of course, the conversation will be different if your subject is a three-year-old child compared to a sixty-year-old businessman. But chatting as a photographer is no different to the way we communicate every day with people of all types. So just be natural.

Another technique commonly used is to make people laugh. Many photographers play the fool—it doesn't

need to be the best stand-up ever, and is not necessarily to force the subject to smile. But if a subject feels silly or self-conscious, simply messing around yourself can help them to relax too. If it doesn't work, don't panic, simply stop and try talking to them again. Work out the approach that works for you.

Of course, the talking does not have to stop as soon as the shutter button starts clicking. Many experienced photographers have learned that using a shutter release cable, for example, allows them to continue talking or to maintain eye contact with their subject. This constant verbal and non-verbal communication maintains the connection between photographer and subject that often creates the most striking portraits. Disappearing for long, silent periods of time behind the viewfinder will very quickly dissolve any connection previously established.

Confidence

Photographers command a rather immense amount of authority during a shoot. If a photographer says, "please stand over there," then a group of high-flying, chief executives of multinational companies will do exactly as they are told. Photographers must exude confidence. If that does not come naturally, then we need to develop a mask that makes it appear that way.

Like yawning, confidence is contagious. If you are confident, the subject is confident, which always makes for

© iofoto

better portraits. This is not only true in the studio, but also for location editorial or fashion shoots. You will essentially be in control of that shoot until you let everyone know otherwise—i.e. that it's time for a break or a wrap.

When you project confidence and professionalism, subjects are more willing to trust you, to do what you ask, and to invest more of themselves into the shoot.

For photographers, the first port of call for projecting confidence is to know your equipment: both camera and lighting. There can be no quicker way of losing the subject's confidence than

halting a shoot and muttering: "Sorry, I'm not sure how to change the aperture on my camera."

Also be aware that most subjects will require authoritative direction during a shoot or sitting—if they don't, just shoot away and enjoy! But that is rare, so appearing calm and in control at all times will get the best out of the session and the model. Without experience it is difficult to know what kinds of things to say when directing a subject.

One of the most obvious ways around this is to pre-plan the shoot, and some of the poses that you might require. Doing this can provide confidence in

↑ Control & confidence

It is important to exude confidence and professionalism. Confidence is contagious, and will almost certainly transmit to the model. On a shoot, you have to be in complete control of the technical aspects, and be capable of giving assured direction to models. Constant positive feedback can generate a reliably dynamic mood on set.

itself, for both photographer and subject, and will allow you to work out beforehand the kinds of things that you might need to say to the subject to create the poses. Running through a list of directions and poses on shoot will sound professional, experienced and, of course, confident. Memorize your subject's name beforehand, if you know it.

Camera Matters

There is a well-known quote by war photographer Robert Capa that states: "If your photographs aren't good enough, you're not close enough." While most photographers will immediately empathize with this statement, it does not tell the whole story, at least not for portrait photography.

Of course, tight or close framing can create striking images with interest and impact. However, it is also vital to understand how camera position and distance can have a significant impact on portrait perspective, distortion and, ultimately, the physical characteristics of a subject. To put it another way, photographers must know how to use camera position, lens focal length, and depth of field to enhance or diminish certain physical features in a portrait subject.

Height of the Camera

As a general rule of thumb, the camera's height should be set at the point at which the subject is split in half in the viewfinder. So for a full-length portrait, the camera height should be around the waist area; for a two-thirds portrait place the camera around the same height as the bottom of the ribcage; while for a head-and-shoulders portrait, the camera should be roughly the same height as the end of the subject's nose.

These camera heights, in conjunction with a camera plane that is kept parallel to the subject (i.e. no tilting backward or forward of the camera relative to the subject), should help to ensure that the natural perspective of the human face and body is retained. Of course, it is likely that there will be times when a subject pleads with you to enhance or diminish a specific feature. How many times, as photographers, are we asked: "Please could you do something to hide my double-chin (… / hips / receding hairline / nose / belly / some other feature)?" Just as likely, you may make your own decisions about how best to portray the physical aspects of the subject in the most desirable way.

For full-body and two-third shots, for example, raising the camera height will emphasize the head and shoulders and make the hips and legs appear thinner. Lowering the camera will emphasize feet, legs, and hips (depending on the extent of movement), while diminishing the head and shoulders. Tilting the camera in the same direction as the height change (i.e. tilting down when lowering, or tilting up when raising the camera) will multiply these effects. Overdo it though and you will start to add distortion, giving the body an unnatural appearance.

For closer shots, such as head-and-shoulders portraits, lowering the camera below the tip of the nose will make the chin appear more prominent and the jaw wider, while shrinking the nose and diminishing the forehead. Moving the camera upward has the opposite effect: lengthening the nose and broadening the forehead, while thinning the jaw line and diminishing the chin. Again, tilting the camera in the same direction accentuates these effects. In addition, the closer the camera is to the subject, the more pronounced the distortion.

Also be aware that raising or lowering camera height can confer an apparent status on the subject, in the eyes of the viewer. Used in a certain way, a higher camera height can make the subject look more demure, vulnerable or inferior—the viewer literally looks down on them. Likewise, a low shooting angle can confer an appearance of height, superiority or strength, depending on how the other factors in the portrait are combined.

Focal Length

Standard lenses are often used by photographers as all-rounders (i.e. a 50mm lens for 35mm format, a 35mm lens for APS-C format, an 80mm for medium format, and so on). While this is a good general rule of thumb for full- and two-thirds-length portraits, as well as for group shots, the most commonly used portrait lenses, particularly for head-and-shoulders shots, are a longer focal length than standard lenses.

While standard lenses are considered to best approximate the natural perspective of the human eye, in head-and-shoulders portraiture they may require you to move uncomfortably close to the subject in order to fill the frame.

As well as being disconcerting for the subject, shorter focal lengths can start to add distortion at shorter distances, due to an effect called foreshortening, whereby wide-angle (short focal length) lenses exaggerate features in the foreground and diminish those farther away.

To avoid this, favorite portrait lenses for head-and-shoulders shots commonly include 70mm, 85mm, 100mm, 135mm, and even 200mm focal lengths (above 200mm and the room required for the shot may become unfeasible, and can create compression distortion).

Depth of Field

Using a lens with a longer focal length can also create shallow depth of field (DoF). As you may already know, setting a wide aperture (or small f-number) such as f/2.8 on our camera or lens not only lets more light onto the film or sensor, but also creates a shallow DoF—a narrow band of focus at a specified distance from the camera. The smaller the aperture number, the wider the aperture, the narrower the DoF.

This narrow band of focus—and its opposite counterpart bokeh (the blurred look that appears in the parts of the image that are not in focus)—is usually a highly desirable commodity among photographers. For portrait photographers, it can be a double-edged sword. For a full-length portrait, using a shallow DoF can isolate and emphasize an in-focus subject from an out-of-focus background. Likewise,

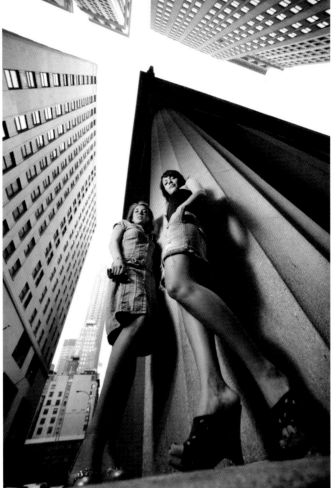

© Konstantin Sutyagin

bokeh can be employed to remove unwanted or distracting elements from the background, by creating a dreamy blur of colors and abstract shapes. On the flip side, a shallow DoF could ruin a family shot, whereby the children on the front row are in perfect focus, while the parents and grandparents at the back are blurred by the bokeh. For group shots, therefore, aperture settings of f/8.0 and f/11.0 are more appropriate.

However, shallow DoF (wide aperture) can also create dramatic close-up portraits. Using this narrow band of focus to keep one eye in focus, and the rest of the face in blurred bokeh, for example, can produce striking results. At very wide apertures, such as f/1.4,

↑ Looking up

An extreme example of how combining low camera height and tilting the camera backward can create dramatic shifts in perspective, emphasizing the legs and hips, and diminishing the head and shoulders. Used more conservatively, these techniques can be applied positively to enhance the physical appearance of subjects in a full-length portrait.

you can create eye-catching, almost surreal, portraits—but be aware that with such shallow DoF at short distances even the smallest movement (by photographer or subject) can result in loss of focus. DoF in this scenario could be something like a 0.5cm band of focus, so it's easy to see how an eye in focus at one moment may not be a second or so later when the shutter button is pressed.

Head Shots

There is a reason why police mug shots look so unappealing. Facing square on to anyone, let alone someone pointing a camera at you, is an unnatural and potentially aggressive stance. From a portrait photographer's standpoint, it is also one of the least attractive poses.

When standing square on to the camera, the facial features appear flat, with no modeling of cheekbones or jaw lines, shoulders appear chunky and broad, and the line of the eyes is straight (parallel to the ground) creating flat and unappealing portraits. In almost every portrait, the head and shoulders should be turned slightly away from the camera at an angle, and tilted slightly either up or down—to create a pleasing and alluring diagonal line using the eyes.

Seven-Eighths, Three-Quarters, & Profile

Most portraits can be classified into three main types, according to the position of the body and face: the profile, the seven-eighths view, and the three-quarters view. The former is fairly self-explanatory, but the other two shots make up the majority of head portraits made, so it is important to understand their nuances.

The seven-eighths view is an almost straight-on view of the subject's face, but with the face turned slightly to one side of the camera. You should be able to see more of one side of the face than the other, including the far ear.

The three-quarters view shows, as it says, three quarters of the subjects face, which needs to be turned 45 degrees away from the camera (either side). The far ear, and much of the far side of the face, will disappear from view. Make sure that the far eye does not merge with the background on the far side of the face, rather it should remain contained within the face by always having skin from the far temple area between the far eye and the background.

You will also hear mention of the two-thirds view. In practice, this is the commonly used term by working photographers to distinguish the shot from a mug shot or a side profile— essentially, the two-thirds shot is halfway between seven-eighths and three-quarters. The important aspect is that the head is angled away from the camera, to create pleasing angles using the subject's jaw line, neck, and the line of the eyes. This angle also allows for modeling of the facial features based on the lighting setup employed.

With a profile shot, it is not simply a case of turning the subject 90 degrees away from the camera and shooting. Rather, ask the subject to slowly move their face away from the camera until the point at which the far eye just disappears from view (behind the nose), and take the profile from that point. Another trick is to ask the subject to raise their chin slightly to make the skin around the neck taught.

↓ **Half of a face**
With a profile shot, ask the subject to slowly turn their head away from the camera until the far eye disappears from view.

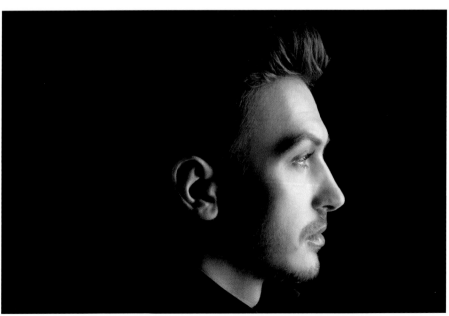

© Igor Borodin

→ **Angle of interest**
Angling the shoulders and head in opposite directions is considered to create a more feminine pose (here, shoulders are turned to the subject's left, and the head to the right).

Head & Shoulders
Tilt & Turn

For most portraits, the shoulders should be turned to one side at an angle. So normally the shoulders should be angled slightly to one side of the camera, while the neck can also be posed at a slightly opposing angle, again adding interesting and pleasing lines to the portrait.

Turning the neck and shoulders in slightly opposite directions provides a more feminine and sophisticated look (the over-the-shoulder look), while a more masculine pose would be consideredto show the neck and shoulders angled in the same direction.

The shoulders should also be tilted slightly—that is, one shoulder should always be higher than the other. Shoulders that are parallel to the ground will look bulky and leave the portrait lacking in drama or tension. Again, there are differences between feminine and masculine poses, with the former commonly placing the higher shoulder nearest the camera, while for males the lowest shoulder is often nearest the camera.

There are several ways of achieving the shoulder tilt. For standing subjects ask them to stand at a slight angle (which also creates the shoulder angle) and put more weight on the back foot. For seated subjects, simply ask them to lean the upper half of the body in toward the camera.

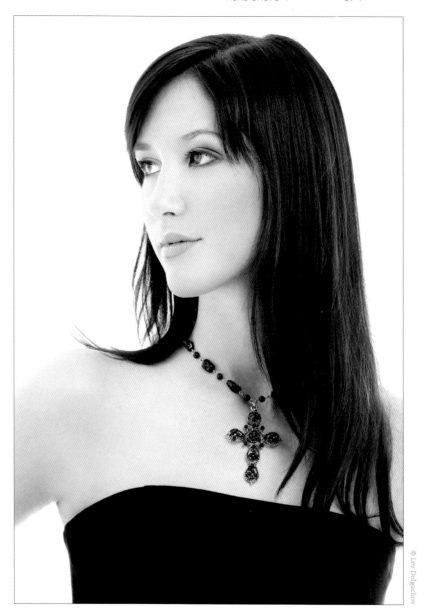

© Lev Dolgachov

Eye Tilt

As we have already mentioned, the head and face should almost always be tilted at a slight angle, creating a diagonal line with the eyes. If the line of the eyes is parallel to the ground, the resulting portrait will appear static, so tilting the head at a slight angle injects more drama and energy into the portrait.

As a general rule, diagonals, triangles, and asymmetric shapes are considered to be pleasing to the human eye and always contribute to flattering or interesting portraits. Aim to create these shapes as often as possible using the subject's eyes, shoulders, jaw line, arms, hands, and so on—these lines and shapes can also be employed to draw the viewer's eyes up to the subject's face.

Challenge

Different Focal Lengths

The focal length we use to shoot a portrait subject has a significant impact on the final outcome. While standard lenses (such as a 50mm-equivalent) are useful for full-length shots and group portraits, they can start to add unwanted foreshortening distortion, whereby features closest to the lens appear relatively large compared to those farther away. Foreshortening perspective distortion is more marked at wider focal lengths and when working at close distances to the subject.

At the same time, a shorter-than-normal (less than 50mm) lens requires you to stand very close to the subject in order to fill the frame. As a result, wide and standard lenses are rarely used for close-up head-and-shoulders portraits, as they distort facial features, notably making the nose and chin appear to stretch close to the lens, while making the forehead, ears, and neck recede and appear unnaturally small.

Longer-than-standard lenses (anywhere in the range 75–200mm) remove any unwanted foreshortening effects, and allow you to stand a comfortable distance away from the subject, while still filling the frame, which can also help to capture more candid shots.

↓ **Wide-angle distortion**
Using a wide-angle lens at close distance can create a striking portrait, but will also introduce a form of distortion known as foreshortening, whereby facial features closest to the lens—such as nose, mouth, and chin—loom large, while more distant elements, such as head and ears, appear unnaturally small.

© Konstantin Sutyagin

Challenge Checklist

Using the same subject in a similar pose take a number of head-and-shoulder portraits at different focal lengths, say 24–35mm, 50mm, 85–100mm, and 135–200mm, making sure the subject fills the frame. The exact focal length isn't important, but try to use a standard lens (50mm), a lens that has a longer focal length than standard (telephoto), and one that is shorter (wide).

If you don't have all of these focal lengths, try sharing lenses with a friend—hopefully between the two of you, there will be a wide enough variation in focal length.

Assess the impact of the different focal lengths on the amount of perspective distortion on the facial features of the subject. What does a wide lens do to the model's nose, forehead, and chin? Does a longer focal length have the same effect? What is the optimum focal length for a head-and-shoulder portrait?

Compare the effects of the different focal lengths on a number of parameters, including perspective, distortion, and depth of field. With a wide or standard lens, see how close you have to stand to the subject in order to fill the frame with their head and shoulders. How close do you need to stand with a telephoto lens? What effect does this have on the subject?

↑ Telephoto compression

Using longer-than-normal focal length lenses (more than 50mm) for head-and-shoulder portraits removes the foreshortening effect caused by wide lenses, and retains a natural perspective for the facial features. Telephoto lenses also allow you to stand farther back while still filling the frame, which can result in more relaxed and candid portraits. Finally,

Review

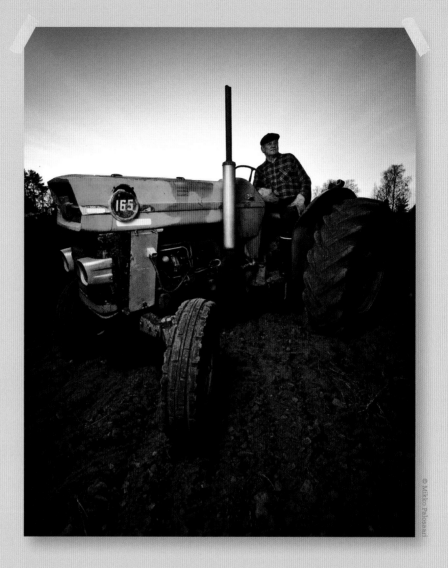

© Mikko Palosaari

My father-in-law had just turned 70 and I persuaded him to model for me in his natural inhabitant for the occasion. The photo was taken with a APS-C camera at 10mm focal length to emphasize the tractor. Two speed lights with shoot through umbrellas were used to light the scene from camera left and right.
Mikko Palosaari

At a 35mm-equivalent focal length of 15mm, this is ultra-wide angle territory, and it shows—but effectively. The tractor is prominent, but not grossly distorted, and the soil fills the foreground with nice radiating lines. Although the subject is probably only a few feet from the camera, it's a natural consequence of this kind of lens that he appears quite small in relation to his tractor—which could well be intentional.
Michael Freeman

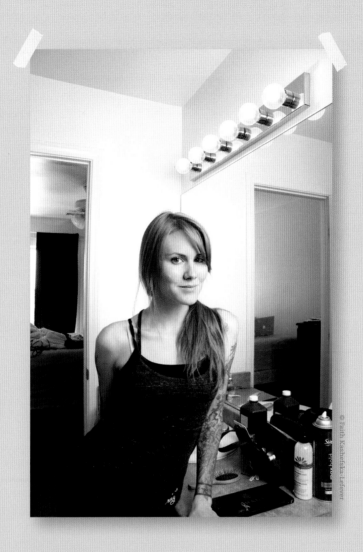

For this photo, I wanted to create an evenly lit scene, incorporating the ambient light. I have one strobe just to the right of the camera, and used a slower shutter speed to include the light from the bulbs in the fixture, as well as the back ground lighting from the sliding glass door in the room behind the subject. It was obviously a cramped space, and the 28mm-equivalent focal length was a necessity in capturing the environment.

Faith Kashefska-Lefever

There's an interesting contrast here between the excellent lighting and attractive posing on the one hand, and the rather haphazard environment on the other. It invites interest in the subject's character and story—a classic use of the wider focal lengths (this particular one not being too wide so as to distort the subject).

Michael Freeman

Eye Contact or Not?

Direct eye contact is the strongest means of communication we have, so it is no exaggeration to say that the direction of the subject's eyes in a portrait will have a significant impact on the final look and feel of the image. For head-and-shoulders and closely framed shots, it is the defining aspect. Indeed, the eyes are the focal point of the majority of portraits, so getting them posed and exposed correctly is paramount.

In general, there are several options when it comes to portraits: the subject looks directly into the camera lens (and therefore at the viewer of the final portrait); the subject looks at something outside of the frame (which can create curiosity within the viewer as to what the subject might be looking at); or the model looks at an object or person within the frame of the image (which can create another level of meaning and communication within the portrait).

Direct Eye Contact

To have the subject looking directly into the camera lens equates to the subject looking directly at the viewer. Portraits with eye contact between subject and viewer are apparently more saleable than off-camera gazes. This could be because eye contact creates a connection with the viewer of the final portrait, which compels them to consider the portrait for longer, contemplating what the subject might be trying to communicate.

© Warren Goldswain

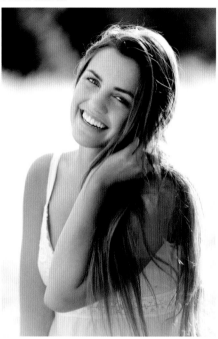

↑ Connect using your own eyes
To motivate a genuine smile and engaged eyes, don't disappear behind the viewfinder or ask the subject to "look into the lens." Instead, raise your head above the camera during exposure and smile or talk to them, using a shutter-release cable if necessary. This not only maintains the connection between photographer and subject, but it also creates natural eye contact.

The eyes tend to look more engaged when they are gazing at a person rather than an object, so many photographers will ask the subject to look at them, rather than into the lens. By keeping the head close to the camera axis—preferably above the camera and on the key light side in order to maximize catchlights—you can both engage the subject and create direct eye contact.

This can be done either by using a shutter release cable or just by raising your head from behind the viewfinder before exposure. Talking to a nervous subject from the same position can provide the additional benefit of taking their mind off the portrait shoot.

It is vital that the subject is not bored or tired, as this will show in the eyes. Likewise, be aware that in bright conditions, the pupils can appear small and beady. Tricks such as closing the subject's eyes immediately prior to pressing the shutter, or asking them to look at a dark object before exposure, can help to combat this.

If shooting the model from an angle, make sure that the eyes are not too strained in looking back toward the camera—if so, alter the pose. The iris should border the upper or lower eyelids—if not, the eyes are probably tipped too far in the wrong direction.

Looking Out of Frame

Asking the subject to look out of the frame, usually to either side, can create a sense of curiosity or narrative for the viewer. Viewers of the final portrait will consider what the subject is looking at, and in turn start to build a narrative based on the visual clues within the frame. For example, a shot of a bride looking out of the frame (presumably at their groom) are currently very popular in wedding photographer portfolios.

© Katie Little

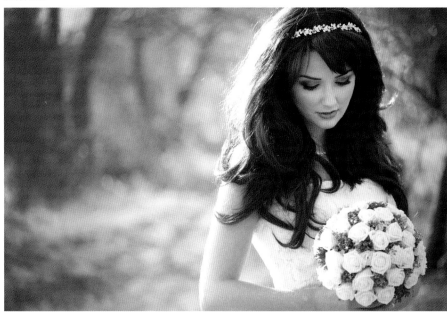

→ Looking down
Averting the gaze of the subject from the camera creates a feeling of coyness, or intimacy.

Combining this off-camera gaze with an expression or visual clues can create images that communicate strong emotional messages. For example, a look of shock might generate a feeling of concern from the viewer. The off-camera look is also associated with candid shots, with the viewer feeling privileged to share a private moment, expression or emotion.

Like direct eye contact shots, the subject's eyes will be more engaged if they are looking at someone rather than something, so ask an assistant to stand off-camera in the position that you want the model to be looking. If this is not possible, consider setting a timer delay and moving yourself out of frame to the position you want the subject looking. The difference in the eyes will be worth it.

A further option for eye direction is to have the subject's gaze averted from the camera, but not necessarily out of the frame—for example, a shy bride might look toward the ground, or away from the camera, so she is engaged with the viewer, but not looking directly into the camera. This technique can be used to signify coyness, giving the impression that the subject is too shy to look directly at the camera.

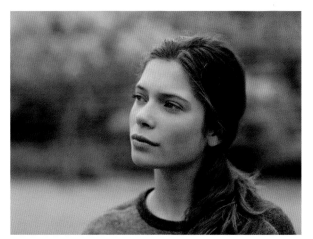

© WavebreakmediaMicro

← What is she thinking?
Asking the subject to look out of frame can create a sense of curiosity in the viewer, and suggests movement and narrative. What is the person looking at? By adding visual clues within frame, you can build a compelling sense of narrative. This pose also suggests candidness, whereby the viewer is privy to the daily life of the subject.

Looking Into the Frame

A subject looking at something or someone else within the frame can create additional layers of meaning within the portrait, and reinforces the sense of narrative. For example, a father gazing into the eyes of his newborn son, a sad lady staring into a mirror, or a young boy looking longingly at another boy's new bike.

This technique essentially adds an additional subject, and another layer of relationship between the main subject and this new subject, so you need to be careful that the visual clues do not cause the viewer to create a false or unintentional narrative—unless, of course, that is the creative intention.

Demeanor

Even before setting up the camera prior to a portrait sitting, it is important for you to consider the mood, emotion, or feel of the final portrait. Will it be a happy portrait with the subject smiling, or will it portray a pensive or melancholic mood? There are as many moods for a portrait as there are expressions and emotions, and combining those with different lighting, poses, clothing, colors and tones, backgrounds, props, and so on, can create an almost infinite variety of unique portraits.

It is therefore important that you have an idea of what you are looking for beforehand. In many instances, this is likely to be preset by the subject or customer—for example, a commercial client that has a specific mood and message in mind for their product, a fashion picture editor with a strong sense of what the final outcome will look like, or even a studio portrait of a family who know exactly the kind of mood and look they like.

In a sense, that makes it a little easier for you to set the desired tone. Otherwise, we have to think carefully about how to achieve that ultimate mood and the combined effect that all our decisions on lighting, clothing, color palette, mood, setting, and so on, will have on the final portrait.

Perhaps the first questions to ask the subject are: What is the intention of the portrait? What are the reasons for having the photos taken? What mood should be portrayed? What is the personality of the subject? Once these decisions have been made, then you can start to think about the setting and background that will enhance and complement the desired aim and mood of the portrait.

For example, which lighting setup and background is most appropriate for a happy, or a serious, portrait? Will the portrait be brightly colored, or a selection of muted, almost monochromatic tones? What impact will these choices have when combined with a specific expression?

Arguably, creating the setting and mastering the technical aspects of the portrait comes easier to many photographers than the most important bit: compelling the subject to express what is intended. How do you make a person you've just met laugh or look melancholy?

Setting the Mood

Many subjects still associate a fear of having their portrait taken with being forced to smile rictus grins, perhaps for family or school portraits as children. Of course, there is no reason why a smile or grin is even necessary in every portrait. Making the session fun can in itself create a natural joy and happiness, which will show more in the subject's eyes and body language than in a false smile.

In reality, many subjects are likely to be a little shy in front of the camera, at least at first. So you will need to develop some strategies for relaxing your subjects, and even making them laugh. If we go into a portrait session in a bad mood, stressed, or unhappy, how likely are we to cajole a subject into smiling or laughing?

The first place to set the tone for any portrait session—happy, serious, sad, pensive—is with ourselves. For example, to create a happy portrait, it is important that the sitting or session is fun and lively for all—photographer included. Tell some jokes, play the fool, use outrageous flattery, pull faces, play happy music on a portable music system—if you have an assistant or friend on set, ask them to join in the jocularity.

Anything to raise the mood on set. If you are bored, rest assured your subject will be. With children, try adding some cuddly toys as props to hold behind the camera at the point of exposure, or just make stupid noises.

Next, think about color scheme and the effect this will have on the overall mood of the image. We know that yellow is associated with the sun, and happiness; grays and blacks less so. Incorporating a bright color palette into the portrait scheme and using high-key lighting will enhance the feeling of happiness and brightness.

On the flip side, if you are aiming for a pensive or thoughtful portrait, setting the mood on set is just as important. Again, we can start with our own tone and mood. Exude calmness, remove sources of noise and clutter, and create a serene ambience.

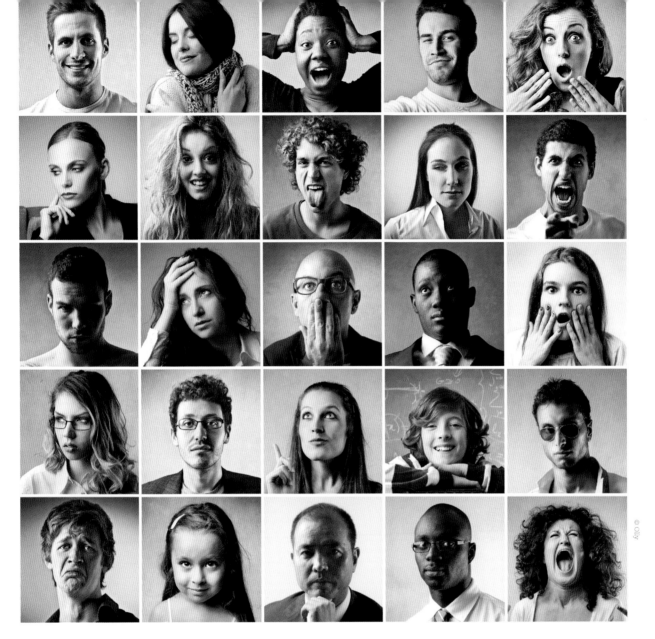

© Olly

Create the setting in the studio or on location beforehand—muted, monochromatic tones and more natural light might be better suited to a pensive portrait. For example, sit the subject looking out of a window bathed in classic, soft north window light or under low-key lighting. Think about appropriate posing, too. Where should the arms and hands be? If it works for you, try playing mood music to set and maintain the tone throughout the sitting. If necessary, create a narrative for the subject to role-play.

Once the overall tone for the session is set, you can then start to experiment with cajoling different expressions from the subject. Try a variety of poses, camera angles, lighting setups, and so on—but be aware not to create the perfect mood and then let it come crashing down as you stop to play around with your lighting setup, look

↑ Not all smiles
Different expressions, emotions etc. Which do you want?

at images on a computer screen, and so on. Maintain the right mood throughout the session.

Challenge

Choose the Tone of the Session

↓ **The pensive portrait**
Serious, contemplative portraits can sometimes be the more difficult to achieve, as your demeanor with the subject can easily slip into a stiff and somber tone. The key is to speak softly, but continue to offer plenty of helpful instruction as needed.

Your mood, the background, the lighting, the color palette, the subject's personality, and many other factors, will all have an impact on the final mood and feel of the portrait. With so many factors to consider, you need to develop the skill of visualizing the final look of the portrait and, more importantly, knowing how to achieve it.

In practice, the main focus of any portrait should be the expression, mood, and body language. In order to control how we want the subject to behave, the first port of call is with ourselves. We can start to set a tone

or mood with the subject based on our own mood and behavior. A happy, relaxed photographer will transfer those feelings to the subject, and the same goes for a stressed, serious, or subdued photographer.

In this challenge you should set out to produce two portraits: one conveying a feeling of freedom and carefree happiness through the use of mood, tone, color, body language, expression, setting, lighting, and so on; and, a second portrait conveying a pensive mood.

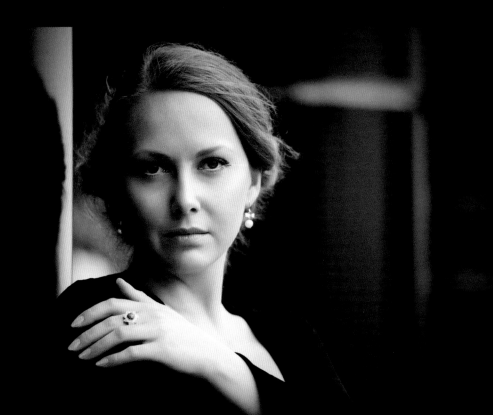

© Wrangler

Challenge Checklist

→ If you expect the subject to be happy and smiling throughout the session, ensure that you play your part and portray a similar mood. If the subject is having fun and enjoying themselves, it will show in their eyes and in their body language. If you are bored, the subject will be as well.

→ The subject should always be the focus of the portrait, so when using setting and background to establish the overall tone of the image, make sure that they enhance and complement the mood, rather than overpower it.

→ Carefully consider how the color palette will affect the mood of the portrait. Tones in similar colors will tend to be more subdued and contemplative, while bright, opposite colors will bring energy, vibrancy, and tension to the image.

→ The use of appropriate props and accessories, used in moderation, can really enhance the prevailing mood or message of a portrait.

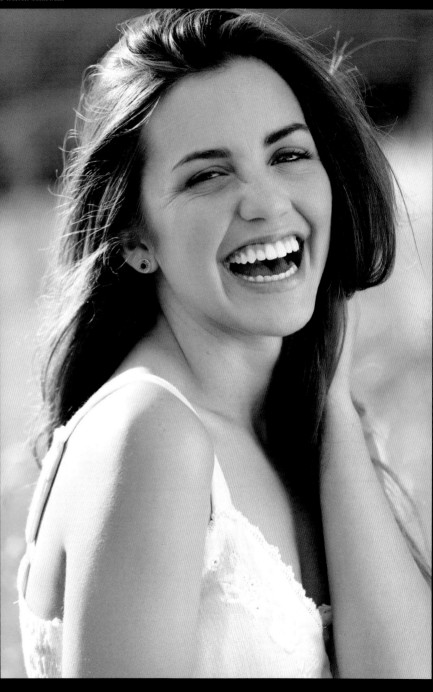

↑ **An energetic personality portrait**
A large part of making a portrait session fun—and thus achieving energetic shots like this—is to maintain the momentum

Review

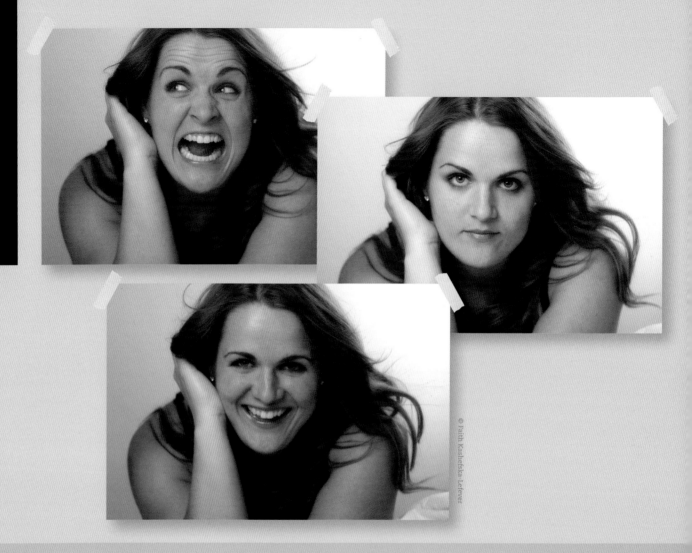

© Faith Kashefska-Lefever

For this session we were going for a simple beauty portrait. I felt we had captured a strong pensive portrait. So for the next few frames we lightened the mood, I got her to laugh and captured a genuine smile. I really enjoy relaxing the people I photograph by getting them to laugh, make faces, and just really be themselves. Once they relax and open up it can be easier to capture any moment you need from them.

Faith Kashefska-Lefever

Interesting approach. As an exercise in helping the model realize the range of possibilities, this can certainly work. The top left shot might just work for a certain kind of stock, but the value of this set is that it shows how a fully smiling face is the best presentation of this particular model's mouth and jaw.

Michael Freeman

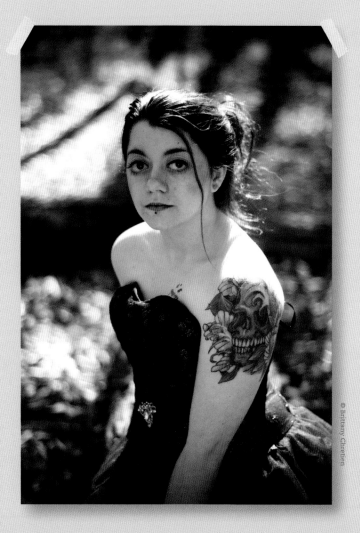

© Brittany Chretien

I like being lost and sometimes my models do as well. This was taken in a local state park around mid-day. The lighting and warm tones really helped capture the magical feeling I was wanting to achieve.

Brittany Chretien

Although the girl is looking at the camera, her thoughts seem somewhat distant ("she's there but she's not there"), so it doesn't interfere with the photographer's objective, and through the combination of quite wide eyes and prominent tattoo, we are invited to imagine what the girl's story is. The soft background and color consistency (I assume some processing work here) helps the model stand out. Less glaring highlights on the forest floor would have helped.

Michael Freeman

Three-quarter Seated Portrait

© Kiselev Andrey Valerevich

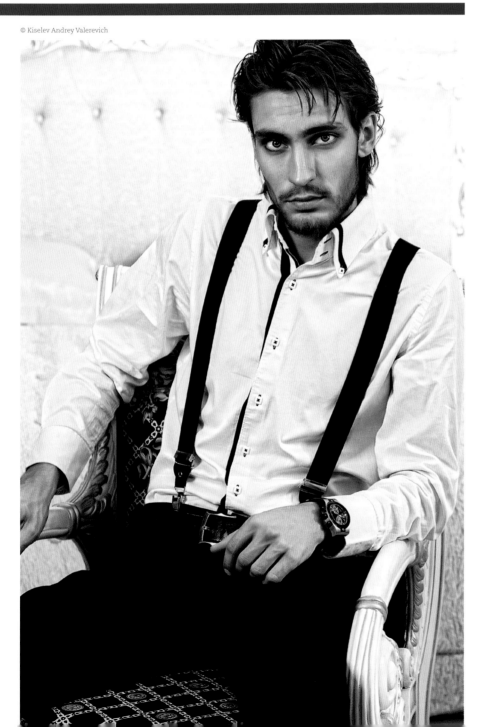

The three-quarter-length, seated portrait is a classic pose. A look back through the history of portraiture shows this pose time and again. It was partly a consequence of the length of time that a portrait took to be painted (or exposed in the early days of photography), which required the subject to remain still for relatively long periods of time. Comfort was also important, particularly for the few wealthy sitters who could afford a portrait.

At the same time, a static seat made it easier for the painter to return the subject to the same pose after a break or over a number of portrait sittings. The pose combines the common characteristics of most portraiture, in that the subject is usually placed at an angle to the plane of the camera (between 30 and 45 degrees), and lit using a key light that may or may not be combined with a fill light, a hair light, and more complex lighting setups.

The three-quarter-length framing will start at a point below the waist and include the remainder of the body and head. The framing can include as much or as little of the surroundings as you want. Choice of focal length,

← Classic yet current
Despite being a classic pose, the three-quarter-length seated portrait is flexible enough to be adapted to suit a variety of both conservative and contemporary tastes.

→ The chair counts as a prop

Consider whether you want to include the seat itself in the frame as an integral part of the portrait. If so, take into account the effect it will have on the mood and meaning of the portrait, and what it says about the status of the subject.

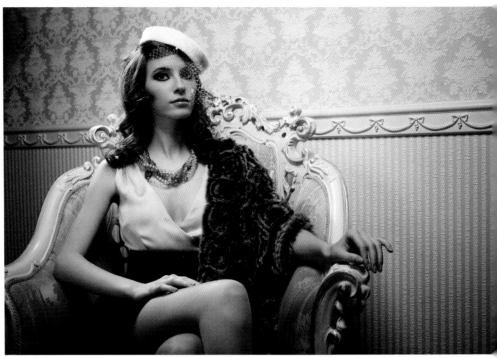

© Sergios

composition and, of course, camera orientation (horizontal or vertical) will have a direct influence on how the portrait is framed and how much of the background can be included. If incorporating a background, ensure that it complements the mood and tone of the portrait. The setting may also add some form of narrative about the subject, so again manage the overall context carefully.

Of course, for a seated portrait the subject will require some form of seat. However, this will have a greater impact on the portrait than you might think, and so again should be considered carefully. Do you want a small stool that is hidden from view and used merely to support the subject, or an opulent chair, a scruffy sofa, or a contemporary futon that is central to what we want to say about the character of the subject? Choice of seat, and the context in which it is used, will directly affect the final perception of the subject.

The subject should sit on the edge nearest to you, as this will naturally throw their weight and stance toward the camera. Ask the subject to retain an upright posture and straight spine, which will act to make them look more lean and elegant. Subjects should also be asked to lean in to the camera slightly from the waist—remember to keep the pose natural.

It is common to ask a female subject to cross her legs or at least her calves, as this will make the latter look smaller and thinner. Hands can be placed on the lap, on the sides of the chair, or under the chin—remember to employ the tips from the section on Posing Hands on pages 36–37. Females often sit cross-legged naturally, and this is a pleasing pose for a three-quarter seated portrait. Once seated, check that their clothes are not twisted, caught or have not ridden up anywhere during the seating process.

Males naturally cross their legs less often, so try to find a pose that the subject feels comfortable with and reflects their personality. A hand crossed over lap pose can work well. If in doubt, consider using a relevant prop, such as a pair of spectacles,

a book, or anything that the subject might normally be seen doing. When photographing males also ensure that the shirt or jacket does not look too tight when seated; likewise pull down sleeves that may have ridden up.

In general, there are two schools of thought when it comes to posing a seated subject: one is to ask them to find a naturally comfortable pose themselves and simply use this— based on the fact that the subject is comfortable so the pose and expression will be; the other is to create a pose that looks comfortable, natural, and most important, appealing, despite the fact that it may be relatively uncomfortable for the subject. That decision is down to you, and the way you prefer to work.

Posing Hands

The hands never lie, the saying goes. Likewise, an experienced model, or a blushing bride, may learn how to look composed and relaxed, but their hands may tell a different story. So learning a few techniques for hand posing can make the difference between an effective and a flawed portrait.

For many reasons, posing hands can be a very tricky aspect of portraiture. When posed incorrectly they can all too easily appear clenched, claw-like, or out of perspective compared to the rest of the body. The overall aim of posing hands is to create pleasing lines and direction within the portrait. A well posed hand under the chin in a head-and-shoulders portrait, for example, can lead the viewers gaze up toward the focus point of the portrait; the face and eyes of the subject.

Hands and arms can also be used to create gentle, curving lines in a full-length standing portrait, and to create a solid, visually pleasing triangle. So first consider composition and posing—are the hands absolutely necessary in the portrait? Hands might be placed behind a subject's back if they are standing or leaning, or may be absent in a head and shoulders shot. If in doubt, try to leave them out by altering the the subject's pose.

If you, or the subject, choose to include the hands, be aware that they are often the closest feature to the camera lens, and so can appear relatively large compared to the rest of the body or face. Careful posing can reduce this effect. Ensure that the hands are not pointing at the lens or close to the lens; otherwise they can suffer from the foreshortening perspective distortion.

Doing nothing with hands and arms will make your subject appear awkward and clumsy. Direct the subject. If there is a narrative to the portrait, consider this in the way the subject's hands are posed—for example, arms out as the subject balances on a wall, crossed in pensive mood, or waving to someone out of frame.

Also consider simple and appropriate props to give the hands something to hold, as long as they suit the mood or aim of the portrait and, of course, the character or personality of the subject. Be aware, however, that props should not distract from the subject in any way. Male hands in particular often benefit from having a small, invisible object such as a pen lid to hold, as it prevents the hand from looking like a clenched fist.

If the portrait is a studio study of the subject, without obvious narrative, consider what the subject's hands are like. The hands of females with well-manicured fingernails, for example, may be easier to pose than a serial nail-biter. The point is to match the pose to the subject's character and to the mood and style of the portrait. There are, however, a few general tips and tricks. One of which is to use a telephoto lens—that is, a lens with a long focal length. This will tend to retain the natural perspective of body features, including hands, partly due to the fact that you can stand farther away.

← Manual communication
Careful consideration and posing is required when including the hands as a significant part of the portrait, as they can give away more about the subject than intended.

© Dundanim

Also, try employing a shallow depth of field—that is, a wide aperture such as $f/2.0$—that can throw the hands out of focus. The eyes or other facial features should remain in focus, but the use of bokeh can reduce the presence of the hands in a simple way.

In general, you should try to face the outer edge of the hands and palm toward the camera. The outer edge of the hand is thin and graceful, compared to alternative views, which can make the hand and fingers appear blocky and thick. For the same reasons, the fingers look better when extended and spread apart—again, this stops them from creating the look of a distracting solid mass within the portrait and lends them grace and definition. Try to curl the fingers so that the tips are staggered.

For standing poses, make use of the entire length of the arm to again create pleasing lead-in or directional diagonal lines and shapes within the portrait. A simple standing pose for a male might be to ask them to fold their arms loosely, which will tend to hide the hands in the folds of the arms, while having the added benefit of creating muscular tone and definition in the biceps and triceps.

For a woman, ask the subject to place one hand on her hip and all her weight on to the back foot, which will create a bend in the leg joints and form a slender, angled line along the form of the body. The other hand can hang naturally to the side. Bending the arm

© Konradbak

at the elbow and the wrist adds interesting and dynamic lines and shapes.

↑ **Twists and turns**
In three-quarter and full-length portraits, use the lines of the arms and hands to create pleasing and dynamic diagonals, and to guide the viewer's gaze toward the main focus of the portrait; the subject's face.

A Classic Seated Portrait

↓ Classic contemporary
While the three-quarter-length seated portrait is a classic pose, passed down from artists through the ages, it is still completely relevant and contemporary to photographers today.

The three-quarter-length seated composition is a classic example of how artists have posed their subjects over the last few centuries. It is elegant and natural, and can be easily made contemporary. Seating the subject allows for flexibility and should ensure that they remain relatively comfortable during the session.

Posing three-quarter standing and seated subjects can be tricky. Ensure that the pose is natural and pleasing to the eye. Gently crossing hands and legs can make the subject look more relaxed, but ensure that it suits the gender and personality of the sitter. If you are having problems posing the hands, consider giving the subject a relevant, but understated, prop to hold.

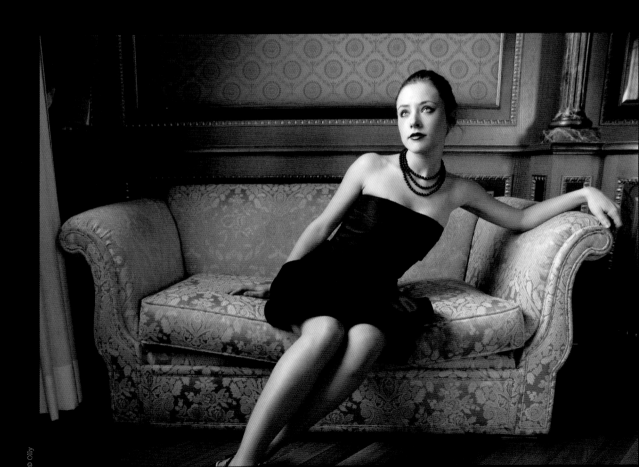

© Olly

© Micro10x

Challenge Checklist

→ One of the most important decisions is to consider the overall mood of the portrait before even setting up. Is it to be serious, fun, and pensive, or should it specifically portray something? Choice of lighting, background, clothing, pose, and so on will then be easier as they will be dictated by the intended final mood and tone.

→ Think about whether the seat, chair, or stool is to be an integral part of the portrait, or invisible to the viewer. If it is to be included, consider what your choice of seat says about the mood of the portrait and, more importantly, about the subject. Any prop should not detract from the intended focus; rather, it should complement or subtly enhance the mood.

→ Is there direction to the shot? Which way is the subject facing, and where are they looking? Do the lines of the body create pleasing diagonals or asymmetric shapes?

↑ Affable and approachable

Turn the subject at an angle to the camera and ask them to place most of their weight on the edge of the seat nearest to the camera. A gentle lean from the waist into the camera straightens posture and engages the viewer. This is an excellent technique for making the subject appear convivial and approachable—particularly suited for certain professional portrait styles.

Review

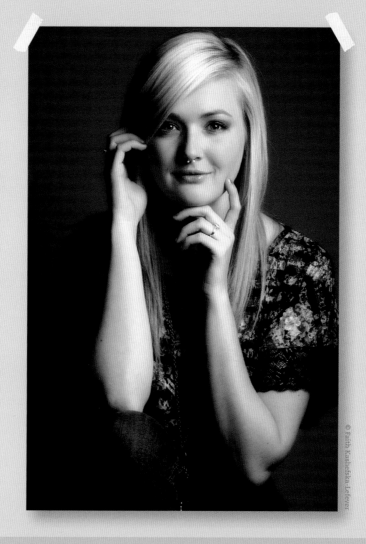

© Faith Kashefska-Lefever

Posing this seated shot is super easy. I had her sit on a stool with no back, and had a small wooden crate for a foot to rest on. Having one foot pointed up on the crate gives a nice staggered look for the legs. I find this pose is comfortable for a lot of girls, as it gives each limb something to do, making them feel less awkward.
Faith Kashefska-Lefever

The model's expression is engaging, sweet and cute, and the photographer clearly knows how to make a subject at ease. The lighting on the face is nicely smooth. However, I'm not certain about this pose, particularly the right hand, which is a little claw-like, and the effect is not particularly natural. I wonder if it might have been more natural had she been using that hand to gently push her hair back— the same approximate position but with purpose.
Michael Freeman

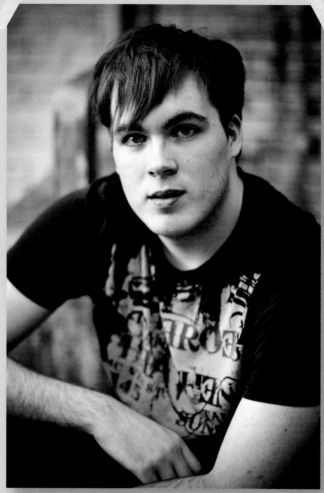

© Brittany Chretien

Outdoor portraiture can be a little tricky since one must constantly be aware of the light. Our session started earlier than expected and the light was originally too harsh. After placing him under an a section of trees, the leaves served as a natural diffuser and the light colored bricks helped reflect light.
Brittany Chretien

Good lighting solution, and the overall color tone is attractive. The pose in general looks comfortable, but that high elbow position for the model's right elbow has forced his shoulder up a little too high for my taste, with the result that there's a slightly unfortunate slouching curve across the back and both shoulders.
Michael Freeman

Standing & Leaning

The more of a subject you include in the shot, the more complex and challenging posing them becomes. When shooting full-length and three-quarter length standing poses there is simply more of the body to pose in an appealing and natural way, which adds another layer of complexity. Head, shoulders, body, arms, hands, legs, and feet all have to be naturally posed.

There is a common saying among wedding photographers that posing starts with the feet. There is a good reason for this. By placing the feet of the subject(s) at an angle of around 45 degrees to the camera, it naturally places the hips and, therefore, the body at the same angle away from the camera plane.

Asking the subject to stand straight-on to the plane of the camera is a valid technique and is used increasingly in fashion portraiture, or to emphasize a subject's bulk or strength. However, for female subjects it will usually have the effect of making them appear wide and bulky. Angling the body prevents this look and creates more graceful lines.

As a rule of thumb, try these tips: Angle the hips away from the plane of the camera; tilt the shoulders (so they are not parallel to the ground); keep the posture straight, but with the spine slightly angled to the vertical (not pointing straight up from the ground at 90 degrees); and aim to create asymmetric shapes and diagonal lines from the body's curves and limbs.

To straighten the subject's posture, ask them to imagine a piece of string running through their body from the feet and out of the top of the head. Then ask them to imagine that someone is pulling the string from above. This should help to maintain a strong posture, and some desirable curvature of the spine.

In order to create an angled line with the spine, ask the subject to either lean against a wall or prop, or to shift their weight onto one foot, usually the back foot. This will also have the effect of creating another diagonal line (relative to the ground) with the hips, which will tilt upward from the side on which the body weight is placed.

© Conrado

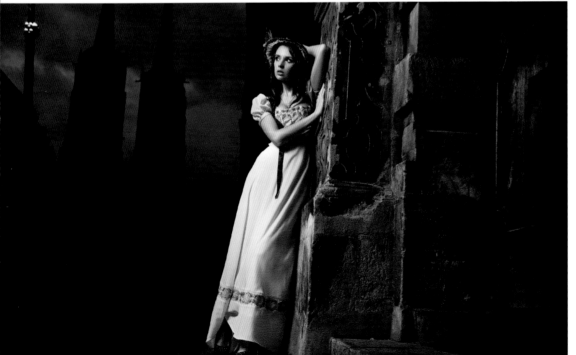

← **Dynamic lines**
This full-length shot shows angled hips relative to the ground and to the camera plane, shoulder and head tilts, bending in the joints, and the use of the arms to create diagonal lines and asymmetric shapes, which give the portrait dynamism and direction.

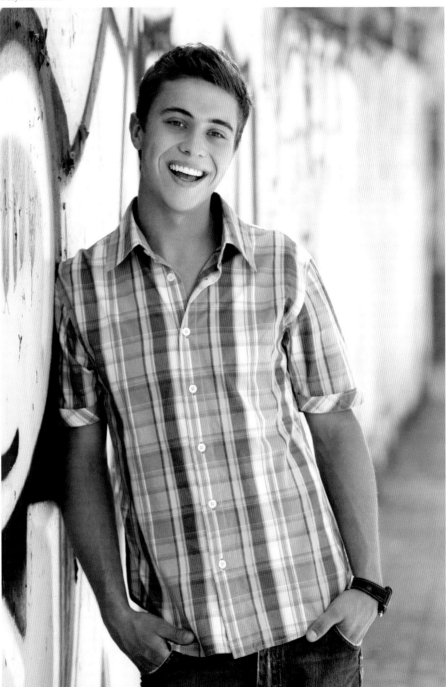

On a more general note, when composing a three-quarter-length portrait, it is advisable to crop the body in between the joints, i.e. between thigh and knee or between knee and ankle—the same goes for the elbows and wrists in closer portraits. There is something uncomfortable for the viewer when portraits are cropped at the joints.

Another saying is to bend the joints. Imagine for a female, a pose with one arm rested on one side of the hip. The arm should be gracefully bent at the elbow and the wrist. The front leg (without the body weight) should be subtly bent at the knee and possibly ankle, depending on the pose. This bending at the joints creates a number of pleasing curves, lines, and shapes.

These rules can also be adapted to male posing. Imagine a male leaning against a wall. Again, angle the body at 30–45 degrees from the camera. The act of leaning against the wall will create shoulder tilt. Ask the subject to fold their arms. Holding arms slightly away will prevent the body from looking too wide—while this might seem desirable in a portrait of a male, the act of folding the arms emphasizes the muscles anyway, and so keeping them tight to the body will be too blocky. The head and gaze can be directed back at the camera or out of frame. Again, the overall aim is to use the body's physical features to create pleasing lines and shapes, and give direction to the portrait.

↑ **A natural pose**

Leaning against a wall or prop is quite a natural stance for males. The pose also creates hip and shoulder tilts (relative to the ground). Hands in pockets or arms folded is a comfortable stance as well, and is a simple way of posing the appendages—just ensure that the arms are held slightly away from the body to avoid bulky portraits.

Challenge

Stance

↓ Stance as story

The setting and costume already invite a narrative interpretation for this shot, and the nonchalant posture of the subject—leaning back slightly, turning the face toward the camera over a dropped shoulder—fleshes out this slightly fairy tale feeling with a hint of seduction.

The more body parts included in a portrait, the more challenging the posing becomes. Standing poses can be the most difficult, as getting the pose wrong, or a lack of photographic direction, can result in an awkward impression—even if the facial expression is perfect. But with some simple guidelines, you can create dynamic and elegant full-length standing portraits.

Aim to create flowing, diagonal lines and shapes with the curves and limbs of the body. Shoulders and hips should be slightly angled compared to the ground, with shoulder and head tilt adding further dynamism. Ensure that the subject adopts an upright stance, and places their weight on a single foot. Employ narrative poses where appropriate.

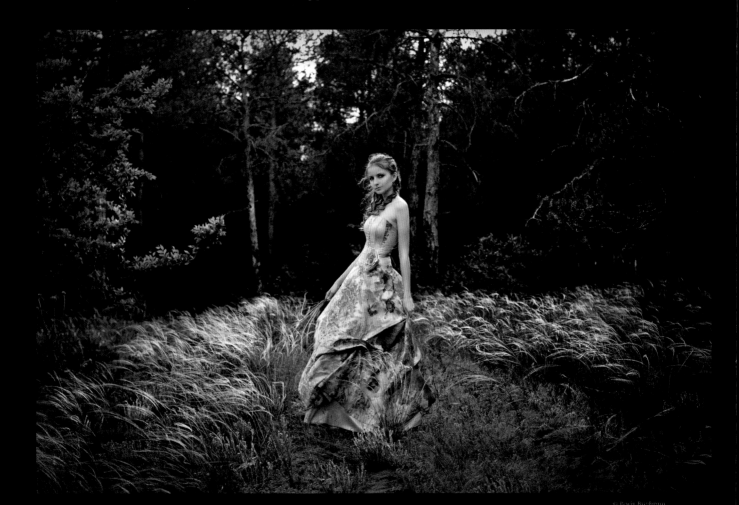

Challenge Checklist

→ Create flowing lines by angling and tilting the body's features. Bending the joints will create further dynamic lines.

→ Leaning the subject against a wall or prop adds a further diagonal line, and gives them an air of casual confidence. For males, crossing the arms can give the subject a relaxed appearance, but make sure that they don't merge into the body and end up looking overly bulky and shapeless.

→ Ensure that the model has something to do with their arms and hands, otherwise they will appear awkward and unnatural.

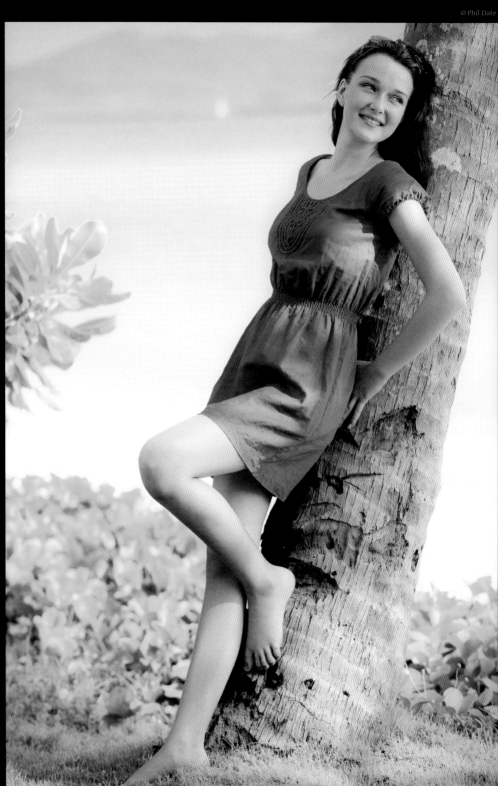

→ **A reclined stance**
A diagonal tree on location was a natural prop, and having the subject then turn her face into the sun made for a cheerful lighting setup.

Review

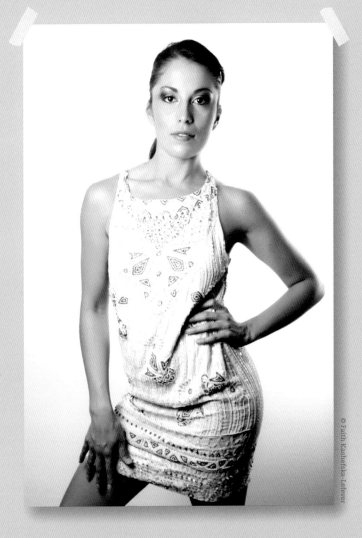

© Faith Kashefska-Lefever

My model had brought this dress to be photographed in—a beautiful dress with lots of beading detail, but it had no shape. I knew I needed to show off her great figure, so I posed her to pop out her hip to one side and rest her hand on it to create a curve, while elongating her body by keeping her other arm straight and lightly resting her hand on her thigh. This pose also helped create a nice body language for the photograph, complementing her personality, as a strong, confident woman.

Faith Kashefska-Lefever

Yes, exactly right. This three-axis stance puts a curve into that waist, and exudes confidence. I also think that's a good crop just below the short hemline. Personally I would not have gone with that eye make-up for a broad strong sidelight, as it tends to look a little bruised on the model's right side.

Michael Freeman

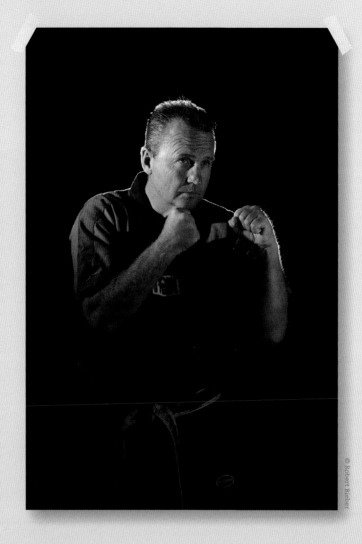

© Robert Bieber

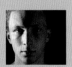

I shot this photo for my father-in-law, a karate teacher and former world-champion kickboxer. I picked the longest open space I could find, to keep as much light off the background as possible. The main light is a speedlight bouncing off a sheet of white foamcore, propped up on a coffee table. The rimlight comes from a single bare speedlight placed behind the subject. I wasn't able to get the background as dark as I wanted out of camera, but a quick levels adjustment took care of the rest.

Robert Bieber

The rimlight works very well—gives just an edge with no lens flare. It's natural to go for a boxing stance, but I'd like to have seen the rest of the take. Would eye contact make it stronger? It would also be more aggressive and you might not have wanted that. But this offstage look makes the pose feel a bit static.

Michael Freeman

Vertical, Horizontal, or Square

© Conrado

There are two main orientations of the camera in photography—vertical and horizontal—and it is perhaps telling that images taken in the vertical orientation are often referred to as being in portrait format, while horizontal images are shot in landscape format. Of course, there are obvious reasons why that should be, but that is by no means a reason to stick to the classical rules today!

The vertical orientation has traditionally been considered to be best suited to portraiture. The aspect ratio—which may be 3:2 or 4:3 in the digital world, or 6:7 or 5:4 in film formats—naturally mirrors the physical shape and dimensions of the human body and head. It's certainly a subjective matter, but there's an argument that the 3:2 aspect ratio can feel rather too long, compared to the 4:3 ratio that allows a typical head-and-shoulders portrait to better fill the frame.

Use of the vertical format is well suited to single upright shapes and figures, and may be dictated by the final intended use of the portrait, for example a magazine cover. The format inherently suggests upward or downward movement and may be suited to portraiture as it focuses the viewer on the subject by removing peripheral vision within the frame and confining the viewer's gaze to the subject.

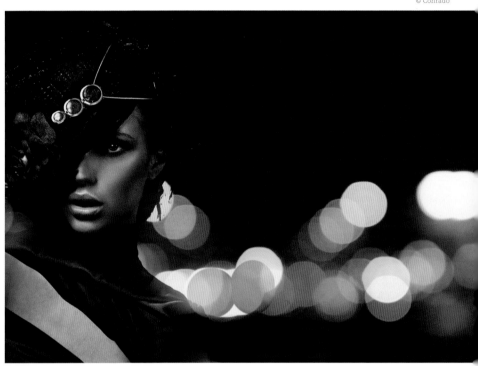

The landscape shot, meanwhile, might be applied to full-length portraits in which you want to include environment and background as creative elements. The horizontal format is generally associated with narrative portraiture, as it naturally leaves space on either side of a subject's head or body (which are of course vertical in dimension) into which you can intentionally project narrative, or into which the viewer can project unintentional meaning.

A compositional rule of thumb when creating a portrait in the horizontal orientation is to position the head and eye direction of the subject so that they

↑ Bokeh as frame filler
You'll create tension by using a wider rectangle—like this 3:2 aspect ratio—from the left to right sides, so be sure to fill the non-subject space with something of interest.

have space in the frame to look into. That is, if the subject is looking to the left, place them on the right side of the frame, and vice versa.

Conversely, you have to take care not to create dead space—an area within the frame that is devoid of any interesting or relevant elements, which can be distracting, and ultimately, diminish the impact of the final image.

There is an implied sense of side-to-side movement within the horizontal frame, which may reflect the way in which we read images. There is ample opportunity for the gaze of the viewer to wander within the frame, so composition and framing are important. Again, use of this format may be dictated by final output, such as an online profile picture.

Square Format

As well as the obvious two formats, a third one—the square format—was made popular in the early 20th century and onward by the portrait and fashion photographers, who used 6×6 medium-format roll-film cameras, notably Hasselblad, Mamiya and Rollei. Arguably, and having stood the test of time, the square format is particularly suited to portraiture, as its neutral aspect demands that all attention be focused on the subject.

However, unlike these film cameras, there is (as yet) no natively square-format digital camera. With most DSLRs, you must mentally crop the scene in the viewfinder, with intention of later cropping in post. Newer digital cameras that have Live View or electronic viewfinders do offer a cropped view, so you can compose a square shot in real-time.

The square format is, almost certainly, more demanding than the other two as the space needs to be balanced properly, and you have to work hard to inject a sense of visual space within the frame or direction through the use of posing. The square format is also suited to symmetry, so a straight-on, facial shot of an interesting character might

be very striking in this format. As always, the creativity begins when you start to break the rules. Closely cropped facial portraits in the horizontal aspect can be striking and dynamic, and indeed are currently popular in family lifestyle portraiture (studio and environmental).

Likewise, a relatively wide-angle head-and-shoulders shot with the subject placed to one extreme of the frame can create empty visual space into which you can project some form of creative intent, from a simple vibrant background color to a complex arrangement of narrative elements—again, make sure that there is no distracting dead space.

↓ **How to balance a square frame?**
The slightly unusual square format invites an innovative portrait.

© BestPhotoStudio

Vary the Format

Traditionally, certain subjects have matched specific orientations—namely, vertical images for portraits, horizontal images for landscape. A third, square format, has entered cultural consciousness based on the medium-format film shooters of the early 20th century. Of course, rules are made to be broken and experimenting with format is a straightforward way to inject variety and creativity into a portrait session—though you may well find that working with certain formats is more challenging than others.

Today, portrait photographers know that experimenting with traditional formats can produce striking and original results. Create a sense of space, fill the frame with an unexpected composition or pose to play with the viewer's sense of expectations. Try mixing up the formats by cropping tightly into a face using the horizontal format, or take a wide-angle full-length portrait in the vertical mode, perhaps with a subject in front of a tall building.

→ Nowhere to hide

The symmetry of the square format can be oppressive and restricting, as normal compositional techniques of balance and tension are difficult to achieve. But at the same time, you can use this in-your-face inclination to your advantage. This shot, for example, combines a sterile background and a totally diffuse (and slightly overexposed) lighting setup with a rather blank expression and lack of clothing to draw attention to the eyes and create a successfully dramatic portrait.

© Justin Black

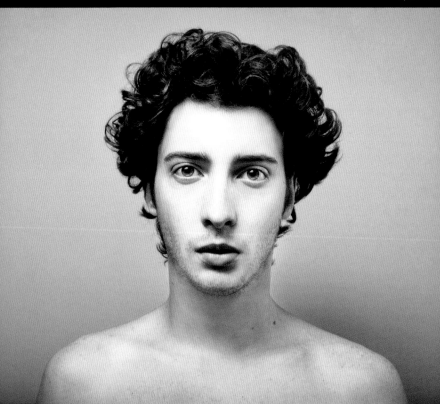

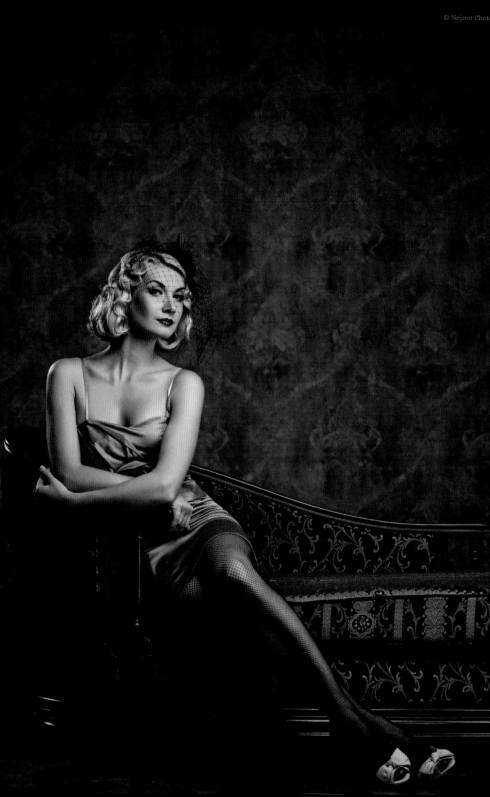

Challenge Checklist

→ Crop in tightly to a subject's face in both vertical and horizontal format, and compare the resulting images. Does the portrait or landscape orientation work best for faces?

→ Experiment with different formats and framing. In the horizontal format, place the head and shoulders of a subject in one corner and see the effect of creating a large amount of space within the frame—try different backgrounds and settings to see how filling the space with different elements alters the mood or narrative of the portrait.

→ As you are likely to not have a natively square-format camera, simply use your normal camera and visualize the square framing as you compose the image before cropping the file in post-processing. If your camera has an electronic viewfinder, read the manual and see if you can mask out the sides of the frame to see and compose in the square format.

→ Diagonals for tension

Even the standard vertical format can be used creatively, as in this shot where, rather than having the subject fill the frame, she is positioned lower-left, creating a diagonal across the length of the shot. The textured background helps by adding interest in the otherwise blank area top-right.

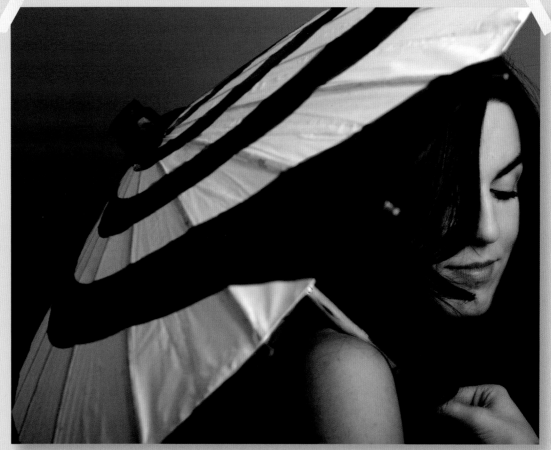

© Faith Kashefska-Lefever

I wanted to create a flirty mood for this shot, so I cropped tightly around the paper parasol, leaving just enough of her face to peak out. Though not exactly intentional, I really liked the strong diagonal division of the almost-square frame. I have one soft box that is to the right of the camera.

Faith Kashefska-Lefever

Excellent use of a prop. I'm not sure if it was intentional to align the black swirl of the umbrella design with the model's face, but the result is quite captivating—particularly as the fluid swirl plays off the strong diagonal and provides plenty of visual interest throughout the frame.

Michael Freeman

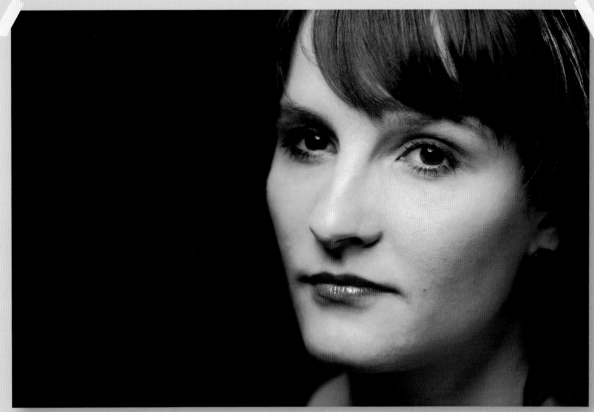

© Mikko Palosaari

Sometimes when I look at this shot, the facial expressions look dull and empty; other times the lack of expression makes it look tranquil and calm. In either case, I think the negative space filling almost the full left half of the frame contributes to the interpretation. For lighting I used a speed light with a small beauty dish from above and a another one as a hairlight from camera right and back.
Mikko Palosaari

I'm always intrigued by the difference in opinion on expression, and how much it conveys a person's feelings. Personally I find this expression quite thoughtful. The framing works—just. I wonder if a hint of out-of-focus detail in the background might have given it depth and a sense of some relationship with the off-center face.
Michael Freeman

Natural Light

Light is essentially the band of the electromagnetic spectrum visible to the human eye. Far from being a constant entity, light is an ever-changing, elusive quantity. Anyone who has woken early to see a misty sunrise, tried to shoot a wedding under harsh midday sun, or stayed late to watch a fiery sunset, can testify to that. Light is not just on or off, and as photographers we inherently understand its subtleties. Time of day, season, prevailing weather conditions, location, surrounding reflective surfaces, and many other factors, all combine to create unique natural lighting conditions at a specific location and time that are rarely, if ever, totally replicated.

While we cannot control the sun or weather, and hence the natural lighting conditions we will get, we can choose when and where to shoot. For example, the hours just after sunrise and before sunset will often provide a soft, yet directional light, usually with a warm color tint, which can be very flattering in portraiture.

While natural light is difficult for us to control, we can use it to our advantage by understanding what conditions are most likely to provide us with the light we seek. At first, the idea that we can understand and control light can be a daunting one, but with experience you can learn to see and read the light in different situations and understand the impact it will have on the final image. Light and lighting should not be viewed as a challenge to overcome, but as a creative tool that can help us to transform a mundane scene into something special.

Most of all, we should never stop learning. Even the most experienced photographers agree that they continue to learn new things about light's behavior every day, so complex and nuanced are its characteristics.

White Balance & Skin Tone

Our eyes are remarkable feats of biological engineering. They constantly and instantaneously adjust for light levels and color temperature every second of the day, largely without our awareness. Our eyes can instantly respond and adjust if we walk from bright daylight into a dim, candlelit room. Unfortunately, our cameras cannot. Even the very best of today's camera sensors are not as sophisticated as our eyes, so they need a little help from us.

Color Temperature

Our eyes evolved to work in daylight, and so we perceive midday light as being white or colorless. As a result, bright daylight is the standard by which we perceive all other types of light sources. For example, candlelight or fire is perceived as orange and warm in tone, while strong shade or overcast days have a noticeable blue tint—the light is considered to be cool.

This concept of different colors of light is known as color temperature. To work with different colors of light, we need to turn to color temperature, which is a precise way of measuring the color of a neutral substance heated to different levels. It is measured in degrees Kelvin (K), ranging from redidsh through white to blueish.

At first, the scale appears slightly counter-intuitive in that color temperatures considered warmer—

such as sunset and fire—do, in fact, have a lower color temperature. However, it is important to ensure that we grasp this concept and are comfortable with it from the outset, as it has a significant impact on our photography.

White Balance

Under different color temperatures, it is the color white that most closely and strongly reflects the main light source. So under candlelight, white will appear to have a strong orange tint. In reality, our eyes do an excellent job of constantly and subconsciously recalibrating the color temperature so that white usually appears white to us, regardless of the type of light.

However, camera sensors cannot do this without our help. So we use the White Balance (WB) setting to make white appear white, regardless of the color temperature of the main light source. By shifting the whites to white this has a knock-on effect of recalibrating, or color correcting, all other colors in the scene. Setting WB essentially shifts the way the camera records the color temperature of light.

There are several ways to set WB. Auto WB setting on most of today's cameras is extremely accurate, doing a sterling job of recalibrating white to white under many different light sources. However, on occasion or under mixed lighting sources (for example, daylight

© Beboy

↑ **Blue eyes, blue jeans, blue tint**
A cool blue tone can appear striking, and be exaggerated by creative use of the WB setting on the camera. However, skin tones should almost always remain natural and accurate.

mixed with fluorescent), Auto WB can produce erroneous results, in which case we need to set WB manually (see below).

Another way to set WB is using the camera's presets. Preset WB can approximate the dominant light source if we know what it is, for example, almost every camera made today will have WB settings for Daylight, Cloud, Shade, Tungsten, Fluorescent, and sometimes more.

The most accurate method for professional photographers, however, is to use Custom or Manual WB settings. With Manual settings, some experienced photographers are able to set a manual color temperature, in Kelvin, and get it right most of the time.

For mere mortals, a Custom WB is the best bet!

A custom WB can be set by using a semi-opaque neutral WB filter fitted to the camera lens, which takes an average WB measurement for that scene and retains it in the camera's memory—the camera will then use this temporary Custom WB until changed. In a pinch, it is possible to use a piece of white card or paper, filling the entire sensor frame, in the same way.

A second method of setting a custom WB is to place an 18% gray card in the scene, under the same lighting conditions that will be used for the actual portrait. In this case, we must shoot in Raw mode, as this allows us to change numerous settings, including WB, in post-processing software without any loss of image quality. By clicking on the gray card in post-processing, we can achieve a custom WB for that scene, which can be applied to all images taken under the same lighting conditions—the software knows what 18% gray should look like, so it can recalibrate the colors in the image accordingly.

For both techniques, the Custom WB should be reset, or the 18% gray card re-shot, if the lighting conditions change in any way.

Understanding WB is vital to any photographer regardless of genre, as it can help to correct unnatural-looking lighting and color tints, as well as being used for creative purposes. But it is particularly important to get it right in portrait photography, as any inaccurate or unnatural color tints, caused by setting an inappropriate WB, will have a marked effect on the skin tone of the subject.

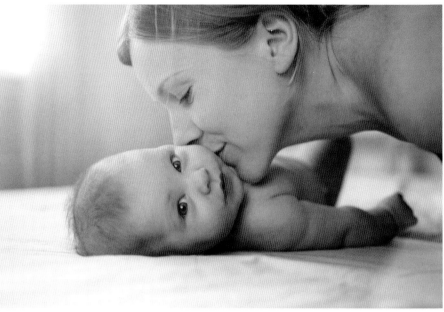

© Konstantin Sutyagin

Our brains are remarkably attuned to what an appropriate skin tone should look like (across a broad spectrum of skin colors, shades, and textures). Therefore, if skin tone is perceived as inaccurate or unnatural in some way, the portrait will look plain wrong.

Setting the WB too cool can give skin and lips a blue look and feel, which is probably not the desired outcome in most cases! Conversely, set WB too warm and it can make a subject look inappropriately red, as a colleague recently said: "He looked like he had high blood pressure!"

Generally, portrait photographers tend to favor a slight exaggeration toward warmer skin tone, as it gives the impression of health and vitality, much like a suntan does. So many will set the WB and then warm it up slightly in post-processing. Absolute WB correction is often undesirable in portraiture, and you will find that some brands of gray cards, charts, and

↑ Golden moment

Skin tones in general tend to look better with slightly warmer WB settings. Though they may not reflect the real color temperature at the time the image was taken, exaggerating a light source can create a certain mood or feeling in the viewer (in this case, warmth and security), as well as visual clues about location or time of day.

neutral WB filters will provide a range of correct calibrations, from cooler to normal to warmer. Of course, the important point is to match the WB to the subject, artistic intent, location, mood, and setting of the portrait. But remember, we are all different. Using the same WB setting to shoot a subject with very pale skin versus someone with dark skin will produce significantly different results. Asian, Caucasian, and Afro-Caribbean skin responds differently to WB, and even within these broad categories there will be a huge spectrum of skin tones and types, so setting the correct, or appropriate, WB is essential.

Window Light

Window light is arguably the purest form of portrait lighting. The technique has been honed by painters over centuries, and has created some of greatest portraits in history. Window-lit portraits take advantage of a wonderful, naturally soft lighting effect that photographic light struggles to match. Window lighting is therefore one of the most popular setups for portraits—of course, it is free and available for portraits for most of the day!

The most desirable type of light has traditionally been north window light. This lighting was made popular by Dutch painter Johannes Vermeer in the 17th Century, with paintings such as Girl With a Pearl Earring. Vermeer's use of a north-facing studio to create soft, diffuse light is well-known and still imitated to this day.

North-facing window light is particularly appealing as it provides a soft and diffuse—yet directional—light, which is low in contrast and perfect for portraiture. A north-facing window receives no direct sunlight, which can create extremes of exposure such as bright highlights and dark shadows that is unflattering for portraiture. All the light it receives is reflected, and so rather than entering the room from one direction—i.e., the direction of the sun—the light has been bounced around via numerous surfaces and textures before entering the room, which creates a soft, diffuse, but directional light. In the Southern Hemisphere, of course, the window will need to be South facing.

In the absence of a north-facing window, wait until a cloudy or overcast day, as this will create the same effect—no direct sunlight and soft, diffuse light that has been scattered in different directions (in this case, by the clouds). Another way to mimic the effect on a sunny day is to employ a translucent scrim over the window. A scrim is a large piece of gauze or similar material, which effectively filters out and diffuses any direct sunlight.

The size of the window affects the intensity and quality of the light entering the room. A larger light source (relative to the subject) creates more light, but also softer light, while a small window may result in more of a spotlight or beam of light effect. This may be out of our control, but there are other ways to affect the quality of light—intensity is, of course, controlled by our exposure settings. However, we do have control over the quality of light.

One of the main factors to consider is the distance we place the subject from the window. As we will see throughout the book, light behaves in predictable ways. One of these characteristics is that the larger the light source is relative to the subject, the softer the light it produces. At the same time, according to the inverse square law (see page 87), the closer the main light is to

© Yuri Arcurs

← Window as part of the subject
If you can't find a north-facing window, try to shoot on a cloudy or overcast day. Including the window as part of the composition can enhance the mood or provide narrative to the portrait.

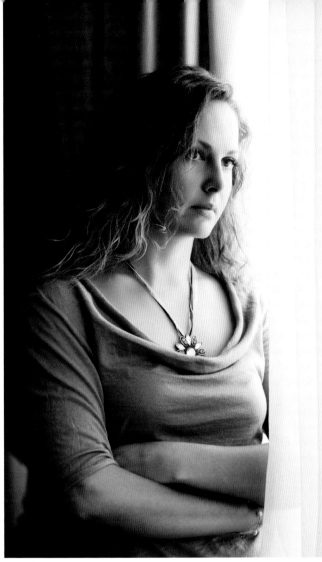

© Wrangler

← **Light fall-off**

The distance we place the subject from the window will make a big difference to the look and feel of the portrait. Too far away and the exposure and contrast between light and shadows may be flat; while too close can create very bright highlights on the areas of the body and face that are close to the window, with a very dark background as the light falls off quickly according to the inverse square law.

Hard versus Soft Light

Photographers often talk about hard or soft light. Hard light is defined by bright highlights and deep shadows, high contrast and dynamic range, and is very directional—i.e. comes from a single direction. Typical sources of hard light include midday sun and spotlights. Hard light causes abrupt boundaries between light and shadow.

Soft lighting is typically low contrast, relatively even across the scene, and with softer boundaries between light and shadow. It wraps around subjects. Soft light is not as directional as hard light, and does not accentuate hard edges—it is therefore ideal for portraiture as it softens features and textures, such as wrinkles and skin pores. Soft light sources include an overcast day or a flash with a softbox or umbrella attached.

The defining factor between hard and soft light is the relative size of the light source to the subject. The midday sun is huge, but relative to our subjects is very small in the sky and very directional, hence it is hard. An overcast day, meanwhile, will scatter sunlight in all directions; the clouds essentially act as a giant softbox in the sky—the light source is very large relative to the subject and therefore provides soft light.

the subject, the faster the light falls off, i.e. loses intensity, as distance from the light source increase. So what does this mean in practice?

Standing or sitting the subject very close to the window will create a soft light that wraps around the face and body of the sitter. Of course, the proximity to the window will mean that the light intensity is high so we need to ensure that all highlight details are retained in the face by setting the appropriate exposure. However, light fall-off will also be strong (according to the inverse square law). Combined with

the high exposure on the face, this will result in a bright subject with the light trailing off quickly to a very dark, or even black, background.

This effect can be very dramatic and striking, but it may not be what you intended; for example, if you want to include some of the room features within the composition. So moving the subject away from the window will dampen this effect. Any objects that are equidistant from the window will, of course, be illuminated to the same degree.

Another challenge is placing the subject in the right direction or orientation for appealing modeling or directionality of the light. Of course, the window cannot be moved, so instead we need to change the position of the model and/or the camera. Treat the window as a key light, so a good starting point would be to stand the subject at an angle of about 45 degrees to the window. Asking the model to change the direction of their face thereafter will alter the light, so instead move the camera around the model for different facial views, such as two-thirds, face-on, and so on.

Indoor Daylit Portraits

Challenge

↓ Dramatic contrast
According to the inverse square law, the amount of light falls off more quickly when the subject is nearer to the light source. In practice, this means that sitting the model close to the window will result in fast light fall-off and a dark room with deep shadows. Moving the subject farther away from the window will mean that subject and room are illuminated relatively equally (but with less strength, meaning you would need to increase the exposure).

A north-facing window does not receive any direct sunlight at any point of the day. The light is therefore softer, with fewer shadows, lower contrast, and remains relatively constant throughout the day. It can provide lush, diffuse light to help illuminate flattering portraits. If no north window is available, use any window on a cloudy or overcast day, which will have the same effect of providing soft, diffuse light. If the sun stubbornly shines, try covering the window with a scrim (a thin veil of diffusing material) to scatter and soften any direct sunlight.

Don't worry too much if light levels are low, as today's DSLRs have excellent high ISO performance, so pushing up the ISO on many cameras to at least 1600, and often beyond, is fine. But be aware that shutter speed should not fall below 1/60 second, and should be significantly faster if possible, to avoid blur from both subject motion and camera shake. Of course, higher shutter speeds will likely require wider apertures, which will affect depth of field. It is a balancing act, so experiment and be prepared to compromise, if necessary.

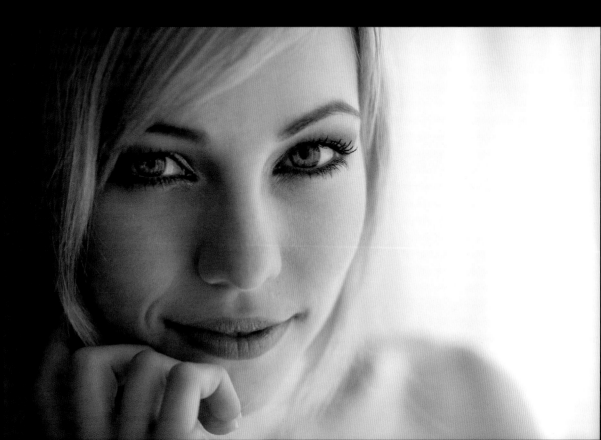

© Grischa Georgiew

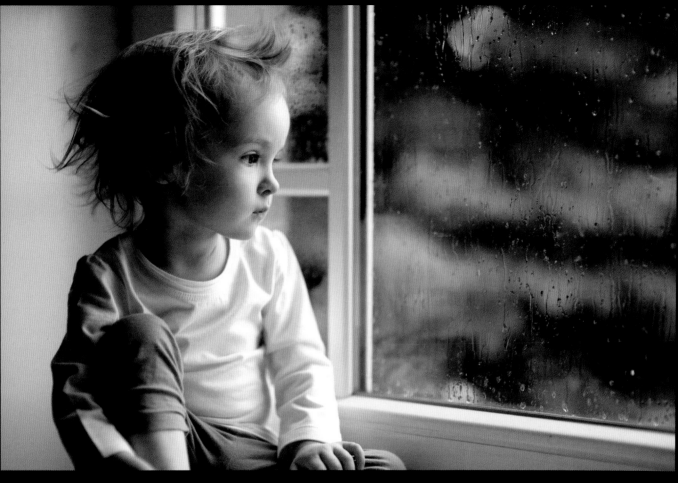

© MNStudio

Challenge Checklist

→ There are a number of factors to consider when visualizing the type of image you want to create. How large is the window, and what kind of light will it produce—soft or hard? What is the background or setting like? Should the room be included in the composition? Will the subject be seated or standing, full-length or head and shoulders? What impact will the subject-to-window distance have on the effect?

↑ Window as part of the subject

Decide whether to include the room or window in the final composition, and what this will bring to the mood and tone of the image. Be aware that including the window could result in blown-out highlights—but this can easily be a stylistic choice if it is well controlled (i.e., the blown-out areas aren't covering up important areas of the frame).

Review

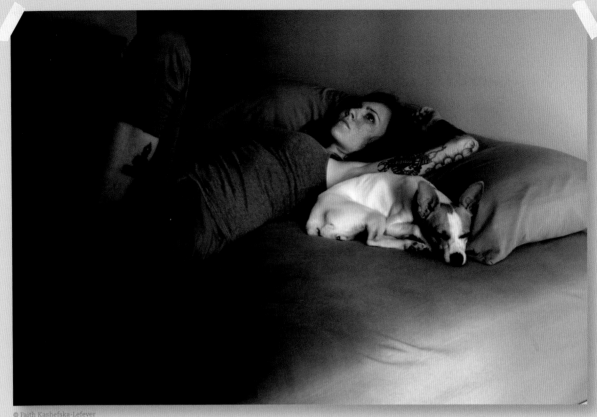

© Faith Kashefska-Lefever

Here the light is coming through a sliding glass door, and I used a black-out curtain to control the amount of light I let in. The camera is in front of the blocked-out part of the glass door.

Faith Kashefska-Lefever

A good choice to go for mood rather than the conventional "solution" for evening out the light fall-off from the glass door (such as a grad), and heightening this with the black curtain. The shading to darkness makes this a personal photographic statement.

Michael Freeman

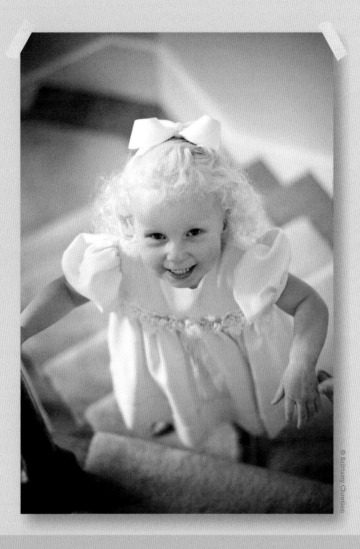

Despite shooting this image inside, the numerous amount of windows, small aperture, and higher shutter speed, allowed me just enough room to capture motion without the blur. The image was originally underexposed but was corrected during post-processing with Adobe Lightroom.
Brittany Chretien

I very much like the luminous effect of the soft daylight, which suits the subject and adds to an overall feeling of light-heartedness and playfulness. It's also an engaging angle and action. A minor quibble is the dark post of the bannister in the lower left corner, which pulls attention slightly.
Michael Freeman

In the Shade

© Lithian

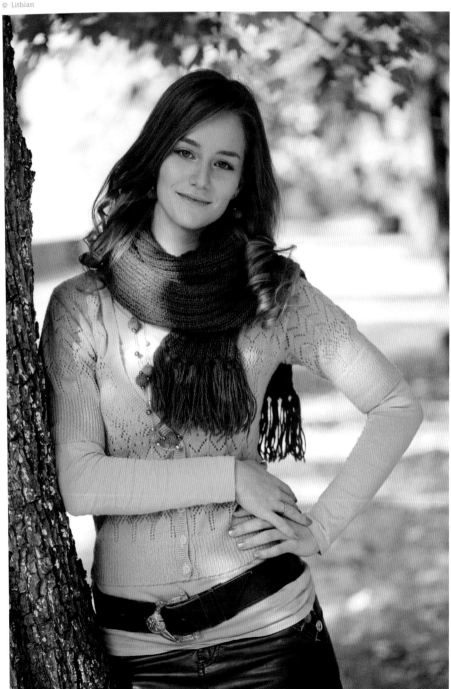

There will be many times when circumstance requires us to shoot an outdoor portrait in the middle of the day. Weddings, magazine assignments, events, and even lifestyle portraits will all fall into that category at some point. Weddings, for example, are often in full flow during the hours of the harshest sunlight, and while it makes for a happy couple and guests, it can make life difficult for photography. The challenge is: How can we avoid harsh sunlight and the unflattering shadows and bleached-out colors that it brings?

One of the easiest ways to counteract harsh sunlight is to move into open shade—such as under a leafy tree, into the shadow of a building or wall, or the shade of any other structure that effectively removes the subject from direct sunlight. The benefit of using open shade is that the light reaching the subject is comprised entirely of reflected light, having bounced off the surrounding surfaces and into the shade. In turn, this provides you with an excellent source of natural, soft, and diffuse lighting.

Again, the trick is to read the light. How strong is it? Which direction is it coming from? How can I best utilize the light for my portrait? It may not be immediately obvious, but even in open shade—with light bouncing in from all angles—there is still likely to be a main directional component to the light.

Color harmony
Be aware that reflected light in open shade can absorb the color of the surfaces off of which it has bounced.

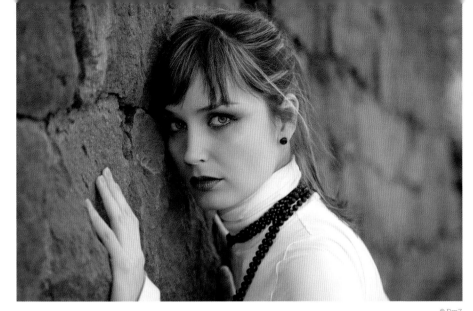

© DmZ

↑ Avoiding harsh light

Shooting in open shade, such as under a tree, by a wall, or in a doorway, is a great way to achieve soft, diffuse, and flattering light for portrait subjects of all ages.

The direction of the light will depend on numerous factors, including the relative position of the sun, the size, shape and color of the surrounding structures, and the reflectivity of the nearby surfaces. For example, if a tree stands close to a white wall, it is likely that most of the light will be bounced into the shade from the direction of that wall, which will act as a giant reflector—most likely providing beautiful soft, diffuse white light.

In this case, the wall can be treated as the key light. While it is unlikely to be this clear cut in practice, with light bouncing in from more than one direction, it is important to assess which direction(s) the strongest light is coming from, and to utilize it to our advantage. Let the direction and quality of the light dictate how you shoot, rather than arriving on location with set ideas that may not complement the location or the prevailing lighting conditions.

There are a couple of things to watch when shooting in open shade, one of which is the color temperature. Light in the shade has a high color temperature—that is, it appears very blue and cool—more so than overcast conditions, which is why cameras have a separate white balance setting for Cloud and Shade. Use a gray card, white card, neutral white balance filter, correct it manually, or use any of the other recognized WB correcting techniques. If in doubt, shoot in Raw mode (which we should be doing anyway), as it gives extra flexibility for altering settings in post-processing.

As we have discussed, light in the shade is reflected, so it is also worth bearing in mind that it can absorb the color of surfaces that reflect it—for example, under a tree in the middle of a lawn will more than likely give a significant green tint to the light, while a nearby red wall will add red light. Dappled light—shade that is not always solid and contains patches of direct sunlight, as seen in the portrait on the opposite page—can be summery and atmospheric, but care should be exercised to ensure the exposure is not

too high contrast, particularly around the face of your subject. Reflectors and fill flash are the obvious remedies.

For something a bit different we can choose whether to shoot into the shade or out of the shade, which will give the portrait a completely different feel. For example, standing your subject at the right spot just under the edge of the canopy of the tree will give wonderful soft, diffuse light and likely a very dark or black background, as the light is sufficient to illuminate the subject but falls off quickly as it struggles to penetrate the shade under the tree and beyond the subject.

Conversely, shooting out from the shade—with you in the shade shooting out toward the light—can create a striking, high-key effect, with the light outside creating crisp rim lighting around the subject, with a soft light on the face. Remember though to dial in around two f-stops of additional exposure compensation: expose for the subject, not for the background, otherwise the result will be a silhouette. Without additional or artificial fill-in light on the subject's face, however, this type of shooting is likely to blow out the highlights behind the subject.

Combined with a shallow DoF, using a wide aperture (small f-stop number) can provide a wonderful high-key, blurred background. This technique also works very well for doorways that transition from outdoors to indoors. Bear in mind that a hat or similar can provide shade for the face, if there is no open shade available.

Using Reflectors

A reflector is an often-underestimated part of your kit. Used to fill shadows in facial features on a sunny day, a reflector can add a bit of pop into daylight portraits and open up the shadows. While a decent external flash unit can do the same job, the light from a reflector is subtler and many photographers like the natural and unique effect that it offers.

Reflectors are usually circular or oval discs of reflective material that bounce light back onto a subject to brighten exposure or remove shadows. So, for example, a reflector could be used to bounce sunlight coming from behind the subject back into their face, thus avoiding a silhouette. Reflectors come in a range of colors depending on the required effect, namely white, silver, and gold. Some have outer discs that can be unzipped to reveal further inner discs of black or translucent material (these are commercially known as 3-in-1 or 5-in-1 reflectors, depending on how many options are offered).

White reflects even, diffuse light at the same color temperature as it receives, while gold will warm up skin tones (and is often associated with a sun-kissed look). Gold can also counteract the cool light of shade or an overcast day. Silver, meanwhile, is similar to white but has a more contrasty and snappy look that is difficult to define—photographers often like the certain something that silver adds to a portrait, but it can be harsh so needs to be used carefully. Silver also creates brighter highlights and stronger catchlights in the eyes.

For those reflectors that have them, black is used much like a cutter in the studio, which absorbs light and is used to control and enhance shadows, while translucent discs are used as a scrim, which diffuses and softens direct sunlight—so if no open shade is available, a translucent reflector can be placed between the sun and the subject to soften the harsh sunlight.

There are a number of factors to consider when using a reflector. It will not create light, but rather merely reflect what is already there. So a weak light source will be reflected weakly, while a strong light source may be reflected too strongly. The main light source also has to come from a direction that can be reflected onto the subject! Light travels in straight lines and is reflected from surfaces at complementary angles, so it is simple to work out how light will be reflected. Finally, the distance of the reflector from the subject will control how much light is bounced into the subject and the quality of that light.

The positioning of the reflector also depends on the intended effect, and where you place the main light source in comparison to the subject—in this case, the sun. For example, a reflector allows you to use the sun as side or backlighting, creating rim or hair lighting and modeling of the facial

© Duke

← **A two-person job, ideally**
Reflectors are great for filling in the shadows in outdoor portraits. Ideally, grab an assistant; otherwise, place reflectors on the floor in front of subjects, or even on their laps.

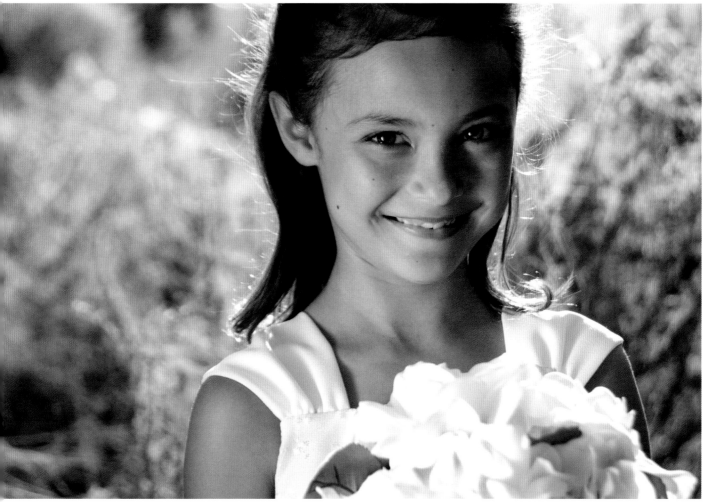

© Warren Jennings

features, as it can bounce enough reflected light back into the model's face to avoid silhouette.

Usually a reflector is used to simply fill in shadow details in the face when shooting in daylight or bright outdoor light. In the middle of the day the sun or light source is above the subject, which tends to create shadows on the undersides of the facial features, such as under the chin, eyebrows, and nose.

As a result, a reflector is often placed under or below the subject—which is unusual positioning for most light sources in photography. Placing the reflector (out of frame) below the subject—such as on a lap or on the floor in front of the model—throws light back into the shadows of the face. However, some photographers do not like this look for that specific reason; light coming from below a subject is unnatural.

Of course, what you see is what you get with a reflector, so experiment. Having an assistant or friend to help can make life easier as they can move the reflector around to get the right effect.

Matching the light

The gold side of the reflector has been used here to match the color of the late afternoon sunlight, bouncing golden light back into the side of the face, thus maintaining shadow detail.

Challenge

Using a Reflector on a Sunny Day

Sunlight and bright outdoor lighting conditions can create exposure headaches for photographers. For subjects, broad daylight can create strong shadows under certain facial features, typically the chin, nose, and eyebrows, and wash out colors and skin tone. One option is to seek out open shade, but if none is available or time is of the essence, a reflector can add a bit of zing to outdoor portraits, balance out the exposure, reduce contrast and, of course, fill in those unappealing shadows. In sunny or bright conditions near the middle of the day, grab a reflector (and, ideally, a friend to serve as your assistant), and shoot a portrait in open space outdoors. For comparison purposes, take your first shot of the subject without using a reflector, using your preferred exposure technique. Assess the results: How does the exposure look? Are there any shadows on the subject's face? If so, where?

Next, consider where to place the reflector for the intended effect. Initially, concentrate on mastering the reflector for simple fill-in purposes, rather than trying more advanced techniques such as backlighting. Ask your friend to move the reflector around and watch the results—where is the reflector most effective at removing shadows, or creating catchlights in the eyes? Try changing position, move the reflector to the other side; try raising the reflector above the subject, or moving it below, until you get the results you are after. Take the shot. If no one is around to help, try placing the reflector on the ground in front of the subject—position the subject sitting or kneeling on the ground, or on steps, to decrease the distance between the two. Or try creating a seated portrait with the reflector on the lap of the subject but out of frame, allowing it to bounce light back up into the shadow areas on the face.

→ **Shooting into the sun**
Once you are more confident using a reflector, experiment! Use it to throw light back into the subject's face when the sun is behind the model. Without a reflector, this shot would have likely resulted in a silhouette.

© Yuri Arcurs

© Flashon Studio

Challenge Checklist

→ What kind of light does the reflector provide? How strong is the reflected light and how does distance affect the amount of light reflected back?

→ Compare the effect of using the white, silver, or gold faces of the reflector. How does each differ in terms of effect, strength of exposure, catchlights, and skin tone?

→ Once you get more confident, try placing the main light source—the sun—behind the subject as rim or backlighting. Then use the reflector to bounce light back into the face of the subject.

→ Studio quality, outdoors
Using a reflector to bounce light back into shadow areas can add a bit of zing to outdoor portraits. Experiment with using the white, silver, or gold sides of the reflector, but try to match the color to the mood of the portrait.

Review

© Faith Kashefska-Lefever

This was taken in the afternoon when the light is harsh and the shadows can be ugly. I positioned her to be in front of the sun because I love the rim light you get as well as the sun flare. With her in front of the sun I set up the reflector and watched how the light hit her face being careful not to shine the reflected light into her eyes.

Faith Kashefska-Lefever

Well, we have essentially the same approach twice on these two pages, but handled differently according to the personality of the photographer. In this image flare and a full exposure bring a soft, feminine atmosphere. It also lowers color saturation and contrast distinctively.

Michael Freeman

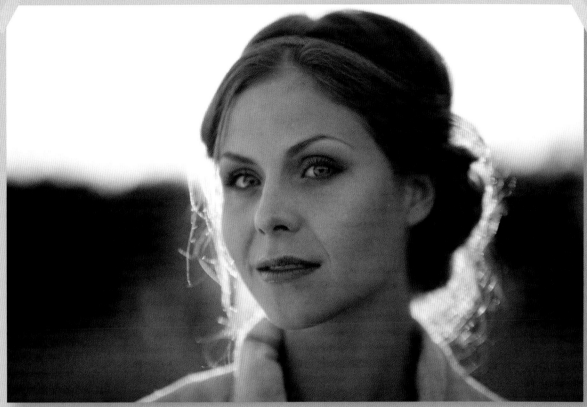

© Mikko Palosaari

A setting sun behind the model gave the nice warm backlight, and a white reflector on camera left filled the shadows on her face. I shot this with 85mm ƒ/1.4 wide open to get the short depth of field and creamy background.

Mikko Palosaari

Beautiful light from the low sun and glowing rim-lit hair, enhanced by your choice of selective focus, which strengthens the presence of those striking eyes. I also like the half-turned head, which helps the woman's gaze connect even more strongly with the viewer.

Michael Freeman

Soft & Golden Light

When you hear discussions about the quality of light, what is really meant is the softness or hardness of the light. As portrait photographers, there are three fundamental characteristics of light that we need to understand: the quantity of light (i.e. intensity or strength); the quality of light (the softness or hardness of the light); and, directionality. Quantity of light simply reflects the amount of light that is hitting our subject, and is controlled, from an exposure perspective, by setting aperture, shutter speed, and ISO.

Quality of light, however, is a much more elusive and subjective entity, and one that can elevate images to another level, and define a photographer's style. While there are other elements that define the quality of light, its softness or hardness is arguably the most important consideration for portrait photographers.

Soft Light

For portraiture, soft lighting is by far the most preferred type. Soft lighting is characterized by a lack of strong directionality, creating even lighting that appears to wrap around the subject matter. Ideally, the light should exhibit some directionality—otherwise it is too flat—at least enough to shape the facial features and body contours. Soft lighting creates low-contrast images and is easy to work with as there are no extremes of exposure (such as strong highlights and deep shadows).

This aspect of light quality is defined by the fact that light travels in straight lines. Soft lighting has usually been diffused or reflected in some way, meaning that each packet of light is hitting the subject from a slightly different angle. Unlike a spotlight, for

example, which produces hard light, as all the light energy is hitting the subject from the same direction. The fact that soft lighting is bouncing around from different directions gives rise to this wrap-around effect—it can appear that soft light travels around corners.

Taking the example of a human face, soft lighting set to one side of the face will illuminate the same side of the face more strongly, but will still light the other side of the face to a lesser degree, due to the fact that the light is not all traveling from the same direction. For the same reasons, soft lighting does not accentuate hard edges, and so diminishes unflattering aspects such as wrinkles or skin pores. Soft lighting, therefore, creates the best possible flattering light for portraiture.

Conversely, hard light creates relatively stark transitions between light and dark, as it is traveling in straight lines from one direction. While hard lighting is good for high-contrast, low-key images with strong modeling, it can also create extremes of exposure that the camera may struggle with. In portraiture, hard light can create unflattering shadows under the chin, nose and eyebrows, and accentuates wrinkles and skin pores.

The softness of light can be determined by the size of the light source relative to the subject—the larger the light source, the softer the light (the same light source would be softer if it is moved closer to the subject, as it is then larger in relation to the subject). This is why strong daylight is hard—while the sun

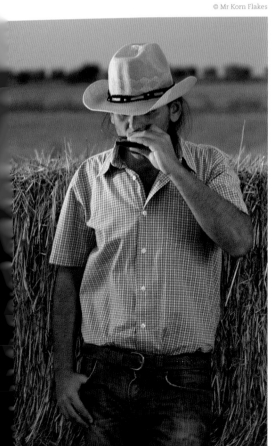

© Mr Korn Flakes

← **Big softbox in the sky**
Hazy, cloudy or overcast days can create beautiful, diffuse, and soft light that is ideal for portraiture. In such conditions, light is bounced around in all directions, creating soft, low-contrast, wrap-around portrait lighting, and reducing unflattering shadows.

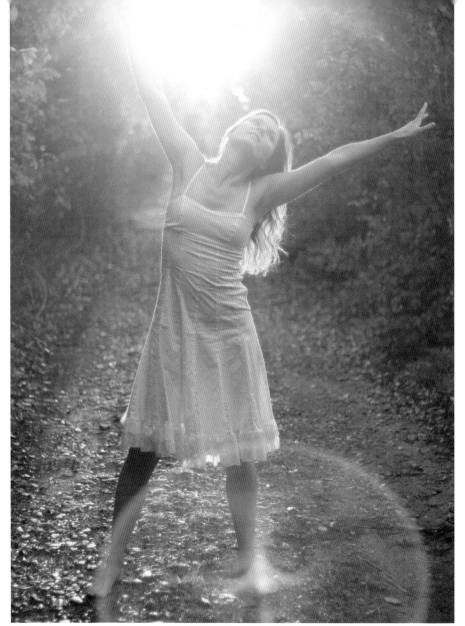

© Petar Paunchev

is massive, its distance means that it is relatively small compared to the subject, and so its light is strongly directional, effectively acting like a spotlight in the sky.

Conversely, clouds and overcast conditions act like giant diffusers that reflect and scatter the overhead sunlight in every direction. Because it is bouncing around and hitting the subject from multiple directions, the light is soft and wrap-around, filling in shadows and softening hard edges.

In other sections of this book, we will talk about modifying the light using accessories, such as softboxes, snoots, reflectors, beauty dishes, and more. These are all aimed at manipulating the quality of light in the studio. But in nature, we need to look for atmospheric light modifiers, which might include clouds, haze, mist, and fog. We know that direct sunlight is harsh and creates high-contrast images with deep shadows (much like an overhead spotlight), while an overcast day will produce soft diffuse light, perfect for portraiture as clouds act like giant reflectors in the sky.

Golden Light

The first and last hours of the day are ideal for portraiture, creating a warm, soft, magical look. Because we only see such light for a relatively brief time every day, golden light can help you to create images with atmosphere and mood, often ephemeral or nostalgic in nature.

When the sun is low in the sky (below an angle of about 20 degrees), its light has to pass through more of the atmosphere to reach the viewer or subject. Particles in the atmosphere filter out light at the blue end of the spectrum, leaving it typically golden. The light retains strong directionality, but has also been scattered by its journey through the atmosphere, creating soft yet dimensional lighting.

The angle, color temperature, and intensity of the light at these times is great for portraiture, producing soft, warm, directional light that retains rich and smooth skin tones. The softness flatters the subject's skin and facial features, while adding a natural tan to their normal skin tone.

Soft & Golden Light

For this challenge, take a portrait in either soft or golden light, both of which can be ideal for portraiture. The only stipulation is that it has to be natural light without the use of light modifiers or accessories. Hazy and overcast conditions can create ideal soft lighting for portraits. It is important to learn how to read the light, as there should be some directionality to this diffuse light—otherwise it will be too flat. We cannot control when and where these conditions appear, but the obvious preparations include studying the local weather forecast.

The golden hours, meanwhile, can create exceptional portrait lighting. The soft, warm, and golden, but directional, lighting produced by a low sun offers the opportunity to create atmospheric images with mood and nostalgia. Decide where to place the subject in relation to the direction of the sun. Such is the appeal of golden sunlight that even standing the model face-on to the sun can give striking results. Or we can use it as a key light to light the face or body at different angles around the two-thirds aspect, for side- or rim-lighting, or as backlighting.

↓ Setting-sun portrait
Natural golden light such as that found around sunrise and sunset can create luscious, warm portraits, with atmosphere and a sense of time and place.

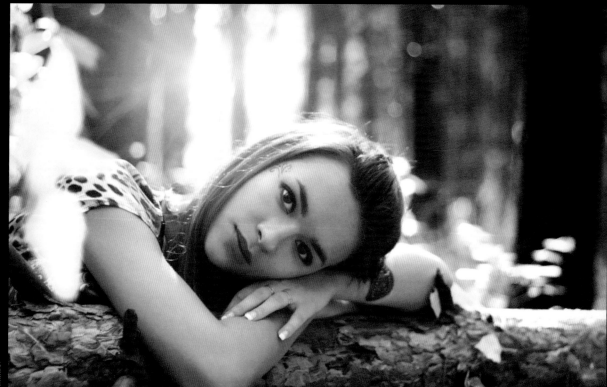

Challenge Checklist

→ Use the lighting conditions at the time to dictate the type of portrait and mood you create. Where is the light coming from? What kind of mood is it creating, and how can you use that in this portrait?

→ Clouds and mist help to diffuse the sun's light, softening its intensity and directionality. In these conditions, the clouds act as a giant diffuser or softbox.

→ Including sun flare in the frame can create striking results at this time of the day.

→ Keep in mind that weather conditions will have an impact on when and where golden light appears, as will the time of the year.

→ Shadowless style

Overcast, cloudy and hazy conditions can produce soft, yet directional light, perfect for portraiture. The diffuse light produced can be very flattering to skin texture and facial features, as there is an absence of deep shadow and hard edges.

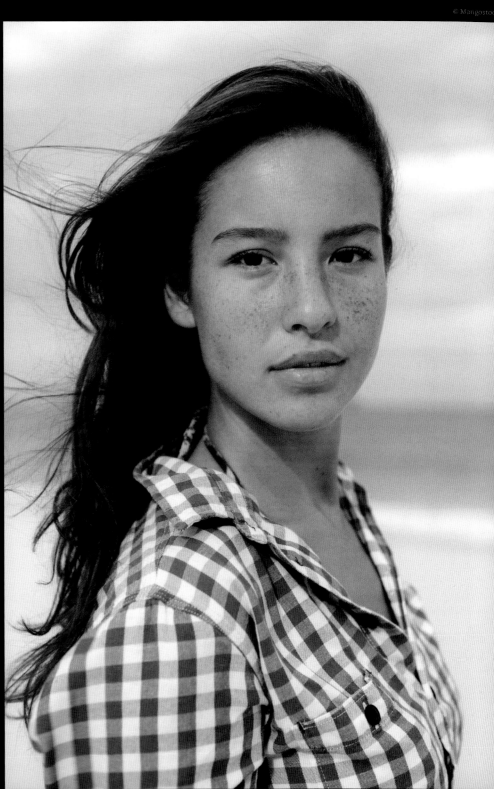

Review

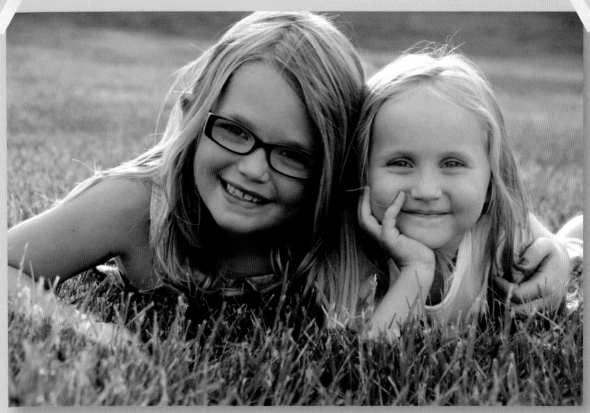

© Faith Kashefska-Lefever

Here I took a photo in the evening time. It was not quite the golden hour, but the sun was lower, and with the clouds in the sky the light was soft and perfect. I had the girls positioned so the sun was behind them, giving off a nice highlight in their hair.

Faith Kashefska-Lefever

A sweet portrait of two happy children, made more engaging by your low camera position—it's often good to shoot at the subject's own level. The light is indeed soft and pleasant, although now that you mention it, I can't help wondering what it would have looked like later, actually during the golden hour.

Michael Freeman

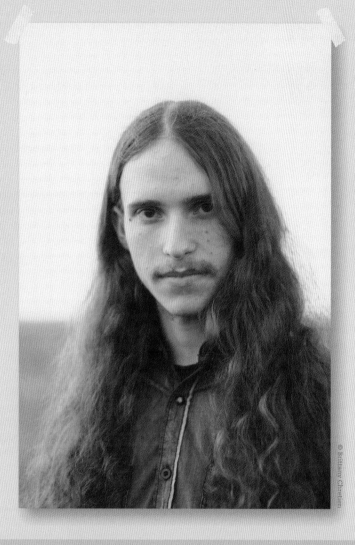

© Brittany Chretien

Early morning light is my favorite to work with since it provides such beautiful golden tones. The model was positioned away from the sun to avoid any harsh shadows along the face and to avoid blown highlights.
Brittany Chretien

Certainly, soft golden light was a good choice for the model's rather eccentric hair, catching its color and softness over the shoulders. The amount of flare that's likely from this angle at this time of day often involves a balance between technical efficiency (flagging it off) and taste (flare equals mood, as we've seen earlier). For me the flare is a little too much and fogs the image.
Michael Freeman

The Value of Spontaneity

Children are naturally spontaneous—they have a thought; they act on it! But as adults we become increasingly cautious and learn not to act on our impulses. The best decisions we make are spontaneous ones, and we certainly have more fun when we do something that we have not over-analyzed beforehand. The same can be said of portrait photography.

While it is essential to plan, organize and consider what, how and where we are going to shoot, there is always the danger that we are creating something that is over-planned. The top photographers scrutinize every detail of each shot, ensuring that it absolutely matches their visualized concept. But get it wrong and a portrait can look overposed and stilted.

Hwever, there is on occasion something to be said for throwing caution to the wind and asking the model be spontaneous. Not only will this enliven them—having been told where and how to pose for the previous few hours—it should also motivate your creativity.

Anyone who has been asked to pose for photographs for more than a few minutes at a time will know how difficult it is to remain comfortable, relaxed, and with natural expression. Muscles set in a specific pose begin to ache, our facial muscles tense, and the result is an uncomfortable-looking portrait.

At the same time, some subjects can feel self-conscious in front of a camera. Shots of spontaneous acts can really help to get the model feeling energized, relaxed and uninhibited in front of the camera.

Asking the model to do something spontaneous—such as jumping, laughing, screaming, going for a walk, kicking some autumnal leaves, splashing in a puddle, or whatever springs spontaneously to mind—will often provide you with natural expressions, poses and mood.

If the model is having fun and being spontaneous, then the viewer feels more relaxed and enjoys observing the portrait. We have all looked at a spontaneous and fun image that has made us smile to ourselves.

© MJTH

← Avoiding artifice

Whether you ask the model to stroll, jump, kick leaves, or smell flowers, even the most simple spontaneous activity can lend the portrait a new or different mood, or reveal a bit more of the model's personality.

→ **Let them run wild**
Children are naturally spontaneous, and indeed happier just doing their own thing than sitting in a studio posing. Spontaneity can provide natural, relaxed, and fun portraits of subjects of all ages.

A favorite trick of wedding photographers during the time set aside for couple portraits is to ask the bride and groom to take a walk around the gardens of the venue or a favorite local spot. While posed portraits of the happy couple can sometimes be natural and relaxed, all too often they feel slightly inhibited and reserved.

Using a long telephoto lens means that you can hang back at a suitable distance and follow the couple as they talk and walk through flowering gardens, past lakes, under trees and so on. The couple—like a tired model—are often grateful for the break and a bit of time out. After a while, they forget about your presence, and you can get some wonderful candid photography.

A similar trick is to ask the groom and groom's party to throw their hats in the air after the ceremony. Slightly clichéd it may be, but the client is shown to be having fun and hence loves the images. There is always something intimate about a candid shot too, which adds to their appeal.

But it does not have to be confined to a wedding. Ask your model to go for a walk, do star jumps, climb a tree, blow up a balloon, pull a face—the only limit is your imagination. Make sure though that the subject is comfortable with the activity; don't make them feel even more self-conscious and, of course, ensure that they are not in any danger! A long focal length lens will help to

© ChantalS

make the model less inhibited, letting you retain a suitable distance, resulting in more candid and relaxed shots. In terms of directing the model, the idea is to be spontaneous! However, it might be wise to tell them where to walk and to give an idea of what you're looking for before they set off. For example, ask them to walk to the far lake and back again via the shady oak tree. Perhaps ask them to do anything spontaneous that comes to mind—ask them to smell a few flowers on the way, or kick the leaves as they pass under the tree. Don't be too predictive about it, but

some loose direction should avoid completely random behavior. Of course, you have to be vigilant, or risk missing a spontaneous act.

Involving the subject is likely to improve the level of their interaction with the activity. Just doing something different can create an entirely new mood and feel to the shoot, and reveal more of the subject's personality, which after all is what a good portrait is all about.

A Short Stroll with a Model

While posing, meticulous preparation, precise lighting, and planned setting may be the staple of the professional portrait photographer, there is something to be said for throwing caution to the wind and being spontaneous with your model every now and then. The purpose of this challenge is to highlight the value of spontaneity in providing the opportunity for fun, unique imagery, and to reveal a different aspect to the subject's personality. If a subject is bored or tense, it will show in the final result. On the other hand, a spontaneous moment can be fun, natural, relaxed and can raise the mood of a portrait, as well as reveal a part of your subject's personality that may otherwise have remained hidden underneath inhibited posing. After all, a good portrait shows the viewer not only the physical representation of the model, but also some aspect of their personality.

For this challenge, take the model for a walk. Whether or not you provide direction to the model is up to you, and you will need to make a decision about how best to deal with each individual. Of course, too much direction will defeat the purpose of spontaneity, but a rough idea might help—for example, tell them where you would like them to walk, and tell them that they can do whatever they want on the walk. Or provide more detail, such as stop to smell the flowers. Asking them to walk slowly is the best option, as this allows you to frame up shots, and not miss anything. After all, there is no reason to rush! Remember that you still have significant control over the mood of the image. For example, you could choose to go for a stroll in bright sunshine, in rain with boots on, in snow, at dusk, and so on. The idea though is to energize both model and photographer, which should help to create some natural, relaxed, and creative shots.

→ **Wedding trick**
The natural poses that we strike while going about our daily lives are difficult to recreate in the studio; but their dynamism can add energy and interesting graphic qualities to an unconventional portrait.

© Javi Indy

© Andreas Gradin

Challenge Checklist

→ Grab a telephoto lens (preferably a zoom) to help keep your distance and make the model feel less inhibited. A focal length of 70–200mm is ideal, as it will allow you to take a broad range of compositions.

→ What's the rush? Ask the model to walk slowly, otherwise the shots will look like the model is hurrying, and more importantly, it won't give sufficient time to grab a range of shots and compositions.

→ You may want to repeat the activity a few times until you are happy with what you have. Timing is important when capturing someone walking, as certain poses can look odd or unnatural. The point at which the leg is bending or just leaving the ground is often the most appealing. But take a variety and review what you have later.

→ Spontaneous walk

Some models are inhibited by posing in front of the camera, while those that are not may become bored and tired of holding the same poses and expressions. Taking the model for a walk, or just being spontaneous, can provide the opportunity to grab some natural, candid shots.

Review

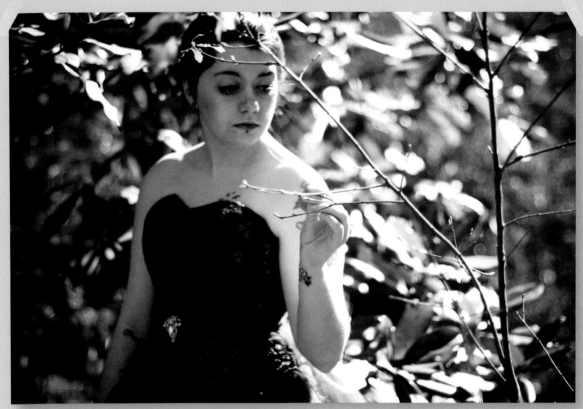

© Brittany Chretien

Being confined to a studio is rarely fun, especially when the weather outside is gorgeous. This image was achieved by suggesting we find another area on the trail we were on, and upping my shutter speed to avoid overexposure due to the bright sunlight.

Brittany Chretien

I take it this is the same shoot as featured earlier on page 33, so inevitably I make comparisons. The location is good and shooting half towards the light gives us more atmosphere. The pose, though, looks unnecessarily self-conscious, as if directed, and I think I would have preferred more spontaneity.

Michael Freeman

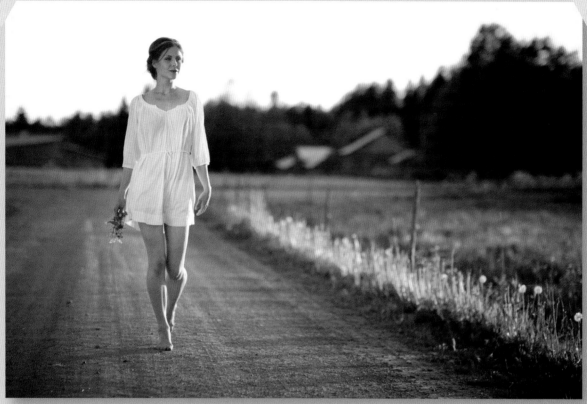

© Mikko Palosaari

According to Finnish folklore, if you collect seven flowers and put them under your pillow on Midsummer night, you will see your future husband in your dreams. An assistant was walking just out of frame next to the model with a white reflector to fill the shadows.

Mikko Palosaari

I very much like this shot! All the ingredients are in place, from choice of model and her styling to location (including the surface of the road) and lighting. It's also an excellent example of how to achieve a natural, unpretentious and apparently unposed effect by walking with the model, even though it was an organized shoot with an assistant. This would make a good magazine spread with room for a headline on the right.

Michael Freeman

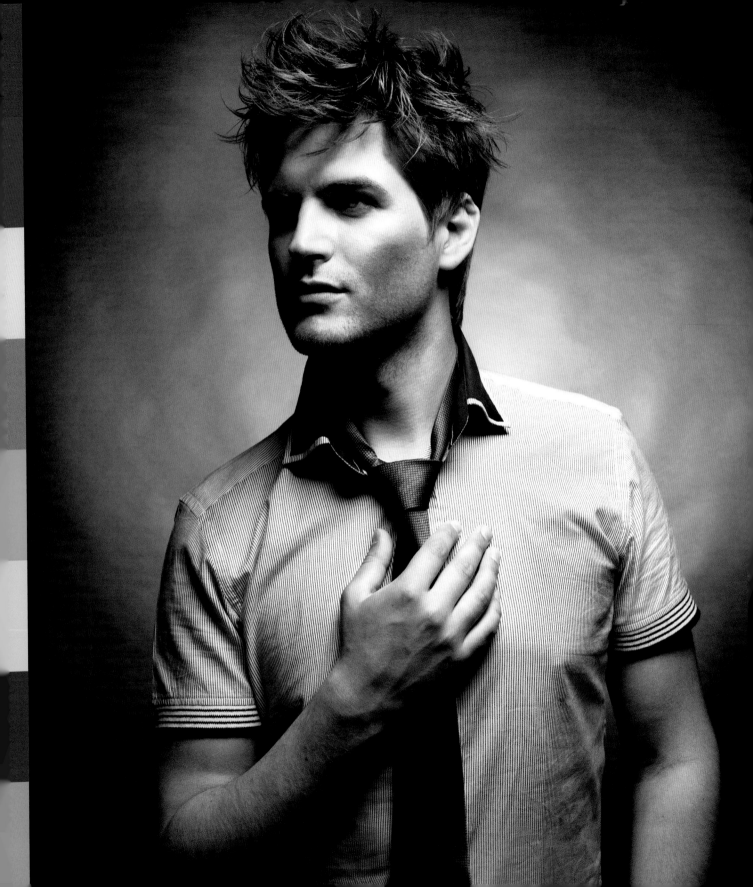

Photographic Light

In the previous section, we learned how to seek out and optimize the best types of natural light. This form of lighting has been more than adequate for centuries of portrait painters. However, there will be times when nature does not always provide the exact type of light we need, or when assignments and commissions demand a specific look or effect. At these times, photographic light can be used to create a complete and fully controllable lighting environment in the studio, or help us to complement or enhance natural light when we are outdoors.

As well as providing the ability to produce different effects and moods, one of the most useful characteristics of photographic light is that, unlike natural light, we can shape, alter, manipulate, move, and control it to a precise degree. We can move a light here, add a light there, create soft or hard light, even subtract light. Photographic light allows photographers to create any lighting setup at any time, according to the desired look, mood, and feel of the portrait.

Of course, learning how to use the different types of lighting, and the light modifiers and accessories that help us to shape and control light, can take years of hands-on experience. Mastering photographic light is an ongoing commitment, but understanding the basics is a strong foundation for that learning process.

Generally speaking, there is a choice of two types of photographic lighting available to us: flash or continuous—each comes with its own pros and cons. The following section aims to guide the aspiring photographer through the different technologies and techniques of photographic lighting.

Flash Equipment

Flash units consist of a tube containing xenon gas. When high-voltage electricity (produced by some form of battery) is discharged within the gas, it generates an electronic arc, which in turn creates a very brief flash of light, lasting thousandths of a second.

Built-in, pop-up flash units are not ideal. They are weak, poorly placed, and often cause red-eye, although they can sometimes be useful in tight situations to add a dab of fill light when time is of the essence.

Much better are the portable flash units commonly known as speedlights or speedlites (after two specific brands of this type of flash unit). These units are much more powerful, portable, flexible, battery powered, and can be controlled either by the camera (typically through some form of through-the-lens [TTL] metering—see box on page opposite), or manually by you. The fast recycling times (the interval after which the flash is ready to fire again) also make speedlights great for photojournalists, paparazzi, sports, and wedding photographers. The power of a speedlight is measured in Guide Number (GN); the higher the number, the more powerful.

Speedlights can be used either on-camera, fitting into the hotshoe bracket on top of the camera, or used off-camera. When used on-camera, speedlights are much more useful than pop-up units, as the flash heads can often be swivelled or rotated up or down and side to side, allowing you to bounce the flash off surrounding surfaces—a favorite trick of photojournalists and wedding photographers.

Bouncing the flash in this way has a number of advantages: it avoids red-eye and provides a much more flattering light for portraiture, as it hits the subject either from the side (off a wall) or from above (a white ceiling), rather than straight on. In addition, the wall or ceiling is effectively acting as the main light source, and so is large compared to the subject, creating softer light. Rarely, if ever, will a bride who has employed a professional photographer be seen with red-eye.

A much better way to use speedlights, however, is to take them off-camera. Many photographers today use multiple speedlights off-camera to light entire location sets—a style of working that has become known as strobist lighting.

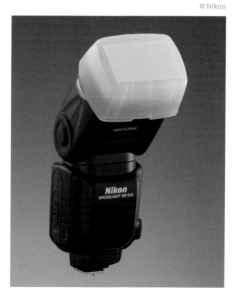

© Nikon

Speedlights are mounted on lightweight stands, or perched on any flat surface, and are fired by the camera, either by an infrared or radio remote control unit, which usually sit in the camera's hotshoe bracket.

There are two types of studio-style lights: monolights or monoblocs; and pack heads. However, neither type is necessarily confined to the studio, but factors such as portability, weather conditions, convenience, and availability of power might be limiting. Power output is measured in Joules or Watts/second, rather than GN.

Monoblocs are powerful, individual, often expensive, flash units that need an external power source (either mains or battery pack). They come in many shapes, sizes and power outputs, and can be fitted with a wide variety of light shapers, modifiers, and accessories. They have their own integrated flash tube, modeling light, cooling fan and electronic circuitry.

A modeling light is continuous lighting embedded in the flash unit that gives you some idea of the effect the light will give before the flash is fired, helping to set up the lights in the first place. Lights can be finely adjusted in terms of output to provide highly accurate and repeatable quality.

← Direct the light
A key advantage of external flash units is the ability to twist and swivel the strobe to fire at an angle, allowing it to be bounced off a ceiling or nearby wall. It will require more power output, however, to reach the subject.

TTL Metering versus Manual Flash Exposure

Most modern cameras will use some form of TTL (through-the-lens) metering when we allow flash exposure to be controlled by the camera. TTL is a double-edged sword. On the one hand, it calculates very accurate flash exposures for us. On the other hand, because it uses light reflected from the subject (i.e. the light reflected back through the lens) to measure exposure, it is dependent on the reflectivity or tonality of the subject—which can create significant differences in exposure calculations between dark and light skin tones, or white and black clothing, for example. At the same time, TTL exposure cannot be controlled by changing aperture or ISO settings on the camera (as the camera merely compensates for this change). Try using flash on TTL or Auto mode, at apertures $f/4$, $f/5.6$ and $f/8$—the exposure should look exactly the same. The only way to change TTL flash exposure is to set Flash Exposure Compensation.

Manual flash exposure, meanwhile, requires a separate light meter, which measures the incident light that is actually hitting the subject. For this reason, it is not affected by reflectance and so is considered a more accurate technique of metering. At the same time, manual flash allows us to change the flash intensity in fractions of maximum power—1/32, 1/16, 1/8, and so on. For more experienced photographers, the control and accuracy provided by manual flash exposure is much more appealing.

Inverse Square Law

The inverse square law describes an extremely important characteristic of light: the amount the light falls off with distance. Simply put, moving a flash light further away reduces its intensity, so it is very important for photographers to have some way of assessing where to place their lights, and how distance will affect their power. Enter the inverse square law, which states: The fall off of light as it moves away from the light source is inversely proportional to the square of the distance it travels. While this sounds complicated, what it actually means is that for every one yard (or meter) we move away from the light, its intensity drops to half the amount at the light source. So two yards (2m) away from the light source, and its intensity drops to one-quarter (1/[2×2]), three yards away and it drops to 1/9th the power (1/[3×3]), four yards it drops to 1/16th (1/[4x4]) and so on. Another way to look at it is that doubling the distance cuts the light by two f-stops each time.

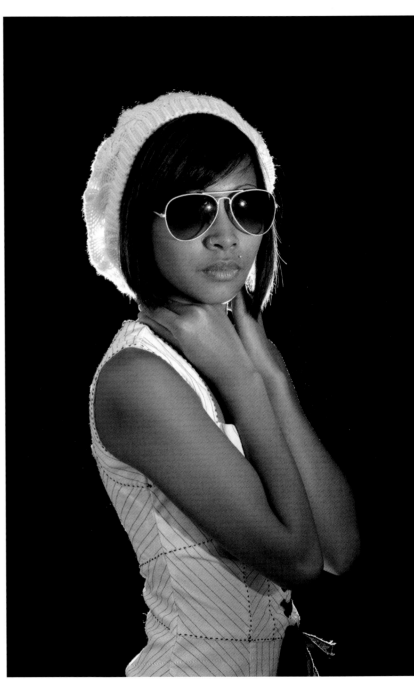

© Shane Trotter

↑ **Make any background pure black**
If the background is both dark enough (i.e., not reflective) and far enough away, it will fall into complete black, while the subject stands out fully illuminated—in accordance with the inverse square law.

Continuous Lighting

Continuous lights are photographic lights that, unlike the brief duration of flash, are on all the time. Continuous lighting has the added WYSIWYG advantage for photographers—what you see is what you get. So setting up continuous lighting for the final exposure is much easier than for flash lighting, as their effect can be seen in real time as lights are modified, turned up or down, moved, and so on.

Continuous lighting has been mastered by video shooters over decades, as it has been used to light movies and programs in Hollywood for many years. The disadvantages of continuous lighting mainly relates to a lack of power compared to flash, and the heat it generates, as well as the elusive nature of the quality of light—many photographers simply prefer the look of flash lighting. Conversely, continuous lighting can be more substantial to work with, allowing you to assess the entire setup by physically walking through it.

Continuous lighting can be incandescent, fluorescent, or vapor discharge, however, more recently LED lighting—again, driven by video makers and the growing number of DSLRs that offer full HD video capabilities—is making a strong showing as the new kid on the block.

Continuous lights are sometimes referred to as hot lights, although more specifically this refers to incandescent, or tungsten, lights. Incandescent lights are the easiest to work with, as they put out a continuous spectrum of light, allowing you to control the color temperature of the output using filters, or gels. They can also be controlled to provide soft, diffuse or hard light. The drawback, however, is that they produce a lot of heat, making the subject feel uncomfortable after long periods of time, and can even set fire to attached accessories if care is not taken.

Fluorescent lights take some of the advantages of incandescent lights, but minus the problems with excessive heat. Designed for photography, fluorescent lamps are powerful, yet cool, but do not provide the light-shaping capabilities of incandescent light and tend to cost more up-front. HMI or vapor discharge lamps, meanwhile, use metal salts—namely Hydrargyrum Medium-arc Iodide (HMI) to provide a clean, pure white light ideal for balancing with daylight. As a result, they are great for outdoor work and do not produce lots of heat. However, these daylight lamps are bulky, lacking in portability and expensive.

In recent years, the popularity of another light source has started to grow, mainly as a result of stills photographers crossing over to the video world as HD-video-enabled DLSRs increasingly become the norm. Panels and banks made up of numerous light-emitting diodes (LEDs) can now provide an inexpensive, extremely portable, and consistent source of light. While a single, small LED lighting unit might fit onto the hotshoe bracket of a DSLR or a video camera to add some fill light, they can also be joined together to create an LED panel, or bank, consisting of hundreds of individual LEDs. So, for example, it is easy to carry around eight individual LED lights, about the size of a fist, in your camera bag. These can then be connected together using a simple hotshoe-style bracket mechanism to create a large LED panel.

→ **New technology**

LED panels like these continue to decrease in price while still increasing in color accuracy and power output. Modern panels can be matched to almost any color temperature, allowing them to be used in a variety of conditions—as primary lights as well as supplementary ones. They do, however, still require accessories such as diffusers and barn doors to be effective in many cases.

© Lowell

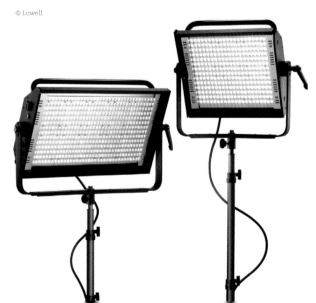

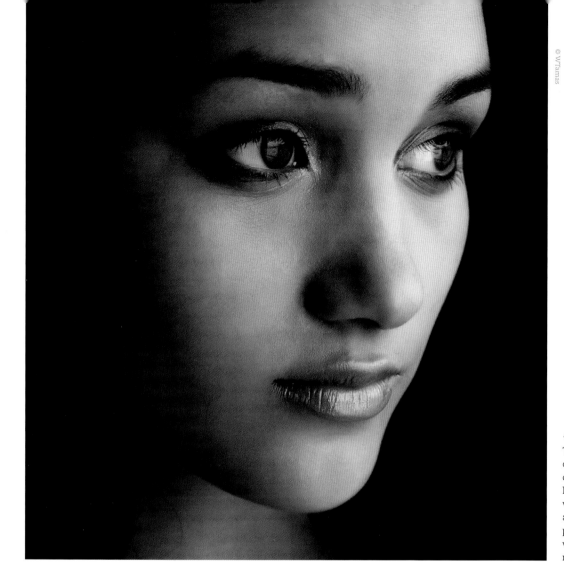

© WTamas

← Easy setup, comfy model
The advantage of working with continuous light is that you can see the results of the lighting setup in real time, which saves you a lot of trial and error (an often necessary part of flash techniques), which accordingly puts your model more at ease.

Today, LED units and panels come in an increasing variety of shapes, sizes, and configurations. The more expensive models allow for stepless control of lighting intensity and, even, color temperature. Their output is cool, in that they do not produce much heat.

While some photographers complain that the color temperature is too cool, filters and gels can be added to the front of the lights to correct this. Of course, the fact that they are continuous means that any changes made to intensity or color temperature at the time can be seen immediately in real time, if using Live View, on the back of the camera. Likewise, simply shooting in Raw mode (which we should be doing anyway) also gives you more flexibility to correct any color issues in post-processing.

LED lights can also be used in conjunction with any suitable light modifier or accessory. While a single LED unit is small and so produces harsh light, the more that are connected together, the softer the light becomes (as the light source is larger compared to the subject). Furthermore, they can be used with an increasing range of commercial umbrellas, softboxes, snoots, and other lighting accessories to shape the light further.

The portable and smaller nature of LED panels also means that they will draw less attention on location, which in turn means that your subject may be more relaxed and comfortable.

Lighting Accessories

When using photographic light, flash or continuous, there is an almost bewildering collection of lighting accessories and modifiers available for diffusing, focusing, reflecting, bouncing, softening, hardening, reducing or enhancing the output from our light sources. Indeed, in the studio there is very little that we cannot do in terms of controlling photographic light.

In the first instance, many studios are painted either completely white or black, immediately neutralizing the effect of unwanted color casts from reflective surfaces, and providing an immediate spill kill or a wall-sized reflector.

Reflector Dishes

One of the mainstays of studio lighting is the reflector dish (different from a reflector used outdoors), which is a bowl-shaped metal fitting that connects directly to the end of a flash head or monobloc unit—without a dish fitted, flash units are "bare bulb."

Reflector dishes are usually white or silver in color and vary in shape and depth, allowing us to precisely control the spread of the light from the flash source, and the quality of the light produced. The light from the bulb hits the curved interior surface of the dish by which it is enveloped, and has the effect of diffusing and scattering the light in multiple directions. The spread of light is controlled by the diameter and depth of the dish we use. So a deep-sided dish with a small diameter will focus the light source, while a wide, shallow dish—a wide-angle reflector dish—will produce a wide beam of soft light that is diffuse and flattering.

A wide-angle reflector dish is often used in conjunction with an umbrella—the wider spread of light it creates fills the entire reflective interior surface of the umbrella, making it more efficient at diffusing and reflecting the light (a focused beam of light would only hit a small central portion of the umbrella).

A diffuser dish—often called a beauty dish—is a slight variation on a reflector dish, in that it has a small, central cap placed directly in front of the flash or continuous lightbulb. This cap prevents the direct passage of light from bulb to subject, bouncing it back into the reflective surface of the dish to provide a very soft, glamorous look, hence the name. Beauty dishes tend to be white, wide (22 inches in diameter, for example) and shallow.

Reflectors can also be fitted with further modifiers, such as honeycombs, which cut stray light and focus the spread of light even more. Like a beehive structure, honeycombs contain numerous smaller grids, which force the emitted light to travel in a straight line; the smaller the grid, the tighter the light beam. Other reflector accessories include diffuser panels, colored gels, and so on.

Umbrellas

The umbrella is a very popular and useful light modifier, thanks to its portability and low price. Photographic umbrellas come in a range of sizes and colors, according to the desired effect. The light source is aimed into the umbrella, which then bounces and scatters the light back out at various angles due to its concave nature, creating an appealing soft lighting effect.

Umbrellas are used to spread the light source over a wide area, creating a soft, wrap-around lighting effect that should not require any further fill light. As well as producing soft light flattering to facial features, umbrellas also create an attractive catchlight in each eye, when positioned correctly. Umbrellas either have a white or silver inside lining (with a black outer cover to prevent light leaking through) or can be translucent and used to shoot through to give a diffuse, but more directional, light. The main downside to umbrellas is that the spread of light, known as spill, is difficult to control accurately.

Softbox

Softboxes are arguably the most popular light modifier used by photographers today. They are tent- or dome-like structures that come in different shapes and sizes—the larger the softbox, the softer the light. Softboxes are often square or rectangular, but can also be hexagonal or octagonal in shape, not dissimilar to

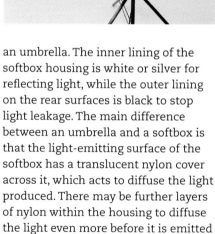

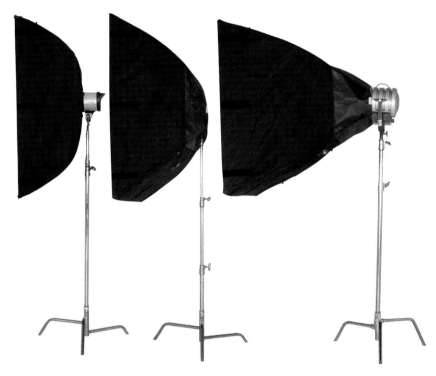

an umbrella. The inner lining of the softbox housing is white or silver for reflecting light, while the outer lining on the rear surfaces is black to stop light leakage. The main difference between an umbrella and a softbox is that the light-emitting surface of the softbox has a translucent nylon cover across it, which acts to diffuse the light produced. There may be further layers of nylon within the housing to diffuse the light even more before it is emitted from the outer nylon surface.

A softbox works by diffusing the light emitted directly from the bulb, and then bouncing it around inside the housing, to create soft, diffuse, window-like light. The light emitted from the softbox, however, is more directional than created by an umbrella, and is emitted in straight lines, thus reducing spill light. They are therefore thought to be more controllable than umbrellas. Softboxes can be modified further by adding a grid or honeycomb-like structure—commonly called an egg crate—that more narrowly focus the light.

Snoots

A snoot is a small, cone-shaped fitting that focuses the light from the source into a tight or narrow beam. The tightness of the cone dictates the focus of the beam—the smaller the diameter of the cone, the narrower the light. Snoots are often used as hair or kicker lights (see pages 99 and 101).

↑ Right tools for the right job
Generally speaking, umbrellas give a more enveloping quality of light that reaches around the contours of the subject, while softboxes are more directional. That said, each can be customized and tailored to your particular needs, and many of their uses can overlap.

© LumiQuest

↑ Portability
This small snoot can be fitted to an external flash, but larger ones exist for continuous light sources.

Supplementary Lighting

In the studio, we can employ photographic light and a wide range of modifiers and accessories to create almost any lighting environment that we desire. Outside the studio, however, things are not so easy because we cannot control lighting variables. However, learning to combine daylight and photographic light can provide striking results and is an essential skill in the repertoire of today's photographers. Photographic lighting can be used to light an outdoor subject just as it can in the studio, and there are some handy techniques and tips that we can use to make our images really stand out.

Using the flash or camera's built-in TTL metering system lets you to achieve very consistent-looking results, and to work in conditions that we would not normally consider. Indeed, wedding photographers may leave their flash on as fill light for an entire wedding, both indoor and outdoor.

Of course, the same effect can be created using any form of photographic lighting; for example, an LED unit fitted to the camera's hotshoe will have the same effect. However, it is difficult to meter continuous light accurately in this way (for example, we cannot take an exposure reading minus the ambient light to measure the effect of the LED alone, compared to flash units that have preset f-stops). At the same time, most small continuous lights that are able to fit into the hotshoe probably lack the power to provide even two f-stops of underexposure in bright daylight.

Fill-in flash

Portable, on-camera flash units are great for supplementing natural or available light, and are as fill-in flash when fitted to the camera's hotshoe fitting. Fill-in flash is achieved by dialing down exposure to around two f-stops below the ambient light meter reading. In this way, fill-in flash adds a splash of light to deep shadows, such as those under the eyebrows, nose and chin caused by sunlight. Because the flash is set to two f-stops below the ambient light reading, it has no effect on the overall exposure and is too subtle to cause red eye or harsh frontal lighting. It does, however, minimize unflattering deep shadows, lifts skin tones, and creates an attractive catchlight in the subject's eyes.

Flash Sync Speed

When a digital camera makes an exposure, two shutter curtains pass across the sensor; the first curtain pass exposes the sensor, while the second curtain re-covers it. Shutter speed works by changing the interval between the first and second curtains. At fast shutter speeds, the first curtain will be exposing the sensor, but before it has cleared the other side of the sensor, the second curtain will be re-covering it. So, for example, at speeds of say 1/160 second, the first curtain will be traveling across the sensor closely followed by the second curtain; the gap between the two reveals each part of the sensor for 1/60 second, and the camera's electronics piece the entire exposure together. This creates a problem for flash, which typically lasts for 1/1000 second. This means that when the shutter speed reaches a critical point, termed the flash sync speed, the rapid flash duration results in only one part of the sensor being exposed to the flash by the two closely traveling curtains—as the curtains travel across the sensor, the flash has already been and gone in the first thousandth of a second. This results in a dark band on the image, which is underexposed as that part of the sensor missed the flash. Typically, the flash sync speed value on most cameras is between 1/60 and 1/250 second. After this value, the camera cannot be used with flash. With some modern flash units, or speedlights, however, there is a solution to the flash sync speed conundrum. High Speed Flash Sync works by emitting an extremely fast pulse of flashes so that whatever part of the sensor is exposed each section will receive one of the pulses of flash. This has important implications when using flash to balance daylight, which typically demands faster shutter speeds to underexpose the ambient light level. The downsides to High Speed Flash Sync are a decrease in absolute power and shorter battery life. However, often this is a compromise that photographers are more than willing to make.

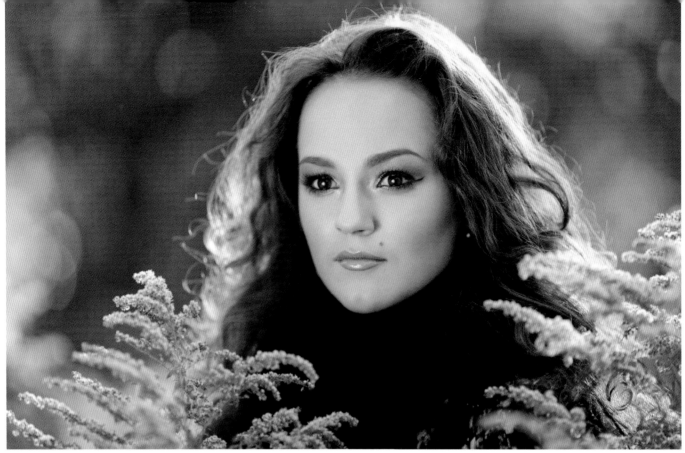

Balancing Daylight & Flash

While outdoor conditions are not always under our control, the use of powerful photographic lights to illuminate the foreground subject means that we do have control over the most important element of the portrait. Quite simply, the lights are set to provide the same exposure as the ambient light. In practice, experienced photographers using flash lights may even underexpose the ambient light levels by around one f-stop, which has the effect of toning down the background slightly to place more emphasis on the subject. This technique is possible because of the extremely short duration of a flash, on average around 1/1000 second or less. Importantly, this means that altering the shutter speed has no effect on the exposure created by the flash—because

the flash duration is so short, it will always be faster than any shutter speed under 1/1000 second. Aperture, however, does affect flash exposure. So when mixing flash and daylight, shutter speed controls the ambient light level, while aperture controls the exposure for flash. Continuous lights can be used to balance daylight, but only by virtue of making them brighter than daylight!

This effect can also be created by grouping together multiple speedlights. As standalone units, speedlights are not powerful enough to match (balance) daylight exposure. However, most brands offer a setting that allows you to electronically group together multiple units that, when fired, act in unison as a large, single light. The same is true of continuous lighting outdoors, which lacks the strength of more

↑ Shooting into the Sun
This shot was taken in bright sunlight, and with a wide aperture. These two factors necessitated a fast shutter speed in order to limit the amount of light hitting the sensor and avoid overexposure—a shutter speed far beyond the flash speed sync of the camera used. Therefore, a neutral density filter was fitted to the lens to drop the exposure by five stops and allow a shutter speed of 1/320 second, which could then be used in conjunction with a full-power fill flash.

powerful flash systems. However, continuous lights can also be grouped together to create brighter lights. For example, many LED units (about the size of a hand) have hotshoe-style slots that allow them to be connected up to one another, making it possible to build a large, single LED array, or panel, made up of multiple conjoined units.

Umbrella or Softbox?

After choosing the lighting setup for a portrait, the next decision is likely to be how to modify the lights. Umbrellas are portable, cheap and offer a relatively simple way to create soft, wrap-around light that is flattering for any portrait subject. However, they do scatter light in multiple directions, which is great for producing a diffuse, soft quality of light, but also results in a fair amount of spill, or stray light. Stray light bouncing off walls, ceilings, and other reflective surfaces can add unwanted shadows to facial features, introduce color casts, or illuminate parts of the scene that you want to render dark. In addition, umbrellas outdoors catch the wind very easily and regularly topple expensive lighting equipment if they are not battened down.

Softboxes, meanwhile, are slightly bulkier (although many are collapsible for ease of portability), but offer luscious, diffuse light. Most photographers consider that light from a softbox is more controllable as it is less prone to straying, particularly if fitted with a grid for further control. For this challenge, use photographic lighting (flash or continuous), modified with either a softbox or umbrella, to create a portrait of your choice. The portrait can be indoor or outdoor, seated or standing, full length or head and shoulders. First set out your intention and use the light modifier of choice to make it happen. If time serves, try comparing the different effects created by each modifier and its impact on the same subject and scene.

© Stuart Monk

→ **Dramatic B&W**
By using a single large umbrella to the right of the camera, the background falls into black, creating this timeless portrait that focuses on the subjects' expression and relationship.

Challenge Checklist

What kind of look are you aiming for? An umbrella will create soft, wrap-around light with no need for any fill-in, but stray light may illuminate parts of the scene, face, or body that you do not want it to. A softbox will create soft, diffuse light, but with more direction (and therefore stronger shadows) than an umbrella.

When using a light stand for off-camera lighting, ensure that it is sturdy enough to hold the equipment and modifiers being used, and that it is weighted appropriately at the bottom to prevent it keeling over and smashing expensive lighting equipment. Take extra care when using an umbrella on a stand outdoors—use a weight to hold it down, or ask an assistant to stand on the base.

Remember that the larger the light source is to the subject, the softer the appearance of the light, so moving the modified light source closer to the subject will impact on the portrait's mood, feel, and appearance. However, moving the light source closer means faster light fall-off that can create very dark or black backgrounds. Use the inverse square law to your advantage.

↑ Enveloping light

Using an abundance of softboxes positioned all around the subject, the light in this portrait has an enveloping quality that makes the subject emerge out of and float in pure white.

Review

© Faith Kashefska-Lefever

A softbox is probably one of my favorite tools to use. This photo was taken near sunset; my strobe was fitted with a softbox and was placed close to the subject just out of frame. I wanted to complement the sunset's light while also showing off detail in the red dress.

Faith Kashefska-Lefever

The theatricality of this shot owes much to the unexpected use of a softbox on location (viewers are more accustomed to small flash units being used in this kind of situation), and its strength—the combination certainly gives the image an unusual interest. You've enhanced this theatrical treatment by the contrast between the setting and the dress and props. It looks almost like a stage set. Was the blank left half meant to take reversed-out type in a print layout?

Michael Freeman

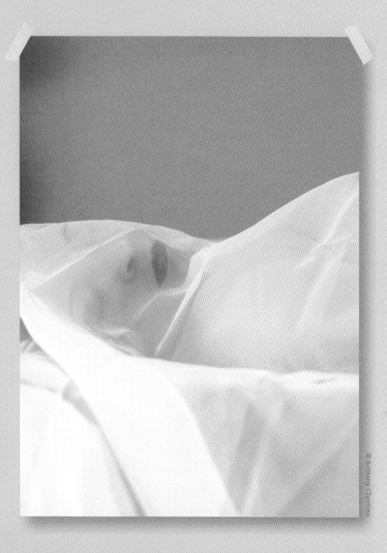

© Brittany Chretien

This image used a homemade softbox made from a thin white cotton sheet wrapped around a cardboard box lined with aluminum with a 400-watt, five-dollar worklight inside. Lens was left wide open to maintain dream-like softness and to make up for limited lighting.
Brittany Chretien

Well done with the homemade softbox—it works! Years ago I made my own area light for studio shooting; not only was it cheaper than a store-bought light, but I felt it was personally tailored! The pastel colors, the graphically effective three-band division, and overall softness give a distinctive image, though the cloth covering the face gives, to me anyway, a slightly morbid touch.
Michael Freeman

Multiple Lights: Basic

The art of portraiture is about learning how to use lights to create highlights and shadows that sculpt the subject's facial features and body contours to create form, and the illusion of depth and dimensionality. Light is the tool by which photographers do this. Whether using natural light, or photographic light in a one-light setup, or multiple lights, it is important to learn how to use a broad range of lighting techniques in order to evolve our own lighting and photographic style.

Key Light

The key light—also known as the main light—is the primary light source for shaping the subject's facial features and will create the overriding pattern of highlight and shadow on the face. The way this light is used, and the modifier employed, will dictate the style of the entire portrait. As the main light source, it will need to be powerful enough to maintain exposure when fitted with some form of modifier, or if used outdoors to be able to compete with daylight.

As discussed in previous sections, a common position for the key light is at a 45-degree angle to the side of the camera and about 30 degrees above the subject. However, moving the key light closer to the axis of the camera will—presuming it is diffused or softened in some way—create a sense of roundness, while moving it further than 45 degrees away from the subject-camera axis will create harder shadows and lighting, with a strong contrast between light and dark.

On a general level, there are two main types of lighting in portraiture, namely broad and short lighting, which relate to the side of the face illuminated by the key light. Consider a portrait subject lit by a key light placed at 45 degrees to the camera. Broad lighting requires angling the subject's face so that the key light illuminates the side of the face most turned toward the camera—that is, it lights the broadest part of the face, relative to the camera. Short lighting, meanwhile, refers to a key light that illuminates the side of the face that is turned away from camera—the shortest or thinnest side of the face.

Broad lighting is not as popular as short lighting as it tends to be flatter with less modeling and shaping. It can, however, be used to widen a thin or long face. Short lighting creates strong contouring of facial features, with deeper shadows, and can be used to thin out a wide face.

→ **See the difference**
Here you can see the full effect of catchlights: The original image (left, with catchlights in the eyes) draws attention to the eyes, which in turn shine outward from the rest of the face. The version on the right has had the catchlights edited out, and while it's still a well lit shot, the eyes have no life to them, and the viewer isn't drawn into the portrait with the same allure.

© Zoom Team

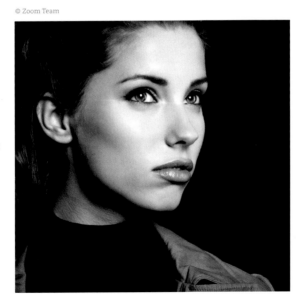

Fill Light

Like a reflector in an outdoor shot, a fill light is used to complement the key light, controlling the lightness or depth of the shadows the key creates. A fill light is used to retain shadow detail to a greater or lesser degree. A fill light is usually diffused by some form of modifier and should not create its own shadow pattern. To that end, fill lights are often placed close to the camera axis in order to minimize their shadow profile on both the subject and the background. Naturally, our brains are hardwired to expect light from a single source (the sun) so a fill light adding its own shadow profile will look unnatural.

Because fill lights are usually diffused, care has to be taken that its light does not spill over into unwanted areas. Also avoid introducing a second catchlight to the eyes of the subject, as this will give the them a vacant or bored look—although it can be quickly removed in post-production.

The difference in output between the key and fill lights is known as the lighting ratio and is very important in setting the mood of the portrait—evenly lit or deep contrast between light and shadow, or somewhere in between? As a rule of thumb, the fill light will be set at one to two f-stops below the key light to give directional light with details in the shadows.

Hair Light

A hair light is often a small light source, or one that has been modified to create a narrow beam of light. It is usually placed above and, sometimes, slightly behind the subject to create a lit edge, or rim of highlights, around the back of

© Subbotina Anna

the head, neck, and hair. The main purpose of the hair light is to create separation between the subject's hair and the background, as well as preventing the hair merging into the background; this separation adds a further layer of depth.

The hair light is often used opposite the key light. Traditionally, a hair light would only illuminate the hair, but contemporary styles increasingly allow it to spill over onto the cheek, neck, and shoulders, effectively doubling as a kicker (see page 101). Generally, hair lights should be set at the same exposure as the main light but altered according to hair color—loosely, blond hair should be one to two f-stops below the key light exposure, while dark hair should be around one to two f-stops over.

← Adding a third dimension

Hair lights are often, but not always, placed above and slightly behind the subject to create separation between the back of the subject's head and the background, and therefore add another layer of depth and dimensionality. Contemporary trends see hair lights doubling up as a form of kicker light, spilling over onto the cheeks, neck, and shoulders.

Eye Catchlights

Studying the eyes in most studio portraits will reveal catchlights, bright spots of reflected light that literally add a twinkle to the eye of any portrait subject, and are suggestive of attraction, health, and vitality. Catchlights are created by the reflection of the key light and are dictated by the position, size, and shape of the main light source. Of course, moving the position of the light source moves the catchlights—the starting point for a two-thirds portrait at about 45 degrees to the left of camera and 30 degrees above the subject, for example, will create catchlights in the top left corner of the eye. Experienced photographers can study a portrait and deduce the lighting setup that was used for the image by judging the position, shape and size of the catchlights in the subject's eyes.

Multiple Lights: Advanced

Studying and mastering photographic light can take years, but building up from simple to more advanced techniques is a good way to establish a platform on which we can continue to evolve our photographic lighting style and knowledge. Elaborating on the three-light setup by adding further lights can create an almost infinite variety of portrait styles and looks.

Second Key Light

Using a second key light reduces the lighting ratio (see page 102), or contrast, between highlights and shadows. A second key light essentially removes the concepts of short and broad lighting when used on a single subject, as they will combine to provide even lighting across the face of the subject. The effect of a second key light is to lose the modeling effect that comes from a single, off-axis light, and can be referred to as high-key lighting, whereby a subject is lit equally from all sides. While high-key lighting reduces drama in terms of using light to create mood, emotion or narrative, it is good for creating an upbeat atmosphere. Many mainstream studios producing lifestyle portraits today employ this effect, whereby the lighting is even, bright, and shadowless, often with a white background. The advantage is that as the subject moves, there is no need to alter the lighting positions, as the subject remains evenly lit throughout the scene.

Background Light

As the name suggests, background lights are used to illuminate the background and create separation between the subject and whatever is behind them. The simplest setup is to use two lights trained on a white background to produce a clean effect. Fitting colored gels will alter the color of a white backdrop. Background lights can also be placed between subject and background (hidden from the camera by placing them behind the subject), and fitted with various lighting modifiers to produce different shapes, colors and patches of light on the background. Whether indoors or on location, background lights should complement the key light, and usually come from the same direction as the key.

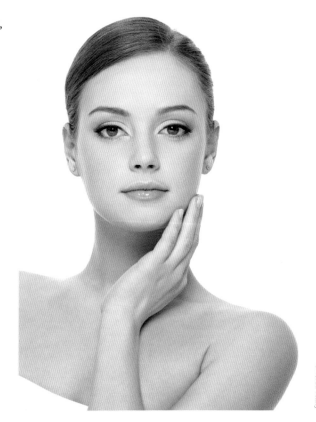

← Nonexistent backdrop
The addition of a second key light creates even lighting across the subject's face or body, or allows you to light two subjects in the same scene. When used to create high-key lighting, such as that en vogue in many popular portrait studios, multiple key lights create an even light that allows subjects to move around the scene, without you having to constantly worry about repositioning the lights. The downside is that the modeling effect of directional lighting is lost.

Kicker Lights

Kickers are used much like hair lights to add highlights to the side of the face, cheeks or body, and increase the feeling of depth or richness in a portrait. Because they are used behind the subject, the light glances off the skin or clothing and produces brilliant highlights, adding pop to a portrait lighting setup. Modifiers such as snoots or barn doors can be used to control these lights and prevent lens flare (as they are facing the camera). They may also be diffused. Aditionally, strip lights can be employed to produce the same effect.

Feathering

Feathering the light involves turning the lighting unit slightly away from the subject (almost lighting across the subject) in order to get a better quality of light.

Set up the lights in the normal way, for example, at a 45-degree angle. Then ask an assistant to slowly turn the light away from the subject (you should stand at camera position in order to assess the effect). At first, there will be little change in the intensity and quality of light, as the light turns. Rotate it too far and the light will drop off rapidly as the edge of the light cone is reached. However, we want the lighting at the angle just before the edge of the light as this is considered to provide the best-quality light possible. First, it does not use the intense, center of the light source, which can be unforgiving, and instead uses the dynamic edges of the light source, which are much gentler and softer. Second, feathering creates a sense of depth as the effect of turning the light

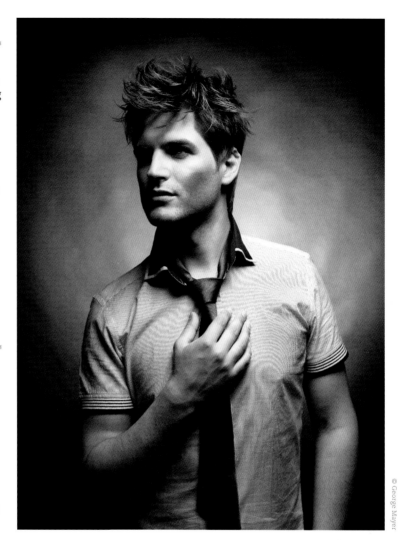

© George Mayer

source away from the subject creates brilliant specular highlights within the highlight areas as light glances off the contours and textures.

Feathering is also a useful technique for group shots, particularly when you have only a single light. Placing a light to one side of the camera means that the subjects in the line closest to it are brightly lit, while those further away are in relative darkness (due to the inverse square law of light fall off). However, by feathering the light toward the far end of the line, the nearest

↑ Drawing attention to the subject
Background lights are used to create separation between background and subject, adding another layer of depth and dimensionality. They can be used to create simple, evenly lit backgrounds of different colors, or fitted with a variety of light shapers and modifiers to create different shapes, sizes and patches of light.

subjects receive a softer, less intense light from the edges of the light, while those furthest away are lit equally—although they are still the same distance away, the light is now pointing directly at them, balancing the exposure across the group.

Vary the Proportions

Varying the position, size, and output of your lights allows you to fine-tune your lighting setup and create a broad spectrum of looks and styles with relatively little equipment. But it is the relationship between each light that makes the difference, rather than an absolute effect. The relationship that has the largest impact on the look and feel of a portrait is the ratio between the key light and the fill light, known simply as the lighting ratio. The difference between these two lights dictates whether the subject is evenly lit or lit with strong contrast between highlights and shadow areas. A ratio of 1:1 means that the key light is set to the same output as the fill light (although neither would be a key or fill in this sense). A ratio of

2:1 means that the key light is twice as bright as the fill light, 3:1 that the key light is three times brighter, and so on. Because we know that each f-stop equates to a doubling of light intensity, a ratio of 2:1 can be achieved by setting the key light one f-stop brighter than the fill light, while setting the key light two f-stops brighter than the fill light equates to a 3:1 ratio, and so on. In practice, most portraiture is shot with a lighting ratio of between 2:1 and 3:1, and can be fine-tuned in 1/3-stop increments.

For this challenge, decide whether to create an evenly lit portrait, a portrait with high contrast between light and shadow, or something in between.

→ **Striking a balance**
This 1:1 ratio lighting setup creates its sense of drama by placement—the lights are on opposite sides of the subject, such that a darker line is created running down the center of the face. Certainly an atypical setup, but the reason it works is because there is just enough detail in the left eye capture to preserve the sense of identity in the face.

Challenge

Challenge Checklist

→ Think about which lighting ratio is likely to help you to achieve the look you want. Do you want it evenly lit or with deep contrast?

→ Remember that moving the lights nearer and further away also alters the light's intensity (as does changing the power output).

→ Also consider how altering the proportions of the background and hair lights affect the mood of the portrait.

→ Asymmetric light

The lighting ratio between the key light and fill light dictates the overriding look of the portrait, a ratio of between 2:1 and 3:1 is common in portraiture (the latter being used in this shot) as it provides directional light from the key with retained shadow detail from the fill.

© Subbotina Anna

Review

© Mikko Palosaari

Here I used a speed light with a 32-inch (80cm) octabox from above, another one with a 12-inch (30cm) beauty dish from below, and one from camera left and behind bare as a kicker. The vignetting of the background was done in post-production.
Mikko Palosaari

Professionally and carefully lit, with admirable restraint in the balance you allowed to the low fill-light and the kicker. Both support the main light and don't fight for attention. The vignetting also is a sound choice to concentrate the viewer's attention (at first I'd assumed you used a softly focused background light aimed at a seamless).
Michael Freeman

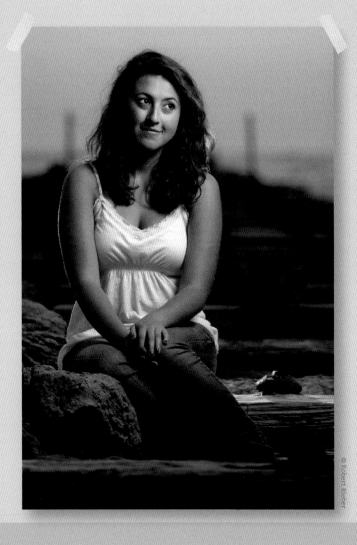

This is a simple light scheme: one shoot-through umbrella for main light, and one bare light behind the subject for a hair-light. I also put a full CTO gel on the main light and compensated my white balance to make the subject look natural, pushing the background to a deep blue in the process. As the sun set I kept shooting and adjusting my shutter speed, eventually ending up with this shot shortly after sunset, the perfect balance of ambient and artificial light.

Robert Bieber

This shot demonstrates how much the lighting balance is ultimately a matter of taste, as you clearly understand the variables. I'm assuming you were going for a theatrical look by keeping the balance high in favor of the flash, and using a CTO for contrast with the blue evening light.

Michael Freeman

Metering & Exposure

One of the most fundamental requirements in photography is the ability to measure the intensity of light within a scene and set the camera's exposure settings—ISO, aperture and shutter speed—in the combination that gives us the exposure we want. Note that there is no necessarily correct exposure for any scene, as we will interpret it slightly differently. While the through-the-lens (TTL) metering systems that control most of today's cameras are very sophisticated, they are not a silver bullet and, as we evolve as photographers, the exposure readings they provide should only be used as a guide to our own experience and expertise of reading the light, and our knowledge of the limitations of TTL systems.

There are two broad ways to measure the intensity of light within a scene; reflective, whereby the camera is pointed at a scene and the TTL system measures the amount of reflected light bouncing off all the surfaces in the scene to calculate the exposure; or incident, which requires a handheld light meter to be placed within the scene in order to measure the amount of light hitting the subject. There are pros and cons to each method, which is why we need to develop our own feel for light as photographers in order to compensate for the limitations of both TTL systems and light meters. In the case of a TTL system, the main issue is that it measures reflected light. This can give slightly misleading results as the numerous surfaces in any scene are likely to reflect light to a greater or lesser degree.

Another issue is that TTL systems are designed to calculate the exposure for a scene based on an average exposure, commonly 18% gray. After extensive analysis, camera manufacturers found that calibrating the metering system to 18% gray equated to the average exposure across thousands of images. This means that in a bright scene, the camera's metering system will err toward 18% gray, i.e. will underexpose it, while for a dark scene it will slightly overexpose it (to 18% gray, not dark gray or black).

Whether using an automatic setting—such as Auto, Aperture Priority, Shutter Priority, and so on—or Manual to derive the exposure, it is possible for us to compensate for these limitations by dialing in exposure compensation. So, for example, if we have a very bright scene in front of us—such as a pale model, with blond hair wearing white clothes—we know that the TTL system's exposure calculation will err toward 18% gray, i.e. will underexpose the scene as we see it. Therefore, we need to dial in around one to two f-stops of overexposure in order to get the camera to record the scene as it should be. Conversely, for a dark-skinned model, with black hair at night, we would need to add one to two f-stops of underexposure. Hence, we need to be continually learning about exposure, and honing our ability to read the light.

A handheld light meter on the other hand is more accurate as a metering tool because it measures the light falling on the subject, regardless of the reflectivity of the objects in the scene. However, it cannot be placed near a distant subject such as an outdoor scenic background (although most have an integrated incident spot meter function), and it too calculates exposure readings based on an 18% gray average. Even when it comes to exposure, therefore, we can see that it is not an absolute value, and there is ample room for us to add our own interpretation, within reason, to what the correct exposure for any scene should be.

Setting Exposure

Another challenge is that any single scene is likely to comprise of a number of elements, each requiring a different exposure value. For example, metering for the blond hair of our subject will give a very different exposure setting than if we meter from the black shirt they are wearing. So how do we derive a correct exposure and where do we meter from?

As we have touched upon earlier, one of the most important aspects to get right in portraiture is skin tone, as any inaccuracy in this will appear unnatural in the end result. Using a TTL system in spot metering mode, therefore, we can aim the camera at a point just under the eye, on the cheek, of the subject, which will give us the right balance of exposure for the skin, as well as for the eyes—even better, take a number of readings across the same patch of skin and average them to even out any wide variations.

Positioning a handheld meter is simpler, as it is not measuring reflected light, so instead it is placed in front of the subject's face with its white-plastic-dome-covered meter pointing back at the camera.

One of the most consistent ways of measuring exposure for a TTL system, however, is to use an 18% gray card from which to meter. By placing the gray card in the same part of the scene (and lighting) as the subject—or simply ask the subject to hold the card in front of them—we can get a reliable exposure that is also matched to the camera's 18% gray metering technology. With all of these methods, however, we will still need exposure compensation applied depending on subject brightness.

Applying the right level of exposure compensation is a skill that photographers continue to develop throughout their careers. However, as a general rule of thumb a very pale Caucasian skin tone requires around 1-2 f-stops of overexposure compensation, while Afro-Caribbean skin requires 1.5-2 f-stops of underexposure, with a spectrum of values in between.

Outdoor portraits bring their own exposure challenges, with bright sky, dense background shadows, and so on. While we should aim to overcome these challenges using photographic light and other techniques described throughout this book, if in doubt the premise remains the same; expose for the patch of skin under the eye of the subject. If this is right, then blown-out highlights in the sky, for example, might be something that we can live with, but a portrait whereby the sky is perfectly exposed, but the subject is in deep shadow is useless.

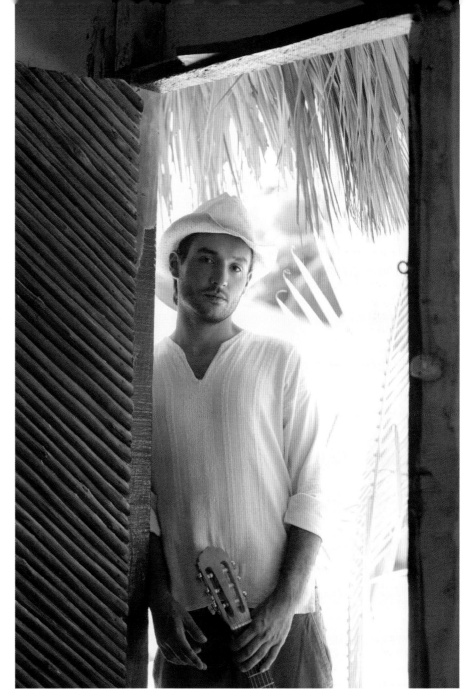

© Blend Images

↑ **Less-than-ideal conditions**

Challenging exposure situations can sometimes add an element of interest in themselves. For instance, this shot is completely overexposed in the exterior sunlit areas, as was necessary to properly expose the man's face and body (spot metering was used). But rather than be a haphazard shot, the luminance spilling over his shoulders and arm make this more than just a snapshot.

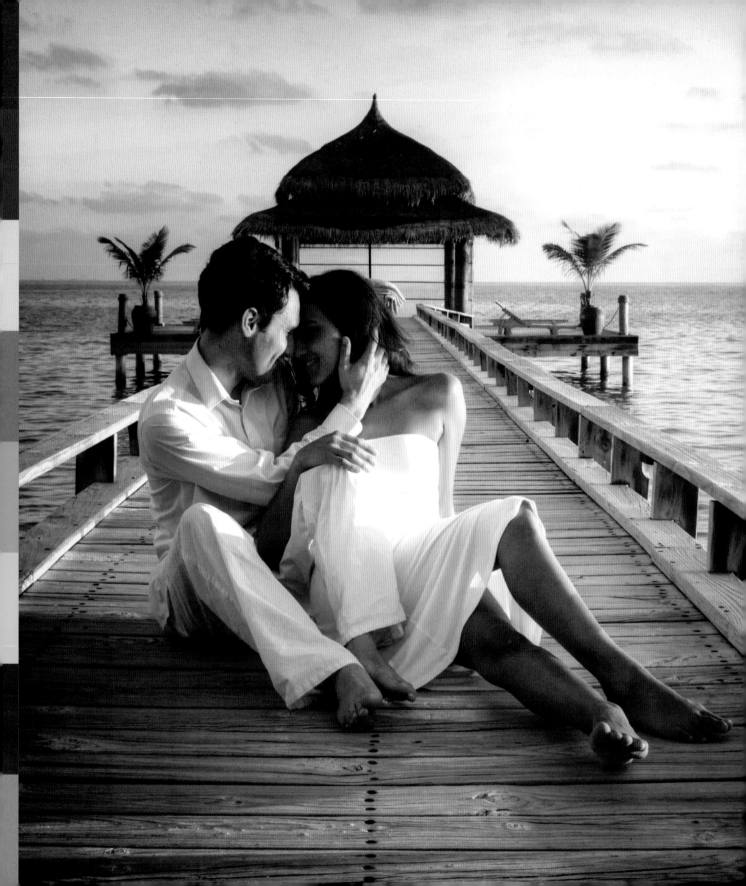

The Setting

The location or setting that we use for a portrait will affect how the subject is portrayed and viewed. Setting can be used to draw attention to the subject, to tell the viewer something about the subject (such as their personality, favorite location or lifestyle), or to generate narrative. They can be minimal, cluttered, outdoor, in the studio, real or created, colorful, dour, and so on. When choosing a setting for a portrait it is vital, therefore, that we first consider what it is we want to say about the subject and how the setting will impact that.

Broadly speaking, portraits can be out of situation (a plain, white background in a studio, for example), contextual, or environmental (in a specific location to tell the viewer something about the subject and their lifestyle), or narrative (real or imagined). An out-of-situation portrait will tend to focus the viewer's attention onto the subject and their physical appearance, while a specific setting (which could be created in a studio) or a location might be used to suggest certain things about the person, their age, status, mood, personality, place of work, and so on.

Neutral Backgrounds

The main focal point of every portrait is, of course, the subject. Every aspect of any portrait—the lighting, the background, the setting, and so on—should have the sole aim of training the viewer's attention onto the model. Getting the background wrong can be one of the most distracting elements in any portrait, pulling the viewer's gaze away from the main subject and out into the distance, so it is vital to get it right. One of the simplest ways to create a neutral background is in the studio using plain walls or backdrops (made of paper or material) that are either devoid of distracting elements, or which somehow enhance and complement the tones of the subject.

Black & White

In the studio, creating a neutral background is a relatively easy task. The simplest neutral background possible is a plain white backdrop, which could be achieved by using a white studio wall, or one of the wide range of paper roll holders or stands for holding sheets of material available from a roster of manufacturers. Remember that, due to the limitations of TTL metering systems, a white background will appear gray (18%) unless we apply around 1.5 f-stops of overexposure to keep it white. A white backdrop provides a very pleasing, bright background and gives the image a crisp, upbeat mood.

The direct alternative, of course, is the black background, which is most effective with a sheet of velvet material draped behind the subject, as this absorbs more light than other materials. While technically neutral, a black background does lend seriousness to images and has a look and feel of its own. A black background is best used with low-key lighting and ambience.

Of course, there is a rainbow of background colors between the two extremes. Choosing one for the background needs more thought than a white background, as the color must complement or enhance the skin tones, hair color, eye color, and clothes of the subject, and match the mood of the portrait.

Gray backgrounds can be achieved by either using a gray paper or material backdrop, or by not applying any exposure compensation to a white background—as the camera forces white to 18% gray to gain an average meter reading. Using a gray backdrop, however,

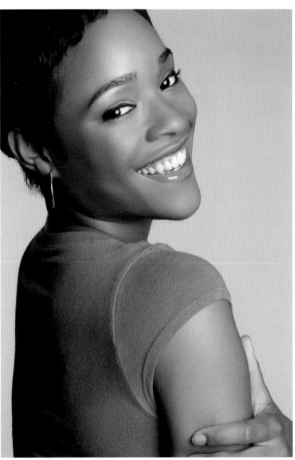

← **Neutral gray**
A gray backdrop (or a white backdrop that is judiciously underexposed) can provide a very flexible, neutral background. Standing the model close to the backdrop is currently en vogue, but beware of distracting shadows cast by the subject.

© Jason Stitt

does allow you to alter its appearance, from whiter to blacker, by altering the exposure, giving flexibility from a single background. Furthermore, adding a background light can provide shaped or colored patches of light that enhance the separation between subject and background, and provide a greater sense of depth. When creating full-length portraits, convention is to use a curved background, which gives a sense of infinity, as there are no edges in the scene.

Colors

Using different colored backgrounds can be very appealing, and can help to create a variety of moods, but the color must not be strong enough to draw attention away from the subject. Muted or pastel colors in a single hue are therefore preferable—mixed colors will also draw attention to the backdrop. When using colors it is important that they do not clash with, or merge with, the skin tones (or hair color) of the subject. If they have pale skin or light hair use a darker tone of the color, and vice versa, as the idea is to create some separation between background and subject. Avoid merging the two altogether. Using a color that matches the eyes of the subject can work well. Lighting a colored background with or without exposure compensation will also have a perceptible effect on the depth of the color perceived by the camera, so overexposing the background with lighting will lighten the color, while underexposing will keep it richer.

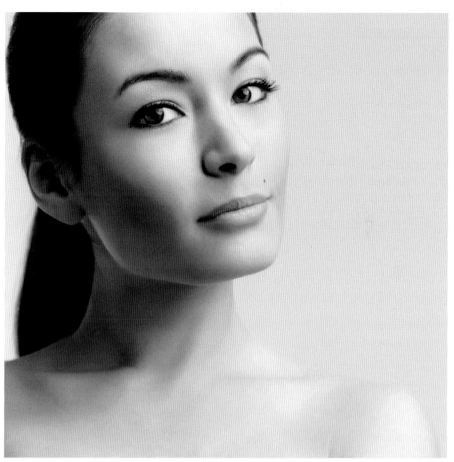

© Elena Kharichkina

Proximity

Proximity to the background can make it more distracting, as even using a small depth of field on the subject could still pick out textures and irregularities on the background. More important, the closer the subject is to the background, the more likely that the key light, and others, will create a shadow of the subject, which, of course, can be distracting. This technique is currently in vogue in fashion photography, but for keeping out unwanted distractions, such as shadows, a subject to background distance of at least 2m is desirable.

↑ Complementary pastels
Subtly colored backgrounds can create mood and vibrancy as long as the color is not strong enough to overpower the subject, or clash with their skin tone, eye color, or clothes.

A Portrait in Limbo

Challenge

A neutral background is one of the least distracting settings for a portrait, focusing all attention on the subject matter. It frees the subject from a recognized setting or location, and suggests a sense of space and freedom. In order to create a portrait in this way, we need to ensure that the background does not interfere in any way with the subject; so a plain black, white, gray or pastel-colored background is a safe bet. Keep the subject away from the background to avoid casting a shadow from the key light onto the backdrop, and ensure that for a full-length portrait the backdrop is curved where it meets the floor, as this will provide a seamless, edge-free, infinity-style background.

Gray backdrops provide great flexibility as they can provide a neutral backdrop (obviously), or be dialed brighter or darker using exposure compensation. Using differently shaped background lights can provide a central pool of light on the background, creating an almost natural vignette effect around the subject. Background lights can be fitted with colored gels or even filters that add a textured pattern to the backdrop. The challenge is simply to create a portrait in limbo with a plain backdrop devoid of distracting elements. Use the background to complement the mood or appearance of the subject.

→ **Speaking for himself**
With nothing to distract from the portrait subject, it's important that they strike a pose for some depth or interest.

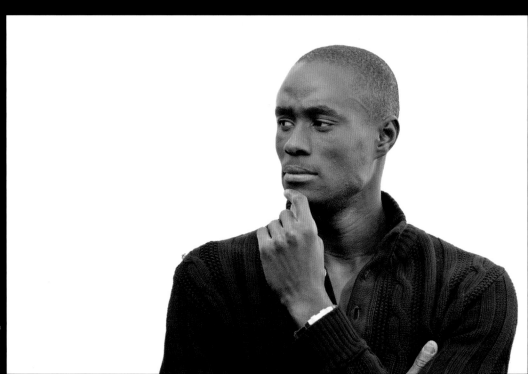

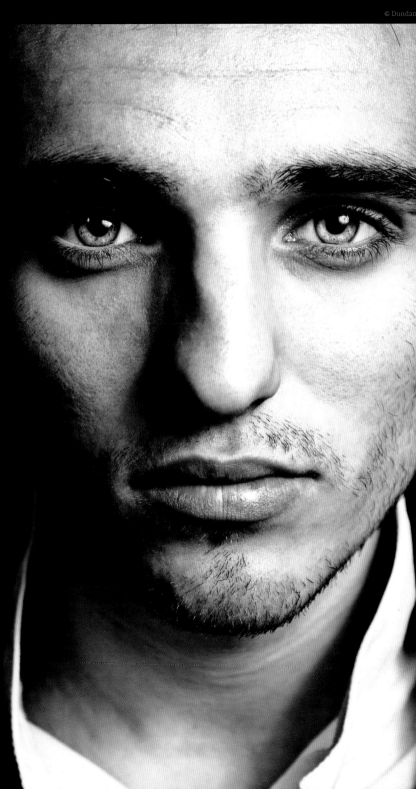

© Dundanim

Challenge Checklist

→ For a white background, remember to take account of the fact that light meter readings may need to be increased by an f-stop or two in order to maintain the whiteness and avoid it appearing gray on the final exposure.

→ If using a colored background, does it complement and enhance the subject, or does it clash with their skin tones, eye color, or clothes?

→ Is the backdrop appropriate to the mood and tone of the portrait? Using a black or gray backdrop for a fun portrait will not work, as the message will likely be muddled.

→ **Unavoidable gaze**
A black background can be very striking, but must be matched to the mood and tone of the portrait. Black suggests an air of seriousness or style.

Review

© Faith Kashefska-Lefever

For some people I love using colorful backdrops. It makes the portrait pop out and adds an interesting mood. For the setup I have one light just behind the subject at just above the waist and angled up slightly to create a lighter blue color. I have two soft boxes on each side of my camera. Both lights in front are raised up high and angled slightly down. My goal was to not have any glare in his glasses.
Faith Kashefska-Lefever

The shading of the background is well managed, and I'm curious how you choose your colors. This reminds me of the work of Thomas Ruff and the Düsseldorf school, using plain studio backdrops and a dispassionate full-frontal treatment that resembles passport photography and aims for an uninflected objectivity.
Michael Freeman

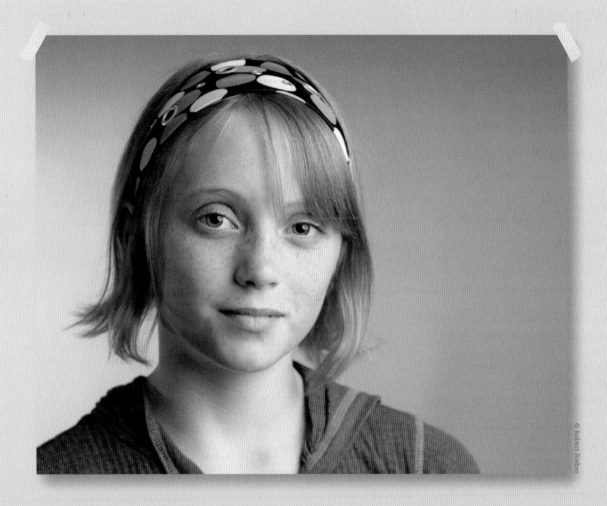

© Robert Bieber

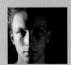

When I got my first roll of seamless backdrop paper in the mail, I asked my little sister to help me test it out, and threw together a quick simple portrait. I used a shoot-through umbrella for the main light, and a bare light to the left raking across the paper to give the background a little bit of a gradient. We shot the portrait on a covered porch, so the shade provided some nice, soft natural fill.

Robert Bieber

Gray sets off the delicate range of colors and keeps our attention firmly on the girl and her striking eyes. The seamless has been graded well with the lighting, and the angle of the gradient gives us a nice example of counter-shading, a method perfected by portrait painters.

Michael Freeman

Simple Location Settings

Finding an ideal location or setting for a portrait can be a challenge. In the studio we can control everything from subject lighting to background color, but on location you need to work that bit harder. Outdoors we cannot control the movement of people or vehicles in and out of the scene, for example, or move buildings, clutter, and other distracting elements from the background. Finding the right location and setting is essential if we are to avoid unwanted elements in the composition drawing attention away from the main focus of any portrait; the subject.

In the studio we can create the ideal setting, but outdoor shooting requires prior research to find the kind of setting or background that might work for a specific style of portrait. In practice, experienced photographers develop a database of locations that suit their needs, some of which are sufficiently varied within themselves to be used more than once for different commissions.

Examples of such localized settings might include a flower-lined woodland path, a relatively unknown structure on the outskirts of town, an unfrequented archway at the edges of the local park, a crumbling wall along a quiet lane, or simply an interesting doorway.

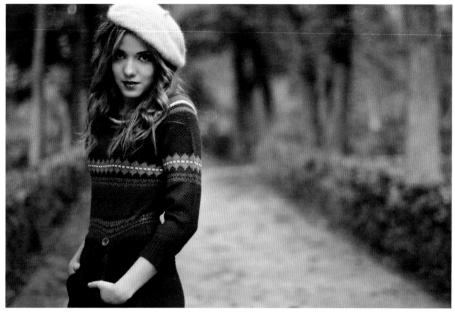

© Santiago Cornejo

Wherever it is, a useful location might include a number of factors; privacy is an important one. On any outdoor shoot, it is nigh on impossible to prevent people walking through the scene or being inquisitive. More importantly, a busy setting is likely to make the subject feel self-conscious and uncomfortable, which will adversely affect the entire portrait.

An uncluttered background is another essential ingredient for finding a good outdoor setting. In urban or residential areas, lampposts, cars, other people, and so on, are all likely to draw attention away from the main subject if we cannot remove them from the background. While setting a wide aperture can create bokeh, which will blur some of the background into a swirl of shapes and colors, it is likely that there will still be some distraction. Ideally, we are looking for something that will provide a single-color background—a white wall, leaves on the trees, a red door, and so on.

↑ **Shallow focus for a painterly effect**
With a bit of creativity, it is possible to transform even a seemingly mundane location into a great portrait setting. Trees, leaves, and greenery always provide a pleasing, simple background, with an appealing natural color. Use a wide aperture to create some out-of-focus bokeh to leave the sole attention on the subject.

Other useful locations might include a woodland path, or settings that provide simple framing opportunities, such as archways, doorways, an avenue of trees, and so on. Also remember that the time of year will make a big difference to your local setting—for example, a wooded area in autumn will look far more appealing than in winter. In open space, there may be no vertical structures to use as a backdrop or no appealing background, but even then, altering our perspective can have a significant effect. For example, shooting from high above the subject allows us to use the floor as a background, such as a lawn, a blanket, or a patch of autumn leaves. If there is nothing to stand on ask the subject to sit down. Conversely,

shooting from below can provide a dramatic perspective, with the sky as a backdrop, but consider how unflattering the angle can be to subjects in the wrong pose (ask them to look down toward the floor so that we are not looking up their nose). When shooting from low down, also be aware that the exposure difference between sky and subject will need to be corrected, usually with photographic light. A tree or wooded area will always provide wonderfully simple background and color, as well as perfect soft shady light.

The added benefit of managing a settings database is that we get to know and understand the quality of light at each location at different times of the day and year. This allows us to get the best out of a shoot at any of the locations, because we know when the best light is most likely to appear. Using the same locations also saves you time on each new shoot, and provides confidence, so you can then present yourself as a knowledgeable, efficient and professional authority to the subject. Compare that to arriving at a new location, stumbling around trying to work out the best background, composition, light, and so on, before shooting the session without really knowing what the final outcome will look like on a large screen or printed out.

→ **Turning clutter into leading lines**
With careful composition, even a cluttered or initially unappealing setting can be made to pull attention toward the subject without intruding.

Camera Techniques

Even in the absence of a simple background, we can ensure that the environment is inconspicuous and simple by employing certain techniques. One of the simplest ways to remove a cluttered background is to set a wide aperture (a small f-number, such as $f/2.8$), which melts the background into a lovely blur of abstract color and shapes—the effect known as bokeh. Bokeh is easier to achieve when using a longer focal length, and if the background is more distant from the subject; so, while a handy and simple method, it may not always be appropriate.

At wide apertures, be aware that the depth of field (the area that is in focus) will be very thin, so if shooting relatively close to the subject it may be

© Javi Indy

that, as well as throwing the background out of focus, a wide aperture throws parts of the subject's face or body out of focus too. While this can be used on facial portraits to create striking effects, it may not always be the intention. An aperture of $f/4$ is often a good balance, but will be dictated by a number of factors, including distance from subject and lens focal length. If in doubt, always ensure that the subject's eyes are in focus.

Another technique might be to employ the invisible black background or day-into-night techniques using photographic flash (described on page 92). If there is no way to avoid a cluttered or distracting setting, this technique can plunge the background into varying degrees of darkness.

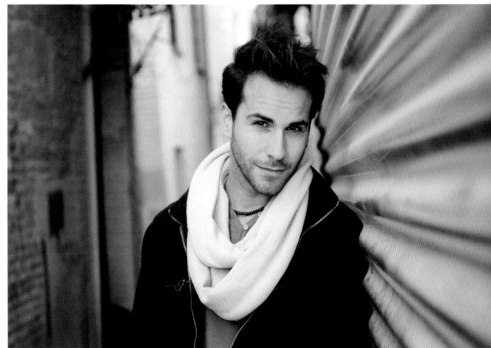

Challenge

Research a Clean Outdoor Setting

A common mistake made by portrait photographers when researching simple outdoor settings is to go for the most visually appealing local beauty spot or amazing view. However, when we want a clean, simple, or out-of-situation portrait—without any clues regarding specific time or place—the simplest setting will always be the most effective. A plain, clean background that acts merely as a canvas for the subject is ideal, anything else and we start to detract from the main subject—a background should never be more interesting than the subject, nor should it detract in any way from them.

By adding a few camera techniques, such as a wide aperture to blur the background, it is possible to find great settings for simple portraits pretty much anywhere. Get out and explore your local area with a newfound sense of observation—visit the park, explore hidden lanes, go for a walk in the local woods, etc. Think not just about the setting per se, but also what time of day the shoot will be, and therefore what direction the sun will be facing. What time of year is it, are the leaves falling? All of these factors will be significant. The challenge is to take an outdoor portrait with a clean, uncluttered background.

→ **Simple & on location**
The simplest backgrounds often make the most effective settings for portraiture, providing an element of color or texture but keeping the main focus on the subject. A doorway is a classic outdoor setting, providing a natural frame for the subject as well as adding narrative. A colored or textured wall or fence is akin to setting up a studio background and can help to create simple but striking portraits.

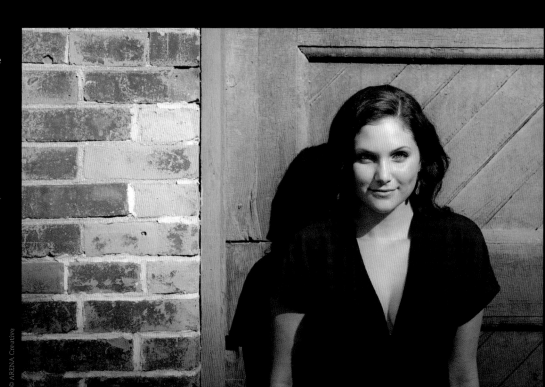

© ARENA Creative

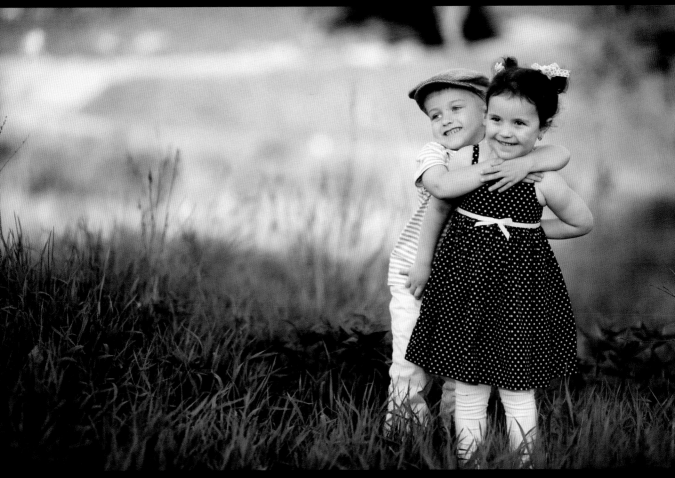

Challenge Checklist

→ Think about your local area, your back garden, your walk to school, work, or to the shops, your local cycle route, and so on. Chances are there are many more ideal portrait settings than you have ever noticed before.

→ A textured wall, a doorway, a field of corn, a line of trees, the sky, a lawn—all of these are great examples of very simple backgrounds that are uncluttered and clean, and can be found almost anywhere.

↑ **Just greens and yellows**
Experienced portrait photographers have developed a database of peaceful, uncluttered local settings and locations that can be used time and again. The advantage is that we become familiar with the nuances of light throughout the day and, indeed, the year. Different seasons can transform a local setting.

Review

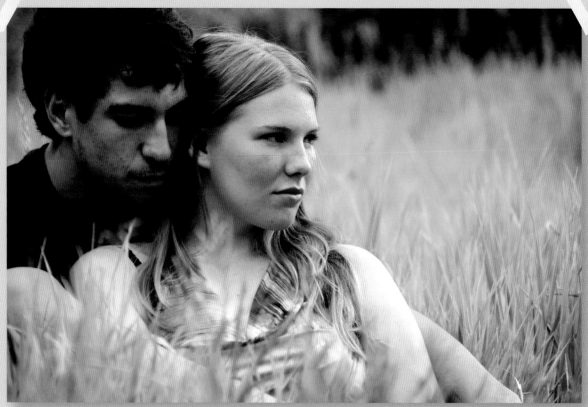

© Faith Kashefksa-Lefever

This area we found was a small little nature trail that wasn't exactly the most beautiful place, but I loved the tall unkept grass. I knew if we went near the evening the lower sunlight would make the grass shine, and help it come to life. I used a longer lens to help distort the background, and bring the focus to the couple.
Faith Kashefska-Lefever

You say it wasn't a particularly beautiful location, but you used it well, and followed one of the precepts of location finding, which is that it's what the camera will see, not what's outside the frame! The grass almost fills the frame, and it was a good choice to have some of it in soft focus in the foreground—makes it more continuous as a setting.
Michael Freeman

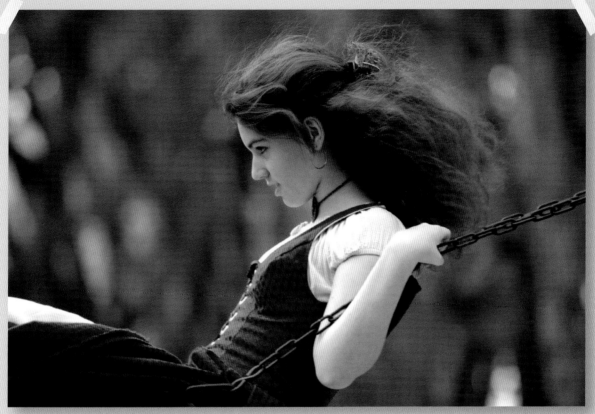

© Robert Bieber

This portrait came about on a whim, after shooting an event with some friends at a park. I had a borrowed 70-200 ƒ/2.8 lens, and decided to shoot some portraits when a friend started swinging. This one is all natural light, just the gentle shade of the canopy and a wide-open aperture to knock out the background.
Robert Bieber

I like this a lot, not just for its natural spontaneity and movement (and framing), but for the way in which you fulfilled the brief on getting a natural location. The color range of the trees in the background complements the off-reds of the girl, and there are no distracting highlights in the background. This is a classic way to use that classic lens for portraiture—at wide aperture to throw the setting out of focus.
Michael Freeman

Environmental Portraits

Environmental portraits are a stock in trade of editorial photographers, and photojournalists, who need to show people in specific locations, circumstances, or at a specific time. Environmental, contextual, or in-situation portraits are a very different proposition to those out-of-situation portraits outlined in the previous sections of this book. While simple portraits are the domain of clean, plain backgrounds and a setting that offers no clues regarding specific time or place, environmental portraits provide almost the exact opposite. The setting and background are an integral element of an environmental portrait, which inherently offers some form of narrative or mini-story regarding the subject and their personality.

Environmental or contextual portraits show people in a specific environment, location, or situation, in order to tell the viewer something about them, other than their physical appearance. It might focus on their favorite location, their place of work, their hobby, their lifestyle, and so on, but could equally convey more conceptual elements, such as their religious beliefs, their habits, social status, likes and dislikes, or skills and talents. For example, a portrait of a farmer with a focus on his hands, complete with dirty nails and minor cuts and abrasions, provides a much deeper narrative about his life and work, than would a simple portrait showing his physical appearance. An environmental portrait might

therefore include anything from a simple portrait of the subject in their favorite outdoor location (with their dogs, for example), to a study of the subject at work or play; a refuse truck driver, a ballerina, a cyclist, a gardener, almost anything. This, of course, requires much greater research and planning on your part; turning up and shooting is not an option as locations are likely to be busy, cluttered and with distracting background elements.

Planning for an environmental portrait might therefore include researching the most appropriate or appealing time of day, trying out different compositions for the image, acquiring relevant

permissions for access to specific locations, sourcing props to be used, noting equipment and lighting requirements, meeting safety regulations, and so on.

While environmental portraits bring planning challenges, on the flip side they do offer wider scope and greater freedom to experiment or create unique and eye-catching imagery. The key is to focus on the requirements for telling the story—nothing more,

↓ All about location

Environmental portraits are placed in a specific location, indoors or outdoors, and tell the viewer something about the subject, beyond their physical appearance—for example, interests and activities, or favorite location.

© Pressmaster

© Diego Cervo

nothing less. Including irrelevant details in the frame will start to introduce complicated and misleading narrative elements (of course, this technique can be employed intentionally).

The evolution of the concept is also more likely to include the subject, as it is their personality or beliefs that you are hoping to reveal—of course, developing an eye for hidden gestures, social clues, and so on is an important component of the environmental portrait photographer's repertoire. This kind of portrait usually requires less formal posing too, and can create informal, relaxed portraits, as the subject is often focused on an activity.

Equipment Requirements

Commonly, but not always, there will be a requirement to include more elements within the frame, and so a wide-angle, or standard, lens is likely to be the most useful in this situation. The subject will be smaller in the frame, so it is important to place them in a prominent position that clearly marks them out as the main focus. Important visual clues, guiding the viewer along the narrative journey, must be placed strategically, but not overemphasized. A wide-angle lens can therefore place greater emphasis on important narrative elements placed in the foreground. A longer focal length can add unusual or more flattering perspectives; don't be afraid to experiment.

↑ Ask questions, visually
Where does the subject work? What kind of work do they do? Are they successful? We spend the majority of our time at work, so an environmental portrait might try to provide clues about what the subject does.

Because the intention is to include more of the background in the image, a smaller aperture will be required, anywhere between $f/8$ and $f/16$, which in turn might require using a higher ISO—although modern DSLRs are well-equipped to handle this. Photographic lighting may also be required, although ambient lighting where possible will be much better suited to an environmental portrait. Creating the studio look will appear unnatural and may flutter the subject. If photographic light is used, ensure that it is diffused, and complements the ambient or natural light.

Capture a Sense of Place

The aim of an environmental—or *in situ*—portrait is to tell the viewer something about the subject, other than their physical appearance. It could simply reveal their place of work, hobbies or lifestyle, or provide clues about a more intangible aspect of their personality, such as their beliefs, dreams, or passions. Whatever you choose to shoot, the key to an environmental portrait is prior research; not just of the physical location, but also regarding the aim, or narrative, of the portrait. What are you trying to tell the viewer about the subject, and what do you need to include within—and, just as important, exclude from—the frame in order to portray a simple and clear message?

There are a number of factors to consider. First, the location: How is it lit? What time of day will the shoot take place, and how will that impact the lighting? In turn, this will have an impact on the lighting equipment that may be required. So you may need to think about what you want to include in the composition in order to tell the story in an unambiguous way—and what does that mean in terms of lens requirements? Are there permissions needed to shoot in that location? Creative considerations might include whether to pose the subject or go for a candid approach. Are they active or looking at the camera? Be sure to plan out your environmental portrait as much as possible.

→ **Complete the context**
Locations work best when they are incorporated into their subject—this couple's fashion dress suggests a classy night on the town, and the background supports that narrative.

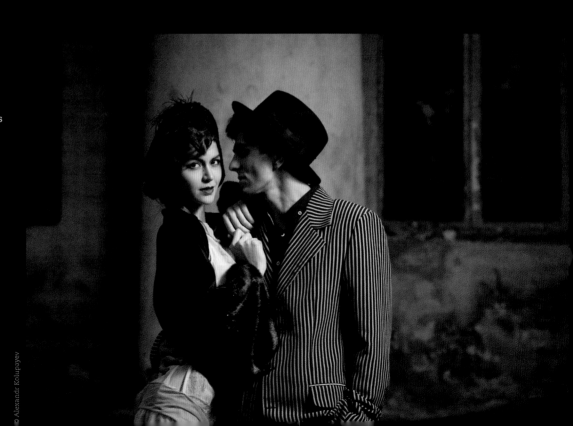

© Alexandr Kolupayev

Challenge Checklist

→ Are all the elements and props within the frame absolutely necessary in order to provide the intended narrative or visual clues?

→ If access to a location is not possible prior to the shoot, research examples of previous shoots at the same location, or similar styles of shot. The aim is not to copy these images, but rather to help you to prepare for what to expect, and to have some conceptual ideas, so that hours are not wasted at the start of the shoot thinking about what to shoot and how to achieve it.

→ What equipment will you require to portray the right message? In terms of lighting: the more natural-looking the better.

→ A musician's instrument
An environmental portrait does not necessarily need to show a specific location, it can equally show the viewer some aspect of the subject's personality, interests, or passions.

Review

© Robert Bieber

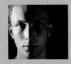

The only artificial light used is a speedlight in a shoot-through umbrella boomed out over my subject's head by an assistant. The remainder of the frame is lit by the room's natural lighting. I noticed a gap between a soundboard and a monitor, so I put a wide lens on my camera and managed to squeeze myself in on the other side of it. By shooting between the two I was able to get my desired background as well as some more detail in the foreground, fully immersing my subject in his environment.
Robert Bieber

This is the opposite approach to the image opposite—suggestive rather than all-inclusive. Shooting through like this also gives it a candid "at work" feel, and your lighting is a very good recreation of what we would expect the room's normal illumination to be. The frame within frame also works well.
Michael Freeman

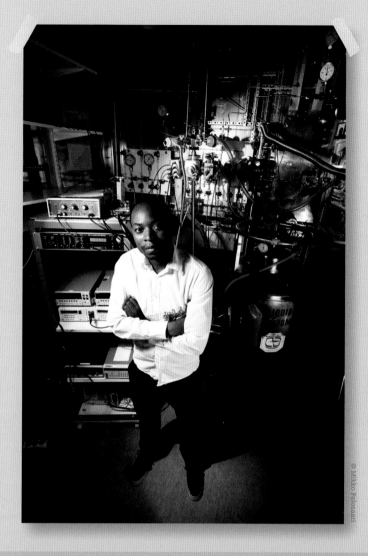

My friend got his Ph.D in nanophysics and I took this shot in a measurement room to show his profession. For lighting I used one speed light with a beauty dish on camera left and another one on camera right reflected from a umbrella.

Mikko Palosaari

Showing context in a cramped space is always a challenge, and given that you wanted to show all of the equipment, you did the right thing by gong high with a wide-angle lens. The subject is unavoidably foreshortened, but the extreme camera angle looking down mitigates this. Overall—effective.

Michael Freeman

Pairs & Groups

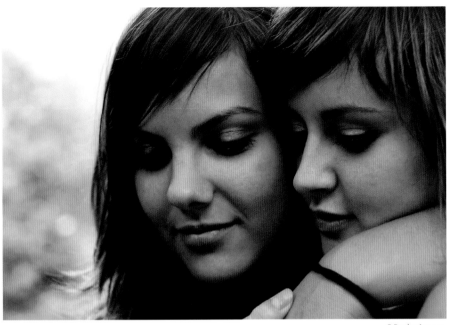

© Bogdan Ionescu

The group photo is one of the most commonly requested types of portrait—from school friends to families to parties to sports teams to weddings—it is also one of the most challenging for a portrait photographer. Invariably, one or more people are blinking, looking away from the camera, or missing altogether. At the same time, with large groups it is vital that you are able to communicate what they want effectively, and above all that they appear confident and in complete control.

Pairs of subjects are easier. The trick for pairs is to focus on the relationship and interaction between the two subjects; mother and daughter, wife and husband, father and baby, friends, colleagues, team mates, and so on, and make that the main theme of the portrait. There are some simple posing tips, too, that can help to create dynamism and drama within the frame.

Perhaps the most common mistake when shooting pairs of subjects is to stand them together at the same height, facing the camera head-on, creating a very flat and uninteresting image. Two subjects facing the camera will also look very blocky and wide. If time is of the essence, a very simple pose is to place the pair in a V-shape, so that they are both slightly turned away from the camera and toward each other. If the pair are romantically involved ask them to embrace or look at each other—it is not often that couples look directly at each other from such close range, so be ready with the camera as this may cause laughter.

For more formal portraits pose the body, arms, and hands of the pair to form flowing lines and diagonals that either create direction within the frame or lead the viewer's eyes toward the subject face. The classical rules outlined earlier in the book apply equally when posing multiple subjects. The trick is to use the relationship to dictate the pose. For example, a mother and daughter—are they best friends, elegant, serious, glamorous, or fun? Set up the pose and mood of the portrait to complement or reveal the type of relationship they have.

Another tip to create interest and drama is to place one subject nearer to the camera, with the second subject further away. This technique is often used in wedding photography as it places the bride center stage, with the groom looking longingly toward his wife. It also adds narrative, as it suggests the concept of hierarchy within a relationship.

In the same way, placing the subjects' eyes on different levels can add energy to the image, as it creates a diagonal line of interest. For example, ask one of the subjects to sit down on a bench, while the other stands, use steps to place them on different levels, or if there is a height difference standing will suffice. For child and parent, the height difference will be too much, so

ask the parent to kneel, squat or sit, but try to ensure that the parent's eye level remains slightly higher than the child's.

Group posing, meanwhile, can be a little daunting for the uninitiated photographer, but with practice comes confidence and experience in dealing with larger groups. In terms of posing, they are the same as for any other portrait; look to create pleasing lines, shapes and grouped elements within the main group. A useful and effective technique is to split large groups into smaller units based on relationship, age, size—whatever works well. Also useful in composition is a triangular shape, with most of the mass of elements at the bottom of the image— this subconsciously lends a sense of stability to the composition in the eyes of the viewer.

However, ensure that these units are kept close together. A common mistake is to create these mini-groups and then place them far apart from each other; this will create distracting space and will look unnatural. The separation of the main group into smaller units should be almost imperceptible from the viewer's perspective.

Placing people in lines is often flat and lacking in dimension; it can also be difficult to keep everyone in the frame. A circle, an oval, rows of smaller lines, layers, a horseshoe shape, almost any other configuration can work better than a line. However, it is important to ensure that the camera can see everyone in the group, and that some are not hidden behind taller subjects. So make use of nearby architectural elements. For example, steps can be a godsend with groups, as it allows you to build rows of subjects on different levels, while the steps ensure that

© Monkey Business Images

← Full of character
Parents and their children naturally exhibit their relationship, and it's largely a matter of finding a striking composition first, then simply waiting for their characters to emerge.

everyone in the group can be seen. Of course, children or shorter subjects may be arranged at the front of the group so that they are not hidden away.

Another challenge with groups is keeping everyone in the frame. Try different arrangements, but also think about shooting from above. A favorite trick of wedding photographers is to arrange the wedding group on a lawn in a circular or horseshoe shape and then either use a first-floor window or a tall stepladder to gain a higher camera perspective. Shooting from above not only creates a more unusual perspective, it also means that no one in the group will be hidden behind others.

Another trick with group photography is to shoot a lot of frames. It is odds-on that someone will be blinking, sneezing, looking away, talking, and so on, if you take a single frame. Shoot away. Do not keep people standing uncomfortably with fixed grins for hours, but shoot many many frames in quick succession and chances are that one of the frames will be perfect. The more people there are in a group, the more frames you will need to shoot in order to insure against someone looking away, sneezing, blinking, etc.

Coordinate a Group Shot

Arguably, group shots are one of the most challenging portraits for a photographer. As well as focusing on the technical and creative aspects of the shoot, you must command the attention of the group and set the pose or mood before patience or interest has disappeared. Not for nothing has posing groups been likened to herding cats, so it is essential to plan the shot by choosing the location and setting up equipment, and to appear in complete control. People do not like to be kept waiting around and will fairly quickly lose patience if you keep moving them around for a better composition, changing camera settings, or provides no direction to the group. So take control.

If posing the group in a line, be aware that the main point of interest may appear flat (in one dimension) and will also fill just a thin central portion of the frame—cropping to a panoramic format will improve the composition significantly, but only if it is the intended final format. Organizing the group into rows or layers of people can overcome this, but ensure that the camera can see everyone in the frame. If not, think about placing taller people at the back, or bringing children to the front, for example, or look for a wide flight of steps, which not only create an air of elegance, but will also mean that everyone in the different rows will be in view. Or shoot from high above for a unique perspective, and to ensure that no one is obscured from the camera.

→ **Unified subject**

Band photos are a classic group shot, and one perpetually in high demand. In such a case it's important that a certain sense of homogeneity be suggested to communicate that this is one cohesive group—in this case, it was the use of formal suits and ties. The stylized approach is what makes the linear pose of the group succeed.

© olly

Challenge Checklist

→ Using photographic lighting with groups can be tricky, as those closest to the lighting will be brightly lit, while those further away will be in relative darkness. If photographic light is required, use the feathering technique to provide even lighting across a larger area.

→ Shoot lots of frames. In the majority of group shots, there is always someone looking away, blinking, talking, and so on. Fire off four or five frames in quick succession to increase the chances of the perfect shot. At the moment of exposure, it also helps to say something that draws the attention of the crowd to you ("cheese" being the traditional choice).

→ Plan and research the shoot beforehand, so that you and your guests are aware that on the day you know exactly what you are doing and what you want to achieve. In turn, this breeds confidence.

→ Motion for energy

Static group shots are complicated enough, but nevertheless can be boring and lifeless. If you have a decent location, it's worth trying to get your group to perform an action together— even if it's as simple as running toward the camera.

Review

© Faith Kashefska-Lefever

The location, time, and the day the photo was taken was chosen specifically to capture three different aspects: the clouds that give such character and contrast, the Joshua Tree National Park, and the setting sun resting on the mountain ridge. We wanted to show off how beautiful the desert is during the sunset. Knowing that the surrounding scene was the most important part of the photograph we kept the posing relaxed and simple, just showing off their closeness as a family.

Faith Kashefska-Lefever

You've balanced the lighting well, and it's precisely timed for the sunset. Quite right about the distinctive tree silhouettes in that location, and you've arranged the tight group to fit in with them, though I would have moved in so that the family were left of center and there was no distraction from the foreground bush.

Michael Freeman

© Brittany Chretien

 This image was taken approximately ten minutes past sunrise. Despite having them positioned with their backs to the sun, I avoiding capturing just their silhouettes by leaving my aperture at *f*/1.4 and shutter speed at 1/60 second.
Brittany Chretien

 The group's arrangement, which is the main part of this exercise, is effective in filling the frame; and I like the way you have the people overlapping each other slightly, and that you shot from a similar crouching position. The only slight jarring note is the out-of-frame gaze of the left person, while everyone else is looking to camera. You could lessen the extreme flare (if you wished) during processing by setting the black point.
Michael Freeman

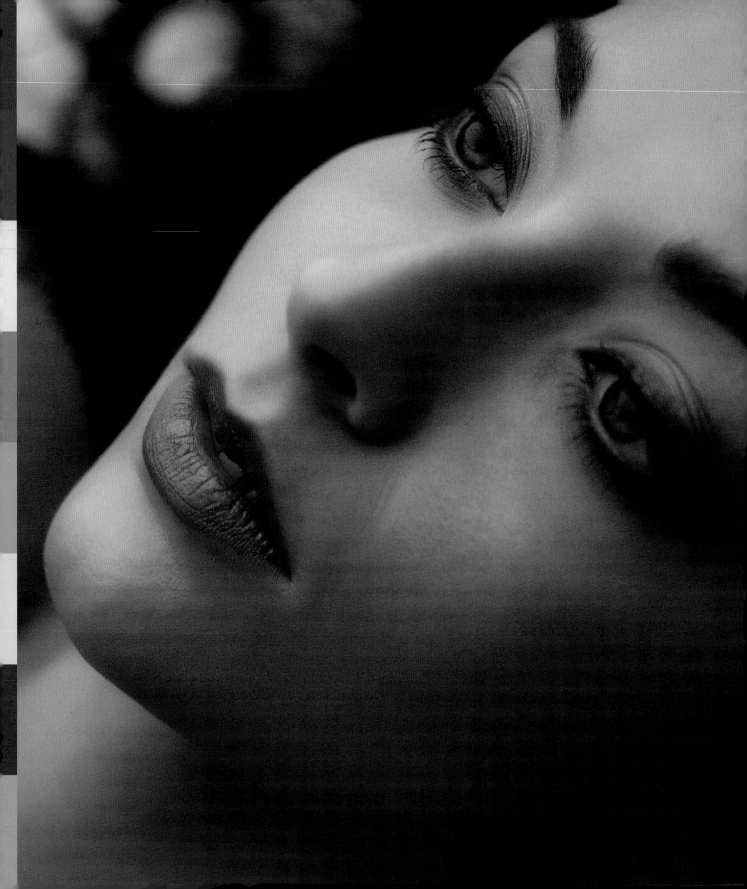

& Retouching

Removing blemishes, minimizing red cheeks, enhancing cheekbones, thinning hips, whitening teeth and eyes in a natural way is often considered an essential part of the entire portrait experience; clients usually want to look the best they possibly can in the final outcome. However, there are ethical issues to navigate. When people talk about retouching, the most common image is one of high-fashion magazines and their cover models sporting impossibly perfect bodies, amazing skin complexion, and whiter than white eyes and teeth. Rightly so, there is an ethical backlash against over-the-top, unrealistic retouching, especially when it is likely to affect the self-image of young girls and boys, who wonder why they fail to match up to these unrealistic images.

However, when performed as an enhancing technique, the judicious use of processing and retouching techniques can significantly improve a portrait. Indeed, very few portraits today will not have had some form of processing or retouching applied in order to enhance or improve them. So love it or loathe it, the majority of portrait photographers will at some time be asked by clients to retouch a portrait, so it is an essential skill to master. Only as individuals can we decide how far to take the process, but for the vast majority of instances, a natural enhancement will be a happy medium for all parties.

Accurate Skin Tones

Achieving accurate skin tones can elevate portraits from the average. Today's clients are also very sophisticated in terms of what they expect, having being fed a diet of impossibly perfect images of models on a daily basis, in magazines, on television and film. So getting the skin tone right is an essential component of portrait photography.

The CMYK Technique

As with many aspects of photography, there are numerous techniques used to achieve the same end result; each photographer will find their own preferred way of doing things. One of the simplest ways to achieve skin tone is to use the Eyedropper tool in many software packages to analyze the CMYK (cyan, magenta, yellow, and black) proportions. By touching a mid-level area of the skin, such as forehead and cheek, the eyedropper will show the relative proportions of each color on that spot. These can then be altered according to preset CMYK proportions for different types of skin; these presets or formulas can be found on the internet and web forums, or are the result of years of experience of each photographer. For example, if we have an Asian model and we use the Eyedropper tool to find the CMYK proportions, we might see that the skin contains too much blue and not enough yellow (the two colors are opposite), according to the preset levels we are aiming for. We can then use levels, curves, channels, color balance, or any other method of altering color to

achieve the predetermined skin tone appropriate for a specific type of skin. This can equally be used in RGB mode, but CMYK is considered to be more suitable for processing skin tones.

Gretag Macbeth Card

A more reliable method is to use a gray card or a Gretag Macbeth card, which is an industry standard rectangular plastic card containing numerous swatches of color, including white, gray, and black (for setting exposure and white balance), and a range of landscape colors (such as greens and blues), as well as a range of common skin tones. The cards are available with 24 or 140 color swatches, with the latter containing 14 different skin tones for evaluating images. The swatches are printed under highly monitored

conditions, and so are extremely accurate. The card works because the supplied, associated software knows what color each swatch should be, so by analyzing the swatches under a specific shooting condition, the software can correct the colors and exposure according to the know values of the color swatches.

Like a gray card, the Macbeth needs to be shot in an image under the same lighting as the model will be shot, and preferably in the same position (ask the model to hold the card up for a shot). Only one shot containing the card is required as the settings can be applied in the processing software across all the other images taken under the same lighting conditions (if the light or anything else changes, the card needs to be shot again, and the settings for the new conditions applied).

The processing software that comes with the card then creates an ICC profile for your camera under those

© Susilk1983

← Tools for consistency
Professional skin tone workflow starts by shooting a color target like this Gretag Macbeth card—but you must continue your color management by working on a properly calibrated screen, and printing on a calibrated printer.

specific lighting conditions. An ICC profile contains all the information about how your camera sensor sees and reads color—every single camera and lens will have slight variations, with large variations between different camera brands. By setting up an ICC profile, the images out of the camera are then calibrated and corrected against the profile (which is based on the swatches on the Macbeth card), and so you know that the colors are accurate. However, more advanced users might only use this as a starting point. While skin tones need to look natural, often a warmer feel to the image is more appealing, so experienced photographers can then tweak the ICC profile to give a warmer, richer, more saturated feel to their portraits—this, too, can be saved as a separate profile and applied to future portraits taken under similar lighting conditions (although professional and commercial photographers will create a new set of ICC profiles for each shoot to ensure accuracy and consistency).

 Diversity of skin tone

Skin tone is as much a part of the personality of a portrait as the subject eyes, mouth, or expression, and it's essential to be able to accurately capture it.

© Ervin Usman

© Oknoart

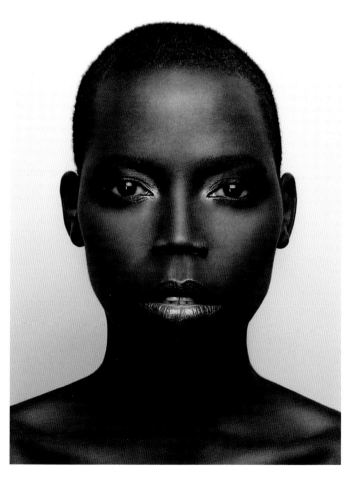

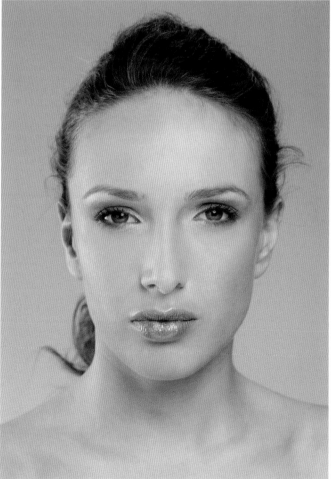

Skin-Tone Workflow

For this challenge, you will need to combine many of the tips and techniques outlined so far in this book, including lighting, posing, exposure, light modification, and so on. One of the best ways to achieve consistent and accurate results is to apply the same working methodology, process, or workflow to every shoot. By doing the same things every time, it reduces the likelihood of making silly mistakes, such as forgetting to check something, neglecting to take a reading, and so on. Developing a skin-tone workflow will help to ensure that a photographer's portraits are not only accurate in terms of color, but also have a consistent, signature look and feel, which helps to differentiate your work in a crowded market.

Using a Gretag Macbeth card for every shoot—and indeed every different lighting condition—to create a unique camera profile means that results will be accurate, natural, and reproducible. The ability to product consistent results under different circumstances is arguably what makes the difference between an experienced photographer and a novice. Creating a workflow process that we repeat every time we shoot minimizes the chances of mistakes, breeds confidence, and creates reproducible results. Create a workflow for skin tone using a Gretag Macbeth color card to create a unique ICC profile for a portrait.

→ **Delicate tones**
Getting a tried-and-tested routine or skin-tone workflow provides a platform for consistency and reproducibility across different lighting conditions and with new subjects.

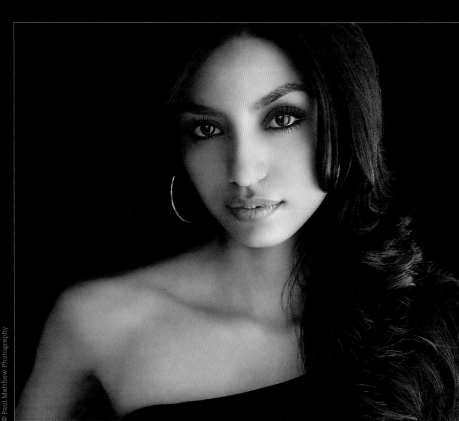

© Paul Matthew Photography

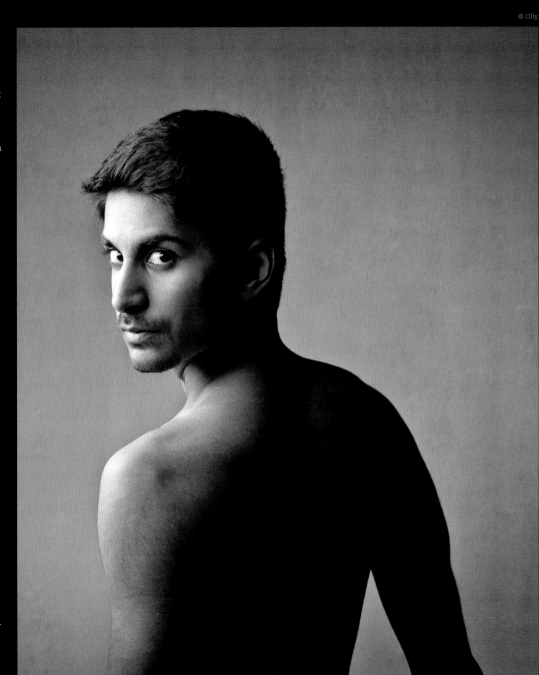

Challenge Checklist

→ Compare the final portrait by viewing it under the original or default profile and then against the unique ICC profile—which gives the best skin tone results?

→ Make a note of the steps you take for future reference—even if you adjust them later, it's wise to start familiarizing yourself with the steps involved so that they rapidly become second nature.

→ Light to dark

Keep in mind that your skin-tone workflow works in conjunction with your lighting and exposure setups—especially when you are going for a dramatic, contrasty look.

Review

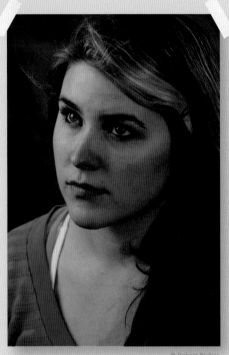

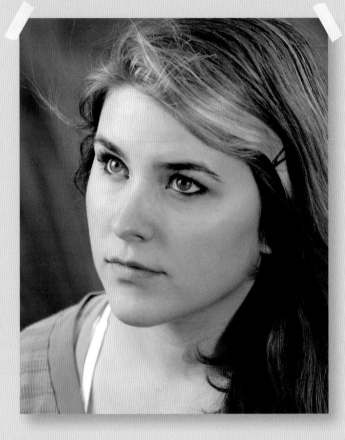

© Robert Bieber

I shot this under a thick canopy, so the ambient light was very soft. The left side of her face I lit with a speedlight through a shoot-through umbrella, and I put a CTO filter on the light to create a color gradient between the orange key light and the more blue-ish ambient. My camera's auto white balance turned the whole thing a deep blue out of camera, but by adjusting the white balance during RAW conversion, using the subject's shirt as a rough guide, I was able to create a more natural skin tone.
Robert Bieber

Just goes to show the paramount importance of shooting Raw! Shooting under shade frequently fools Auto WB systems, and this much of a color cast would have been a mess if you were working with a JPEG. I'm assuming the white balance was set off the small strand of white cloth on the subject's right shoulder.
Michael Freeman

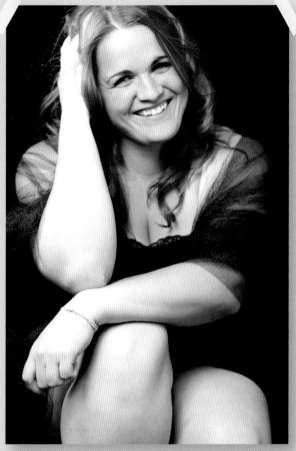
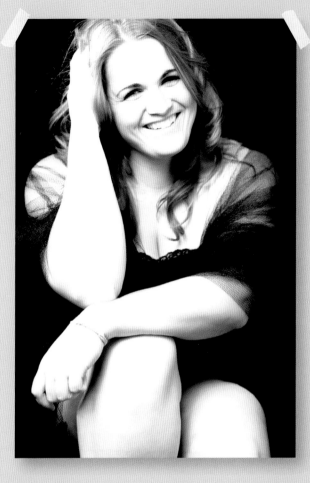

© Faith Kashefska-Lefever

I really like to light and pose my subjects in a flattering manner, so I save myself from doing to much post work. With this photo, I had her in a sitting pose that slimmed her down, and used a soft box just to the left of the camera. Because of her pose I didn't need to take anything away, and only had to focus her skin. She has great skin but for my taste the tone too pink. When I changed it to black and white, and did some curves adjustments, the image really started to shine.

Faith Kashefska-Lefever

Indeed, B&W conversion is often a wise choice for dealing with difficult skin tones. The final B&W shot has a graphic quality that makes it timeless. However, in going for a high-contrast look, the highlights along the subject's right arm, however, is quite blown out, and might benefit from the recovery slider.

Michael Freeman

Smoothing Techniques

Even if skin tone is accurate and natural, there are still further techniques that we can use to make the subject look their very best. Smoothing out skin complexion, removing wrinkles, skin blemishes, marks and spots, and whitening eyes and teeth can add a professional quality to a portrait. Again, there are numerous software packages and, indeed, techniques for creating the desired effect. In practice, there is no right or wrong way; rather, photographers will dip in and out of numerous techniques in order to get the image looking as good as possible.

One of the easiest ways to remove wrinkles and skin imperfections or body marks is to use the Clone or Healing Brush in Photoshop or similar software package. At 100% magnification or more, choose a blemish-free or clear patch of skin elsewhere on the face or body—of similar brightness and color to the area that we will be cloning to or healing— and set that as the source by pressing Alt and clicking on the mouse. The area to be retouched can then be clicked and the tool will fill it with smooth skin from the source area.

Experiment to find a realistic look by alternating between Clone and Heal, and by altering the Opacity of the brush—setting Opacity to, say, 40% will give a much more subtle Clone or Healing effect than at 100% Opacity. By working slowly, carefully and methodically, the results can be surprisingly good when the portrait is then viewed at normal size. The brush

size can also be controlled precisely to ensure that any changes are made exactly where they are wanted and do not overflow onto surrounding areas of the skin. The Softness and Hardness of the brush can also be manipulated. This alters the hardness of the edges of the brush, so at 100% Hardness, there will be a distinct circle coinciding with the size of the brush, showing the difference between the cloned area and the source area. Instead, opt for a softer brush so that the boundaries between the cloned and source areas are soft and fuzzy, and so not visible.

An important note is to perform any retouching on a Duplicate Layer, which as the name suggests, duplicates the original image, or layer—meaning that we can return to the original if something goes wrong. An even better technique is to employ layers with masks. By working on a new layer, it means that any alterations made to the original (layer) can be erased or, more importantly, that we can make an alteration (such as cloning skin, or Levels, or Color Saturation) without affecting the original and we can also control the level of this alteration. So instead of going back and reducing color saturation, for example, if it is on a layer we can simply lower the Opacity of the layer and reduce the effect of the change.

A mask adds a further level of flexibility in that we can make an alteration on a new layer (without touching the original image), and then we can alter where that change occurs by creating a mask using a Brush, Channels,

Selective Color or other tool. A mask essentially asks like a stencil, allowing you to control exactly where on the image any alteration is made. So we can, for example, decrease the level of red in the image (to remove red cheeks), but by using a mask we can ensure that the red is reduced only on the skin, while the lips, eyelids, clothes, and so on, are completely unaffected. Layers and masks are extremely powerful tools.

Another way of smoothing skin might be to add a Blur mask, which would ensure that the skin is blurred slightly, to give a smooth, shiny look, while the eyes, hair, lips, nose, teeth, and so on, are left suitably sharp. Add Gaussian blur to a new layer, which will blur the entire image. Add a layer mask and draw the blur effect only onto the desired areas. Once completed, altering the Opacity of the layer mask allows us to reduce or increase the effect.

Look Closer

For most retouching techniques, the best way to make any alteration is close up, or zoomed in, so for processing and retouching work it is common to work at 100%-plus magnification on images. This way, we can make alterations at a micro level that are not visible at a macro level, or when the image is viewed at intended size—only rarely will portraits be printed or viewed at full size, in which case specialist equipment would be required.

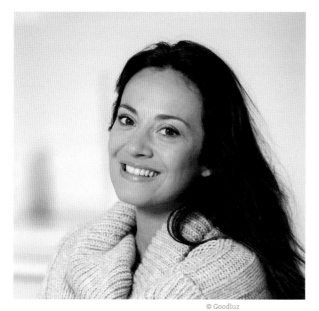
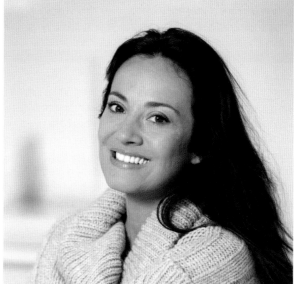

© Goodluz

↑↑ **Magnified view**
After first copying the background layer, and viewing the original at 100% magnification, it's clear that this portrait could use the removal of just a few wrinkles and blemishes.

↑↑ **Smoothed skin**
Spot healing for the blemishes, and clone tool makes short work of the wrinkles. Additionally, a local adjustment of desaturation and a boost in exposure removes the slight yellow tint to the teeth. Finally, a global Gaussian filter of just a few pixels is added to smooth out the overall skin texture.

Whitening Teeth & Eyes

Whitening teeth and eyes is usually a good idea for most portraits, as they suggest youth, health, and attractiveness. Focusing on the skin tone and warmth of the overall portrait can sometimes also add a yellow tinge to the teeth and eyes. Whitening them both is a fairly straightforward technique. Again, using a mask of some sort to select the teeth and applying the effect only to the selected area (also using Feather to remove any hard boundaries between the selected area and non-selected area), it is possible to reduce the amount of yellow in the teeth using the Selective Color tool or Saturation—equally, we can brighten them. Cloning can help to remove any gaps in the teeth, such as chips or broken teeth, if necessary. Simply select an area of tooth that is similar to the one to be reconstructed and start cloning until gaps have been closed or entire teeth rebuilt.

Selecting and applying a mask to the whites of the eyes has the same effect, although in this case we may want to reduce the amount of red in the area, rather than yellow. With all of these alterations, try not to overdo the effect, keep it looking natural and believable, unless otherwise asked. It is also possible to select the iris of the eyes and apply strong contrast using Curves to really boost the patterns and colors. This effect can be striking.

Retouching Workflow

There's no avoiding the fact that retouching is often a tedious and painstaking job. While the results are almost always worth the effort, there's no avoiding that retouching is a painstaking task. The key is to not waste any time; you must visualize exactly what you want to achieve in each portrait, and set about reaching that goal using only the best, most efficient tools.

Fortunately, steamlined workflow software like Aperture and Lightroom include the basic retouching tools in their toolset—except the Clone tool is called Spot Removal. For the more advanced techniques, you will often need to work with Layers, and that means Photoshop. But it's worth exploring what you can achieve with the tools available, before exporting to a more intensive program.

For instance, dodge and burn isn't a dedicated retouching tool per se, but it's incredibly useful for toning down a slight glare off a shiny forehead, or brightening up the shadows inside wrinkles until they no longer distract from the overall portrait. Again, the name is different in Lightroom (it's

simply a matter of using the Adjustment Brush with either negative or positive values in the Exposure slider), but the end effect is the same.

The Adjustment Brush also lets you make negative Clarity adjustments (in effect, decreasing the microcontrast of the midtones) to small, local areas, such as the creases around the eyes or mouth, that deemphasize unflattering areas without the risk of things appearing too plastic and lifeless.

And remember that while workflow programs like Lightroom don't include layers as a feature, they do keep track of every adjustment in the History panel, so you can always take a step back, revert to the original, or call up a side-by-side comparison to give you a point of reference.

Filters & Plugins

There exist a wide variety of dedicated portraiture software that can be used as a standalone product, or as a component of Photoshop, Lightroom, Aperture, etc. The most basic types are simply arrays of presets, usually manipulating the color sliders to achieve skin tones that aren't too red or ruddy. Some of these even attempt to emulate classic films that reproduced exceptionally high-quality skin tones, such as Kodak Portra.

It's outside the bounds of this book to catalog each and every piece of software, but some of the best and most popular include Snapseed and Color Efex Pro (both by Nik), and Portrait Professional.

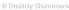
© Dmitriy Shironosov

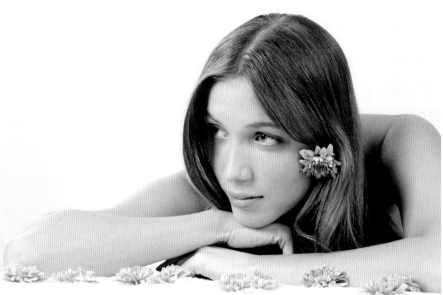

→ Brighten up
While blemish-free, the skin in the original shot was ruddy and uneven. The quickest solution was simply to selectively brighten the face and arm, and effectively lift the subject out of the troublesome tonality.

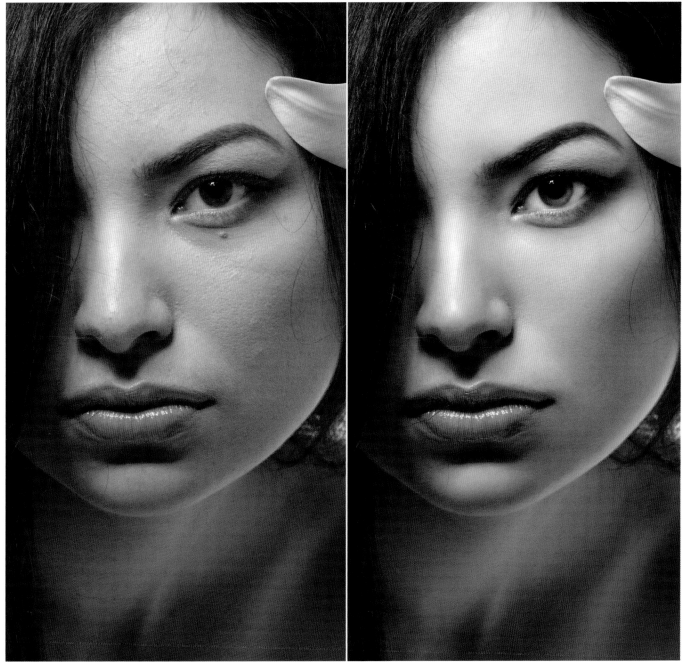

© Vita Khorzhevska

↑ Less work than you think

On close inspection, you can see that very little local-area blemish removal had to be done to achieve this final shot. Rather, much of it was delicate use of smoothing and blurring techniques, which were global and therefore much faster to carry out.

A Perfect Finish

Like accurate skin tone, a perfect complexion elevates a portrait. Combined with subtle teeth and eye whitening, the results can really enhance a portrait and take it to the next level. Even the world's top models may have imperfect skin complexion before the makeup artist and photographer have weaved their magic. Skin can be prone to showing stress, illness, heat, or a late night, so there will be few portraits that cannot be improved by smoothing out the skin and whitening teeth and eyes.

Using one of the techniques outlined in the previous pages—or one of your own design—produce a before-and-after portrait of a subject under the same lighting conditions, to highlight how the techniques can significantly enhance skin complexion and smoothness, and add a glean to teeth and a twinkle to the eyes. Even when keeping the effect subtle and natural, the final image should look miles better than the original when they are placed next to each other.

→ **Silky smooth skin & hair**
Great lighting and exceptional makeup skills can go a long way to creating the flawless skin that we see everyday in adverts, magazine shoots, and so on. But the majority will have undergone some form of retouching, including skin smoothing, and teeth and eye whitening.

© Subbotina Anna

Challenge Checklist

→ Keep the effect natural and subtle, otherwise the portrait will end up looking a bit of a mess.

→ Using layers and masks allows us to create effects and then only apply them to specific parts of the image. If any effect is overdone, the layer or mask can be reduced to a suitable level.

→ Try not to over-whiten teeth or eyes as this will often appear odd and unnatural.

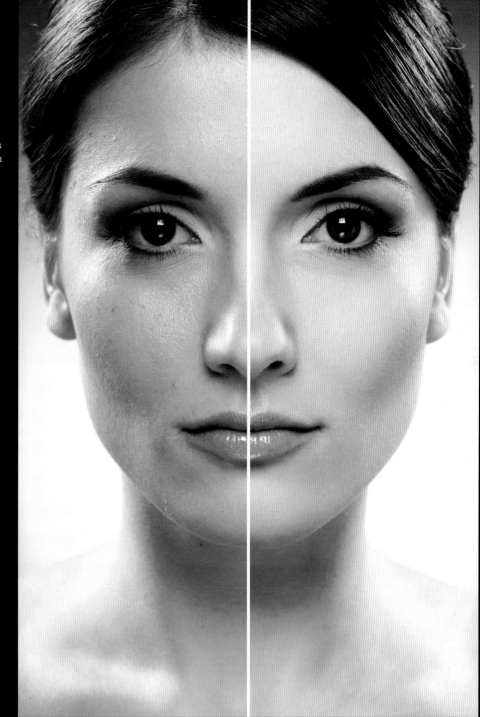

→ **Beautiful made perfect**
Here's a simple before-and-after shot that shows what can be achieved with a few retouching techniques.

Review

© Faith Kashefska-Lefever

My first step in my workflow is working with a good makeup artist—a certified one can make your workflow less of a headache. In post, I use the heal brush to take away any blemishes, spots, small hairs, and sometimes little lines. If I am lucky, I don't need to do anything else. Such was the case for this photo—she had great skin, and hardly any blemishes at all. For others, I like to use a plugin for Photoshop called Portraiture. It does a great job evening the skin tones, and smoothing the skin while still keeping some texture. Just like any plugin or action, you need to make sure you don't go over board and make the skin look like plastic.

Faith Kashefska-Lefever

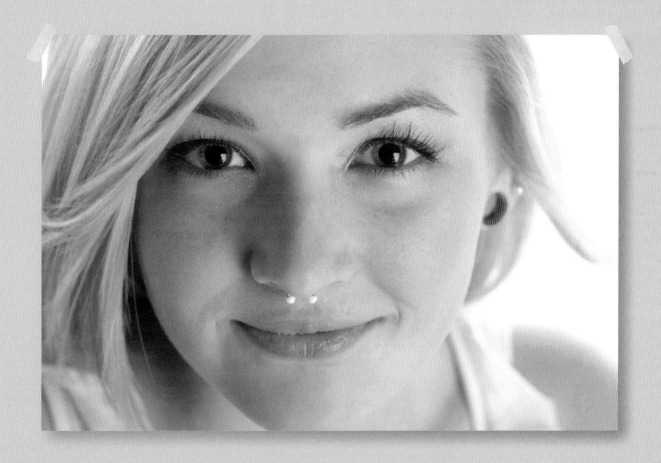

This is rather like the old "spot the difference" games in kids magazines— the original does have great tones and colors already. On close inspection (which is why these images are printed so large), you can start to see the small blemishes that have been cloned out—a spot on the cheek here, a freckle on the nose there. What's interesting is that removing these seemingly minor blemishes really does add significant impact to the final shot. Perhaps we've just had our expectations set high by all the retouching done in advertising these days, but it shows how much it pays off to spend time finishing each portrait in post.

Michael Freeman

Digital Plastic Surgery

A variety of processing techniques allow us to alter the physical appearance of our subjects to almost any degree required. Processing tools provide the ability to shape faces and bodies, to enhance or reduce body parts, and make other significant changes to physical appearance.

One of the simplest methods to enhance definition and form, and subtly control the shape of facial features, such as the nose, is known as contouring. Contouring is essentially dodging and burning for portraits, whereby sections of the image are darkened or lightened in order to enhance the areas of shadow and highlight, for example, to accentuate cheekbones, jaw lines, muscles, eyelashes, the shape of the nose, or to generally create a sense of depth and dimensionality in the image.

In the days of the darkroom, photographers would dodge and burn certain areas of the print in order to create contrast and modeling in the final outcome. Dodging and burning means either to lighten or darken, respectively, and was used to create whiter or blacker areas in black-and-white prints, and later to add brightness and darkness when processing color prints. Dodging and burning are still important components and tools in the digital darkroom today. Contouring, meanwhile, is a technique still applied by makeup artists, as it allows them to enhance and minimize certain facial features using light and shadow, and without the need for plastic surgery! Viewing the image at more than 100% magnification lets you make accurate alterations to specific parts of the image, further manipulating the areas of light and shadow that create contrast and modeling. So by adding areas of shadow through the use of the Burn tool, it is possible to accentuate a cheekbone or refine its shape. Contouring is often used to accentuate eyes and lips too, as it creates definition to their shape. Again, it is advisable to use a new layer upon which to dodge and burn. Altering the Opacity of the Dodge or Burn brushes controls the extent of their effect.

Liquify Tool

Liquify is a tool found in Photoshop's Filter menu, and which allows you to change the shape of facial and body features, simply by clicking and dragging. In this way, Liquify might be used to pull the ends of a straight mouth upward to create a smile where there was none, or to drag a waist inward or a chin upward. Liquify lets you push, pull, rotate, reflect, pucker, or bloat any feature to a subtle or drastic degree. By defining the size of the area to be moved, and using Freeze and Thaw tools (similar to using a mask), you can control the area of the image that is moved or affected. As the name suggests, a pucker might be used to pull in a subject's waist from all angles, while a bloat might be used to plump lips. The tool also allows for pushing larger areas, which might be used to suck in cheeks, reduce the size of a nose, minimize a double chin, and so on. Liquify is therefore a very powerful processing tool—be aware that it is all too easy to get unnatural results, so subtlety is the watchword when using Liquify. Use the Reconstruct command to undo an overzealous effect.

Puppet Warp

Puppet Warp is a relatively new technique introduced in Photoshop version CS5 and has a similar effect to Liquify. Puppet Warp is a precise tool for changing the shape of multi-dimensional shapes, and so can be used to lengthen legs, shrink noses, or create a smile on an unsmiling face. The tool will only work if the area of the image to be altered is first selected carefully, cut, and placed on an empty background. Once the area for work has been refined and selected, and placed on a new plain layer, the software will create a complex grid of lines that outline the shape of the cut-out image element, and present a number of pins that can be used to change the shape of the selection. So, for example, if the lips are selected, cut and placed on an empty layer background, the pins can then be used to alter the shape of the lips. Once this has been completed, the altered shape can be applied to the original image and manipulated further.

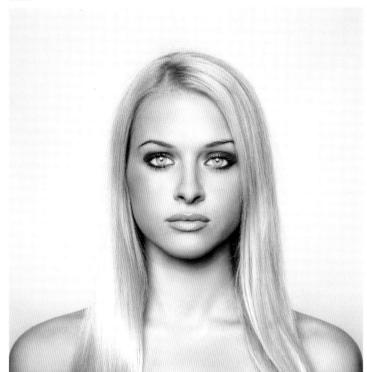

← ↑ Start with a selection

While it's easy to get carried away with the Puppet Warp tool (as it can manipulate a face into any shape you wish), let's just try to add some levity to this shot by making the model smile (after the fact). It starts by using the lasso tool to make a selection just around her mouth—being sure to include the neighboring cheek areas, and feathering it by at least 10–15 pixels.

↑ → Pull the lips into a smile

After copying that selection to a new layer, going to Edit > Puppet Warp will project this grid across the selected facial area. Your tool now defaults to an anchor, which you can use to set points anywhere in the selection. Here, just six anchors are set: two at the top and two at the bottom center of the lips, which are not moved at all; and two at the far corners of the mouth. These corner anchors are then delicately dragged up and slightly out, until the lips form a realistic smile. Note that by including the cheek areas in the feathered selection, it mimics the appearance of the muscles pulling the lips into a smile.

Glossary

additive primary colors The three colors red, blue, and green, which can be combined to create any other color. When superimposed on each other they produce white.

aliasing The jagged appearance of diagonal lines in an image, caused by the square shape of pixels.

alpha channel A grayscale version of an image that can be used in conjunction with the other three color channels, such as for creating a mask.

anti-aliasing The smoothing of jagged edges on diagonal lines created in an imaging program, by giving intermediate values to pixels between the steps.

aperture The opening in the camera lens through which light passes on its way to the image sensor (CCD/CMOS).

artifact A flaw in a digital image.

ASIC (Application-Specific Integrated Circuit) A silicon chip that is dedicated to one particular function, such as to graphics processing, or to a specific program, such as Photoshop. Used in an accelerator board, this is a fast solution, but it has limited uses.

aspect ratio The ratio of the height to the width of an image, screen, or page.

axis lighting Light aimed at the subject from close to the camera's lens.

backlighting The result of shooting with a light source, natural or artificial, behind the subject to create a silhouette or edge-lighting effect.

backup A copy of either a file or a program, for safety reasons, in case the original becomes damaged or lost. The correct procedure for making backups is on a regular basis, while spending less time making each one than it would take to redo the work lost.

banding Unwanted effect in a tone or color gradient in which bands appear instead of a smooth transition. It can be corrected by higher resolution and more steps, and by adding noise to confuse that part of the image.

barn doors The adjustable flaps on studio lighting equipment which can be used to control the beam emitted.

bit (binary digit) The basic data unit of binary computing.

bit depth The number of bits-per-pixel (usually per channel, sometimes for all the channels combined), which determines the number of colors it can display. Eight bits-per-channel are needed for photographic-quality imaging.

bitmap (bitmapped image) Image composed of a pattern of pixels, as opposed to a mathematically defined object (an object-oriented image). The more pixels used for one image, the higher its resolution. This is the normal form of a scanned photograph.

bracketing A method of ensuring a correctly exposed photograph by taking three shots; one with the supposed correct exposure, one underexposed, and one overexposed.

brightness The level of light intensity. One of the three dimensions of color.

buffer An area of temporary data storage, normally used to absorb differences in the speed of operation between devices. For instance, a file can usually be sent to an output device, such as a printer, faster than that device can work. A buffer stores the data so that the main program can continue operating.

bus Electronic pathway for sending data within a computer or between a computer and an external device. A "data highway."

byte Eight bits—the basic data unit of desktop computing.

cache An area of information storage set aside to keep frequently needed data readily available. This allocation speeds up operation.

calibration The process of adjusting a device, such as a monitor, so that it works consistently with others, such as scanners and film recorders.

CCD (Charge-Coupled Device) A tiny photocell, made more sensitive by carrying an electrical charge before it is exposed. Used in densely packed arrays, CCDs are the recording medium in low- to medium-resolution scanners and in digital cameras.

CD (Compact Disc) Optical storage medium originally developed by Philips.

CD-R (Compact Disc-Recordable) A writable cd-rom. Designed for desktop production using a relatively small recorder, CD-R discs look like ordinary cd-roms and are compatible with cd-rom drives, but have a different internal structure. They can be used as high-volume removable storage (700MB), and for producing multimedia projects and portfolios.

CD-ROM (Compact Disc Read-Only Memory) A optical disc storage medium in which the information can only be read, not altered. The information is "written" onto the disc by a laser that creates small pits in the surface, and so cannot be changed.

CD-RW (Compact Disc Rewritable) A CD on which data can be rewritten any number of times.

CGA (Color Graphics Adapter) A low-resolution color video card for PCs.

CGI (Computer-Generated Image) Electronic image created in the computer (as opposed to one that has been transferred from another medium, such as a photograph).

CGM (Computer Graphics Metafile) Image file format for both bitmapped and object-oriented images.

channel Part of an image as stored in the computer; similar to a layer. Commonly, a color image will have a channel allocated to each primary or process color, and sometimes one or more for a mask or other effect.

clip art Simple copyright-free graphics stored on disks or CDs that can be copied for use in a layout or image.

clipboard Part of the memory used to store an item temporarily when being copied or moved.

clip library Collection of simple units in any recordable media (such as graphics, photographs, sound) stored on disks or CDs that can be copied into an application.

clip photography Photographs stored on disks or CDs that can be copied into an application.

cloning In an image-editing program, the process of duplicating pixels from one part of an image to another.

CMOS (Complementary Metal-Oxide Semiconductor) Energy-saving design of semiconductor that uses two circuits of opposite polarity. Pioneered in digital cameras by Canon.

CMS (Color Management System) Software (and sometimes hardware) that ensures color consistency between different devices, so that at all stages of image-editing, from input to output, the color balance stays the same.

CMYK (Cyan, Magenta, Yellow, Key) The four process colors used for printing, including black (key).

color gamut The range of color that can be produced by an output device, such as a printer, a monitor, or a film recorder.

color model A system for describing the color gamut, such as RGB, CMYK, HSB, and lab.

color separation The process of separating an image into the process colors cyan, magenta, yellow, and black (CMYK), in preparation for printing.

color space A model for plotting the hue, brightness, and saturation of color.

Compact Flash card One of the two most widely used kinds of removable memory card in digital cameras. CF cards are used by Canon, Fuji, and others.

compression Technique for reducing the amount of space that a file occupies, by removing redundant data.

continuous-tone image An image, such as a photograph, in which there is a smooth progression of tones between black and white.

contrast The range of tones across an image from highlight to shadow.

CPU (Central Processing Unit) The processing and control center of a computer.

cropping Delimiting an area of an image.

cursor Symbol with which the user selects and draws on-screen.

cut-and-paste Procedure in graphics for deleting part of one image and copying it into another.

database A collection of information stored in the computer in such a way that it can be retrieved to order—the electronic version of a card index kept in filing cabinets. Database programs are one of the main kinds of application software used in computers.

default The standard setting or action used by a computer unless deliberately changed by the operator.

depth of field The distance in front of and behind the point of focus in a photograph, in which the scene remains in acceptably sharp focus.

desktop The background area of the computer screen on which icons and windows appear.

desktop computer Computer small enough to fit on a normal desk. The two most common types are the PC and Macintosh.

device Hardware unit that handles data, such as a scanner, printer or modem.

dialog box An on-screen window, part of a program, for entering settings to complete a procedure.

diffusion The scattering of light by a material, resulting in a softening of the light and of any shadows cast. Diffusion occurs in nature through mist and cloud cover, and can also be simulated using diffusion sheets and soft-boxes.

digital A way of representing data as a number of distinct units. A digital image needs a very large number of units so that it appears as a continuous-tone image to the eye; when it is displayed these are in the form of pixels.

digital zoom A false zoom effect used in some cheaper digital cameras; information from the center of the CCD is enlarged with interpolation.

digitize To convert a continuous-tone image into digital form that a computer can read and work with. Performed by scanner.

DMax (Maximum Density) The maximum density—that is, the darkest tone—that can be recorded by a device.

DMin (Minimum Density) The minimum density—that is, the brightest tone—that can be recorded by a device.

dpi (dots-per-inch) A measure of resolution in halftone printing.

draw(ing) program Object-oriented program for creating artwork, as distinct from painting programs that are pixel-based.

driver Software that sends instructions to a device, such as a printer, connected to the computer.

dynamic range The range of tones that an imaging device can distinguish, measured as the difference between its dmin and dmax. It is affected by the sensitivity of the hardware and by the bit depth.

edge lighting Light that hits the subject from behind and slightly to one side, creating flare or a bright 'rim lighting' effect around the edges of the subject.

fade-out The extent of any graduated effect, such as blur or feather. With an airbrush tool, for example, the fade-out is the softness of the edges as you spray.

feathering Digital fading of the edge of an image.

file format The method of writing and storing a digital image. Formats commonly used for photographs include tiff, pict, bmP, and jpeg (the latter is also a means of compression).

fill flash A technique that uses the on-camera flash or an external flash in combination with natural or ambient light to reveal detail in shadows.

fill light An additional light used to supplement the main light source. Fill can be provided by a separate unit or a reflector.

film recorder Output device that transfers a digitized image onto regular photographic film, which is then developed.

filter Imaging software included in an image-editing program that alters some image quality of a selected area. Some filters, such as Diffuse, produce the same effect as the optical filters used in photography after which they are named; others create effects unique to electronic imaging.

FireWire The Apple bus that allows for high-speed transfer of data between the computer and peripheral devices. Data can travel up to 400 megabytes-per-second.

flag Something used to partially block a light source to control the amount of light that falls on the subject.

flash meter A light meter especially designed to verify exposure in flash photography. It does this by recording values from the moment of a test flash, rather than simply measuring the live light level.

focal length The distance between the optical center of a lens and its point of focus when the lens is focused on infinity.

focal range The range over which a camera or lens is able to focus on a subject (for example, 0.5m to infinity).

focus The optical state where the light rays converge on the film or imaging sensor to produce the sharpest possible image.

frame grab The electronic capture of a single frame from a video sequence. A way of acquiring low-resolution pictures for image-editing.

fringe A usually unwanted border effect to a selection, where the pixels combine some of the colors inside the selection and some from the background.

frontal light Light that hits the subject from behind the camera, creating bright, high-contrast images, but with flat shadows and less relief.

f-stop The calibration of the aperture size of a photographic lens, used to determine precisely how much light is allowed through the lens and onto the sensor. Also used in the determination of depth of field.

gamma A measure of the contrast of an image, expressed as the steepness of the characteristic curve of an image.

GB (GigaByte) Approximately one billion bytes (actually 1,073,741,824).

GIF (Graphics Interchange Format) Image file format developed by Compuserve for PCs and bitmapped images up to 256 colors (8-bit), commonly used for Web graphics.

global correction Color correction applied to the entire image.

gobo Anything used to block or partially block light, particularly when it contributes a shape or texture to the light as it falls on the scene—much like a stencil.

gradation The smooth blending of one tone or color into another, or from transparent to colored in a tint. A graduated lens filter, for instance, might be dark on one side, fading to clear on the other.

graphics tablet A flat rectangular board with electronic circuitry that is sensitive to the pressure of a stylus. Connected to a computer, it can be configured to represent the screen area and can then be used for drawing.

grayscale A sequential series of tones, between black and white.

hardware The physical components of a computer and its peripherals, as opposed to the programs or software.

haze The scattering of light by particles in the atmosphere, usually caused by fine dust, high humidity, or pollution. Haze makes a scene paler with distance, and softens the hard edges of sunlight.

HDRi (High Dynamic Range imaging) Software-based process that combines a number of images taken at different exposure settings to produce an image with full shadow to highlight detail.

histogram A map of the distribution of tones in an image, arranged as a graph. The horizontal axis is in 256 steps from solid to empty, and the vertical axis is the number of pixels.

honeycomb grid In lighting, a grid can be placed over a light to prevent light straying. The light can either travel through the grid in the correct direction, or will be absorbed by the walls of each cell in the honeycomb.

hotshoe An accessory fitting found on most digital and film SLR cameras and some high-end compact models, normally used to control an external flash unit. Depending on the model of camera, information to lighting attachments might be passed via the metal contacts of the shoe.

HSB (Hue, Saturation and Brightness) The three dimensions of color. One kind of color model.

hue A color defined by its spectral position; what is generally meant by "color" in lay terms.

icon A symbol that appears on-screen to represent a tool, file, or some other unit of software.

image compression A digital procedure in which the file size of an image is reduced by discarding less important data.

image-editing program Software that makes it possible to enhance and alter a scanned image.

image file format The form in which an image is handled and stored electronically. There are many such formats, each developed by different manufacturers and with different advantages according to the type of image and how it is intended to be used. Some are more suitable than others for high-resolution images, or for object-oriented images, and so on.

incandescent lighting This strictly means light created by burning, referring to traditional filament bulbs. They are also know as hotlights, since they remain on and become very hot.

incident meter A standalone light-measuring instrument, distinct from the metering systems built into many cameras. These are used by hand to measure the light falling at a particular place, rather than (as the camera does) the light reflected off of a particular subject.

indexed color A digital color mode in which the colors are restricted to 256, but are chosen for the closest reproduction of the image or display.

interface Circuit that enables two hardware devices to communicate. Also used for the screen display that allows the user to communicate with the computer.

interpolation Bitmapping procedure used in resizing an image to maintain resolution. When the number of pixels is increased, interpolation fills in the gaps by comparing the values of adjacent pixels.

inkjet Printing by spraying fine droplets of ink onto the page; by some distance the most common home printing technology.

ISO (International Standards Organisation) An international standard rating for imaging sensor sensitivity, with the sensitivity increasing as the rating increases. ISO 400 is twice as sensitive as ISO 200, and will produce a correct exposure with less light. However, higher ISOs tend to produce more grain and noise in the exposure, too.

JPEG (Joint Photographic Experts Group) Pronounced "jay-peg," a system for compressing images, developed as an industry standard by the International Standards Organisation. Compression ratios are typically between 10:1 and 20:1, although lossy (but not necessarily noticeable to the eye).

Kelvin Scientific measure of temperature based on absolute zero (simply take 273.15 from any temperature in Celsius to convert to kelvin). In photography, measurements in kelvin refer to color temperature. Unlike other measures of temperature, the degrees symbol is not used.

lasso A selection tool used to draw an outline around an area of the image.

layer One level of an image file, separate from the rest, allowing different elements to be edited separately.

light pipe A clear plastic material that transmits light, like a prism or optical fiber.

light tent A tent-like structure, varying in size and material, used to diffuse light over a wider area for close-up shots.

lossless Type of image compression in which no information is lost, and so most effective in images that have consistent areas of color and tone. For this reason, not so useful with a typical photograph.

lossy Type of image compression that involves loss of data, and therefore of image quality. The more compressed the image, the greater the loss.

lpi (lines-per-inch) Measure of screen and printing resolution.

luminosity Brightness of color. This does not affect the hue or color saturation.

lux A scale for measuring illumination, derived from lumens. It is defined as one lumen per square meter, or the amount of light falling from a light source of one candela one metre from the subject.

macro A mode offered by some lenses and cameras that enables the lens or camera to focus in extreme close-up.

mask A grayscale template that hides part of an image. One of the most important tools in editing an image, it is used to make changes to a limited area. A mask is created by using one of the several selection tools in an image-editing program; these isolate a picture element from its surroundings, and this selection can then be moved or altered independently.

menu An on-screen list of choices available to the user.

microdrive Miniature hard disk designed to fit in the memory-card slot of a digital camera and so increase the storage capacity.

midtone The parts of an image that are approximately average in tone, midway between the highlights and shadows.

mode One of a number of alternative operating conditions for a program. For instance, in an image-editing program, color and grayscale are two possible modes.

modeling light A small light built into studio flash units which remains on continuously. It can be used to position the flash, approximating the light that will be cast by the flash.

monobloc An all-in-one flash unit with the controls and power supply built-in. Monoblocs can be synchronized together to create more elaborate lighting setups.

noise Random pattern of spots on a digital image that are generally unwanted, caused by non-image-forming electrical signals.

noise filter Imaging software that adds noise for an effect, usually either a speckling or to conceal artifacts such as banding.

open flash The technique of leaving the shutter open and triggering the flash one or more times, perhaps from different positions in the scene.

Pantone Pantone Inc.'s color system. Each color is named by the percentages of its formulation and so can be matched by any printer.

parallel port A computer link-up in which various bits of data are transmitted at the same time in the same direction.

paste Placing a copied image or digital element into an open file. In image-editing programs, this normally takes place in a new layer.

PDF (Portable Document Format) An industry standard file type for page layouts including images. Can be compressed for Internet viewing or retain full press quality; in either case the software to view the files—Adobe Reader—is free.

peripheral An additional hardware device connected to and operated by the computer, such as a drive or printer.

photo-composition The traditional, non-electronic method of combining different picture elements into a single, new image, generally using physical film masks.

pixel (PICture ELement) The smallest unit of a digitized image—the square screen dots that make up a bitmapped picture. Each pixel carries a specific tone and color.

plugin module Software produced by a third party and intended to supplement a program's performance.

PNG (Portable Network Graphic) A file format designed for the web, offering compression or indexed color. Compression is not as effective as JPEG.

PostScript The programming language that is used for outputting images to high-resolution printers, originally developed by Adobe.

ppi (pixels-per-inch) A measure of resolution for a bitmapped image.

processor A silicon chip containing millions of micro-switches, designed for performing specific functions in a computer or digital camera.

program A list of coded instructions that makes the computer perform a specific task.

ramp Gradient, as in a smooth change of color or tone.

Raw files A digital image format, known sometimes as the "digital negative," which preserves higher levels of color depth than traditional 8 bits per channel images. The image can then be adjusted in software—potentially by three *f*-stops—without loss of quality. The file also stores camera data including meter readings, aperture settings and more. In fact, most camera models create their own kind of proprietary Raw file format, though leading models are supported by software like Adobe Photoshop.

real-time The appearance of instant reaction on the screen to the commands that the user makes—that is, no appreciable time-lag in operations. This is particularly important when carrying out bitmap image-editing, such as when using a paint or clone tool.

render(ing) The process of performing the calculations necessary to create a 2D image from a 3D model.

Res (RESolution) The level of detail in a digital image, measured in pixels (e.g. 1,024 by 768 pixels), or dots-per-inch (in a half-tone image, e.g. 1200 dpi).

resampling Changing the resolution of an image either by removing pixels (lowering resolution) or adding them by interpolation (increasing resolution).

resolution The level of detail in an image, measured in pixels (e.g. 1024 by 768 pixels), lines-per-inch (on a monitor) or dots-per-inch (in the halftone pattern produced by a printer, e.g. 1200 dpi).

RGB (Red, Green, Blue) The primary colors of the additive model, used in monitors and image-editing programs.

saturation The purity of a color; absence of gray, muddied tones.

scanner Device that digitizes an image or real object into a bitmapped image. Flatbed scanners accept flat artwork as originals; slide scanners accept 35mm transparencies and negatives; drum scanners accept either film or flat artwork.

scrim A light, open-weave fabric, used to cover softboxes.

selection A part of the on-screen image that is chosen and defined by a border, in preparation for making changes to it or moving it.

shutter The device inside a conventional camera that controls the length of time during which the recording medium (sensor) is exposed to light. Many digital cameras don't have a shutter, but the term is still used as shorthand to describe the electronic mechanism that controls the length of exposure for the imaging sensor.

shutter speed The time the shutter (or electronic switch) leaves the sensor open to light during an exposure.

slow sync The technique of firing the flash in conjunction with a slow shutter speed (as in rear-curtain sync).

SLR (Single Lens Reflex) A camera which transmits the same image via a mirror to the film and viewfinder.

snoot A tapered barrel attached to a lamp in order to concentrate the light emitted into a spotlight.

softbox A studio lighting accessory consisting of a flexible box that attaches to a light source at one end and has an adjustable diffusion screen at the other, softening the light and any shadows cast by the subject.

stylus Penlike device used for drawing and selecting, instead of a mouse. Used with a graphics tablet.

subtractive primary colors The three colors cyan, magenta, and yellow, used in printing, which can be combined to create any other color. When superimposed on each other (subtracting), they produce black. In practice a separate black ink is also used for better quality.

sync cord The electronic cable used to connect camera and flash.

thumbnail Miniature on-screen representation of an image file.

TIFF (Tagged Image File Format) A file format for bitmapped images. It supports CMYK, RGB, and grayscale files with alpha channels, and lab, indexed-color, and it can use LZW lossless compression. It is now the most widely used standard for good-resolution digital photographic images.

toolbox A set of programs available for the computer user, called tools, each of which creates a particular on-screen effect.

top lighting Lighting from above, useful in product photography as it removes reflections.

TTL (Through-The-Lens meter) A device that is built into a camera to calculate the correct exposure based on the amount of light coming through the lens.

tungsten A metallic element, used as the filament for lightbulbs, hence tungsten lighting.

umbrella In photographic lighting umbrellas with reflective surfaces are used in conjunction with a light to diffuse the beam.

USB (Universal Serial Bus) In recent years this has become the standard interface for attaching devices to the computer, from mice and keyboards to printers and cameras. It allows "hot-swapping," in that devices can be plugged and unplugged while the computer is still switched on.

USM (Unsharp Mask) A sharpening technique achieved by combining a slightly blurred negative version of an image with its original positive.

white balance A digital camera control used to balance exposure and color settings for artificial lighting types.

WiFi A wireless connectivity standard, commonly used to connect computers to the Internet via a wireless modem or router.

window light A softbox, typically rectangular and suitably diffused.

wysiwyg (what you see is what you get) Pronounced "wizzywig," this acronym means that what you see on the screen is what you get when you print the file.

zoom A camera lens with an adjustable focal length, giving, in effect, a range of lenses in one. Drawbacks include a smaller maximum aperture and increased distortion over a prime lens (one with a fixed focal length).

Index

Bibliography & Useful Addresses

Books

The Complete Guide to Light and Lighting in Digital Photography
Michael Freeman

The Photoshop Pro Photography Handbook
Chris Weston

Perfect Exposure
Michael Freeman

Mastering High Dynamic Range Photography
Michael Freeman

Pro Photographer's D-SLR Handbook
Michael Freeman

The Complete Guide to Black & White Digital Photography
Michael Freeman

The Complete Guide to Night & Lowlight Photography
Michael Freeman

The Art of Printing Photos on Your Epson Printer
Michael Freeman & John Beardsworth

Digital Photographer's Guide to Adobe Photoshop Lightroom
John Beardsworth

The Photographer's Eye
Michael Freeman

The Photographer's Mind
Michael Freeman

Websites

Note that website addresses may often change, and sites appear and disappear with alarming regularity. Use a search engine to help find new arrivals.

Photoshop sites
Absolute Cross Tutorials
www.absolutecross.com

Laurie McCanna's Photoshop Tips
www.mccannas.com

Planet Photoshop
www.planetphotoshop.com

Photoshop Today
www.designertoday.com

ePHOTOzine
www.ephotozine.com

Digital imaging and photography sites
Creativepro
www.creativepro.com

Digital Photography
www.digital-photography.org

Digital Photography Review
www.dpreview.com

Short Courses
www.shortcourses.com

Software
Alien Skin
www.alienskin.com

ddisoftware
www.ddisoftware.com

DxO
www.dxo.com

FDRTools
www.fdrtools.com

Photoshop, Photoshop Elements
www.adobe.com

PaintShop Photo Pro
www.corel.com

Photomatix Pro
www.hdrsoft.com

Toast Titanium
www.roxio.com

Useful Addresses

Adobe www.adobe.com

Apple Computer www.apple.com

BumbleJax www.bumblejax.com

Canon www.canon.com

Capture One Pro
www.phaseone.com/en/Software/

Capture-One-Pro-6 Corel
www.corel.com

Epson www.epson.com

Expression Media
www.phaseone.com/expressionmedia2

Extensis www.extensis.com

Fujifilm www.fujifilm.com

Hasselblad www.hasselblad.se

Hewlett-Packard www.hp.com

Iomega www.iomega.com

Kodak www.kodak.com

LaCie www.lacie.com

Lightroom www.adobe.com

Microsoft www.microsoft.com

Nikon www.nikon.com

Olympus www.olympusamerica.com

Pantone www.pantone.com

Philips www.philips.com

Photo Mechanic www.camerabits.com

PhotoZoom www.benvista.com

Polaroid www.polaroid.com

Ricoh www.ricoh-europe.com

Samsung www.samsung.com

Sanyo www.sanyo.co.jp

Sony www.sony.com

Symantec www.symantec.com

Wacom www.wacom.com